THE NORTH LIGHT ARTIST'S GUIDE TO
Materials & Techniques

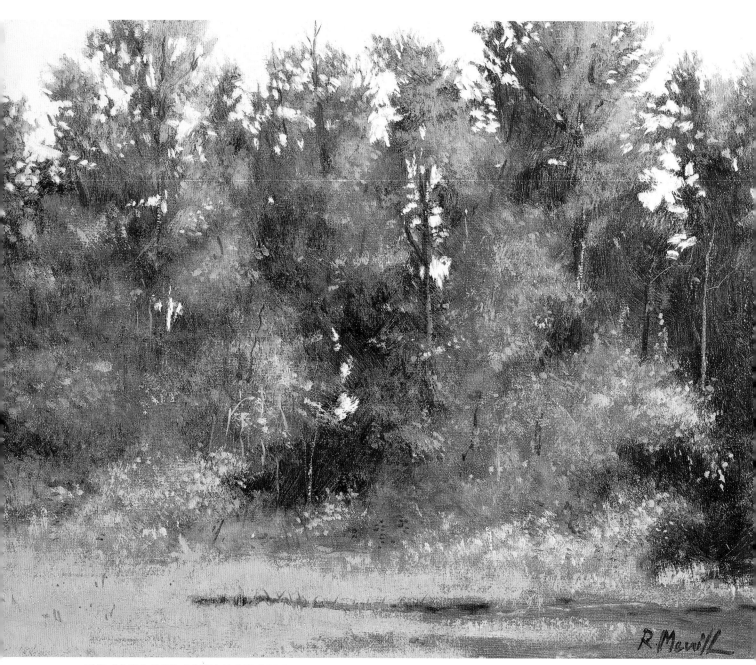

END OF SUMMER, POTOMAC WOODS
Ross Merrill
Oil on canvas
14" × 18"

THE NORTH LIGHT ARTIST'S GUIDE TO Materials & Techniques

PHIL METZGER

NORTH LIGHT BOOKS
CINCINNATI, OHIO

SPECIAL THANKS

Each book I write is inspected and proofread by my partner, Shirley Porter. She's a talented artist, skilled in many mediums, but she also has a good eye for what looks right in print. Not much gets by her, especially baloney. Her critiques are like those an artist gets from teachers and peers and critics—temporarily painful but ultimately necessary and helpful. She gave me advice about how to handle some of the art and contributed several of her own paintings. She also helped with some of the photography—she has a hand (literally) in many of the illustrations. Thanks Shirley—I appreciate your help.

DEDICATION

Years ago, when I still worked for IBM and wore a tie, I began puddling around with oil paints and watercolors. My first teacher was a friend and neighbor, and a gifted painter. She now lives in West Virginia with her husband, Hunter, an ex-IBMer who lists among his passions barbershop singing and fireplaces. With fond memories, I dedicate this book to

DIANE McCARTNEY

The North Light Artist's Guide to Materials & Techniques. Copyright © 1996 by Phil Metzger. Manufactured in China. All rights reserved. No part of this book may be reproduced in any form or by any electronic or mechanical means including information storage and retrieval systems without permission in writing from the publisher, except by a reviewer, who may quote brief passages in a review. Published by North Light Books, an imprint of F&W Publications, Inc., 1507 Dana Avenue, Cincinnati, Ohio 45207. (800) 289-0963. First paperback edition 2001.

Other fine North Light Books are available from your local bookstore, art supply store or direct from the publisher.

Visit our Web site at www.nlbooks.com for information on more resources for artists.

05 04 03 02 01 5 4 3 2 1

Library of Congress has catalogued hardcover edition as follows:
Metzger, Philip W.
 The North Light artist's guide to materials & techniques / Phil Metzger.
 p. cm.
 Includes bibliographical references and index.
 ISBN 0-89134-675-9 (hardcover)
 1. Artists' materials. 2. Artists' tools. 3. Art—Technique. I. Title.
N8530.M48 1996
702'.8—dc20 96-5909
 CIP

 ISBN 1-58180-253-6 (pbk: alk. paper)

Edited by Kathy Kipp and Rachel Wolf
Designed by Brian Roeth

METRIC CONVERSION CHART		
TO CONVERT	**TO**	**MULTIPLY BY**
Inches	Centimeters	2.54
Centimeters	Inches	0.4
Feet	Centimeters	30.5
Centimeters	Feet	0.03
Yards	Meters	0.9
Meters	Yards	1.1
Sq. Inches	Sq. Centimeters	6.45
Sq. Centimeters	Sq. Inches	0.16
Sq. Feet	Sq. Meters	0.09
Sq. Meters	Sq. Feet	10.8
Sq. Yards	Sq. Meters	0.8
Sq. Meters	Sq. Yards	1.2
Pounds	Kilograms	0.45
Kilograms	Pounds	2.2
Ounces	Grams	28.4
Grams	Ounces	0.04

ACKNOWLEDGMENTS

It takes more than an author to make a good book. First you have editors (Kathy Kipp and Rachel Wolf) who get the project under way and then provide guidance month after month until the book is finished. Once the text is written, a content editor (Julie Whaley) corrects and shapes it for readability, and a copyeditor (Anne Slater) weeds out your bad English, rotten spelling and poor construction. Then a content-reviewer (Ed Brickler, artist and art materials consultant) looks for factual errors and omissions—and there were many. A designer (Brian Roeth) organizes text and pictures into an eye-catching, readable format. And finally, a production editor (Marilyn Daiker) oversees the transformation of marked-up text and pictures into a beautiful book. I'm grateful that all these people did their jobs with such excellence.

Without the contributions of the artists whose work appears on these pages, there would be no book. I also got a lot of help from others, particularly George Stegmeir (Grumbacher), Ross Merrill (National Gallery of Art), Laurie Doyle (ACMI), Hilary Mosberg (Savoire-Faire), Wendell Upchurch (Winsor & Newton), Tim Hopper (Holbein), Alan Witt (Whatman), Larry Salis (Salis), Kathryn Clark (Twinrocker), Sandra Erwin and Faith Wismer (Koh-I-Noor), Joan Floyd (Berol), Stacy Faramelli (Crescent), Robert Dominici (Fabriano), Johnny Binator (Fredrix), Beverly Satterfield (Hunt), Jack Hines and Jessica Zemsky (Pro Arte), Mark Smith (Sanford), Tina White (Shiva), Charlee Doyle (Staedtler) and Robert Simmons. Thanks to all of you!

I also had help from the people who work at Macco of Bethesda, a Maryland art supply store. As you can imagine, for a book of this type, there were lots of details to run down, and I relied on the people at Macco to give me accurate information. These people are unusual in their willingness to help a customer and in their knowledge of their products. Thanks to Karin Dillet, Gerry Mitchell, Nancy Rodrigues, owners Louis and Barbara Rubin, and especially to Geoffrey Davis, who fielded most of my questions.

Since photography is such an important part of books like this one, I need help and I get it from Fred Kaplan, local camera-store owner, unofficial Mayor of Rockville, and raconteur. Need a roll of film? See Fred. Need a story? See Fred. Thanks Fred!

ABOUT THE AUTHOR

Phil Metzger claims he's still trying to decide what to be when he grows up. He left a solid career in computer programming management at IBM in 1971 to make his way as a painter. Along the way he wrote a successful management book. The success of that first book gradually nudged him toward more writing. He now has a couple of management books to his credit as well as two books for North Light (*Perspective Without Pain* and *Enliven Your Paintings With Light*). In addition he has written and published several books himself under the name of LC Publications and has sold them through mail order. Since 1971, he has explored many mediums, including watercolor, oil, alkyd, egg tempera, pastel, pencil, acrylic . . . he loves them all. Still trying to decide.

REMEMBERING RON DEMBOSKY

A sense of humor goes a long way toward surviving in the art world. Ron Dembosky was one of those artists whose wit and humor helped a lot of us weather hundreds of street art shows, good and bad. Ron was talented, hardworking, helpful, always ready with a joke, a good and faithful friend. Ron, we'll miss you.

TABLE OF CONTENTS

Some Basics

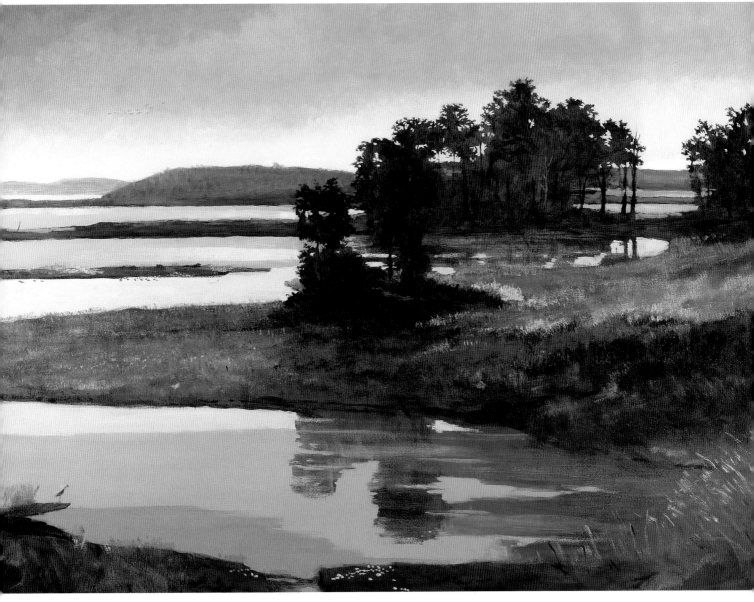

THE STILLNESS OF EARLY MORNING
Ross Merrill
Oil on canvas
36″×50″
Collection of the artist
Courtesy Susan Conway Gallery,
Washington, D.C.

This book has two goals: To help you choose *materials* when you begin working with a new medium, and to give you a set of basic *techniques* for getting started in each medium. For each medium there's a suggested shopping list of materials to get you started, and advice from practicing, successful artists telling you what materials and techniques *they* use.

Each chapter is self-contained so that you can read it without a lot of page-flipping to other chapters, but some basic information is gathered here to avoid repeating it in every chapter.

PAINTS

Most paints have two basic ingredients: a *coloring* material and a *binder* that traps the color and holds it in place. Most coloring materials are powdered, insoluble *pigments*, while others are liquid, soluble *dyes*. Common usage, except among chemists, calls *any* coloring material a *pigment*, so that's the convention we'll use here. In addition to pigment and binder, some paints have a number of other ingredients.

When you buy any manufacturer's paints, ask for a complete color guide to their line. If your store or catalog doesn't offer a color guide (usually a booklet or glossy sheet showing color swatches), write or call the manufacturer and ask for one—many manufacturers' addresses and phone numbers are listed at the back of this book. You'll find most of them happy to send you information about their products.

HUES

The variety of colors, or *hues*, available to you today would make a Renaissance artist phthalo-green with envy! Most manufacturers offer dozens of basic colors. Although many artists settle into using relatively few, experimenting with new ones from time to time will open your eyes to ever broader creative possibilities. The chart on page 11 shows some of the transparent watercolor colors available from one manufacturer. Equivalent hues are available in most mediums.

There is another meaning for *hue* that causes some confusion. When substitute pigments are used to create a color, the color name contains the word *hue*. Such substitute colors are often used (a) in student-grade colors to reduce cost, (b) to replace pigments that are no longer available (example: Indian Yellow Hue) and (c) as substitutes for pigments that are poisonous (example: Naples Yellow Hue).

"The longevity of a painting is dependent on the quality of three key elements: the materials selected by the artist, the construction of the painting and the environment to which the painting is exposed. The artist can control the first two of these elements by selecting durable materials and using sound painting technique, but the artist rarely controls the third element, the environment in which the painting is exhibited and stored. The best environment is one that is moderate, without extreme changes of temperature or humidity.

The painting materials must be of the highest quality if they are to be lasting. The support must be durable whether it is a fabric, paper, a seasoned wooden panel or other material. Like the support, the ground materials must be of high quality, and most importantly, the paints must be compounded of lightfast, stable pigments ground into a durable binder. After aging, any varnish used should be free from yellowing and easily removed without damage to the paint.

The best of today's artist's materials are remarkably durable if properly used and the paintings appropriately housed. Most manufacturers provide lightfastness or durability ratings for their various grades of paints. Using these ratings, the artist can anticipate the longevity of the materials in the painting. The artist cannot expect second-grade or student-grade materials to provide the longevity of the highest quality materials.

If the painting is to last, the artist must use sound painting techniques so the painting is free from construction faults that may lead to premature degradation. Unfortunately, many artists do not understand or follow sound techniques. Many paintings from the mid-1900s have prematurely aged due to a combination of these factors and as a result, the subtlety of the image has been destroyed. The untimely deterioration of the support, delamination of the various layers or premature cracking can lead to a dramatic distortion of the appearance of a painting and compromise the artist's intent. With the passage of time, we reassess the past and the artist should assure that his works offer a fair representation of his skills and creative intent."

ROSS MERRILL, CHIEF OF CONSERVATION AT THE NATIONAL GALLERY OF ART, WASHINGTON, D.C.

SOME POPULAR HUES

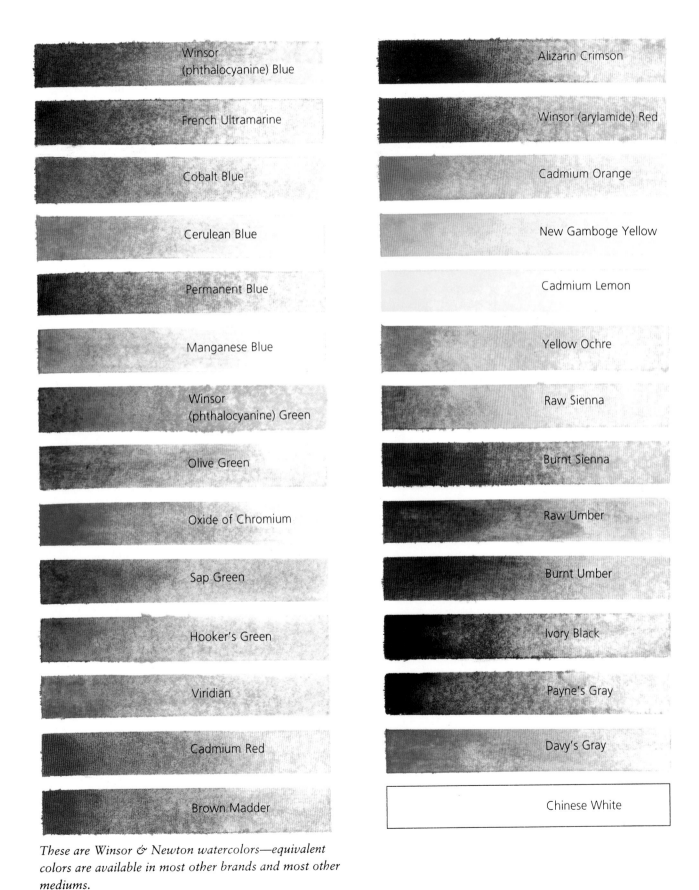

Winsor (phthalocyanine) Blue

French Ultramarine

Cobalt Blue

Cerulean Blue

Permanent Blue

Manganese Blue

Winsor (phthalocyanine) Green

Olive Green

Oxide of Chromium

Sap Green

Hooker's Green

Viridian

Cadmium Red

Brown Madder

Alizarin Crimson

Winsor (arylamide) Red

Cadmium Orange

New Gamboge Yellow

Cadmium Lemon

Yellow Ochre

Raw Sienna

Burnt Sienna

Raw Umber

Burnt Umber

Ivory Black

Payne's Gray

Davy's Gray

Chinese White

These are Winsor & Newton watercolors—equivalent colors are available in most other brands and most other mediums.

KINDS OF PAINT

Most paints are basically combinations of a binder and pigment. The binder depends on the type of paint, but the pigments are usually the same regardless of the type of paint. For example:

burnt sienna oil *paint =*
iron oxide pigment + linseed oil binder

burnt sienna watercolor *paint =*
iron oxide pigment + gum arabic binder

burnt sienna acrylic *paint =*
iron oxide pigment + acrylic emulsion binder

In recent years, however, new specialty paints have been added to the acrylic, oil and watercolor product lines. They contain ingredients in addition to the usual pigments and binders. Their names and makeup vary among manufacturers, but here is a brief look at some of them.

Interference Paints

Surfaces painted with these colors look different depending on the angle at which they are viewed and the angle of the light striking the painted surface. At some angles, the color appears as the stated color of the paint (for example, red) but at other angles, the color will appear to be the *complement* of the stated color (in this case, not red, but green). You can get other color effects by mixing the interference paints with noninterference paints, or by painting over a variety of light- and dark-colored surfaces.

Interference paint contains tiny flakes of mica coated with titanium dioxide, which give the paint its unique qualities. Some wavelengths of light striking the upper surface of a mica flake are reflected while other wavelengths pass through to lower layers, where they are reflected at different angles.

Iridescent Paints

These contain materials similar to interference paints, but they are opaque and do not exhibit the color shifts that are the hallmark of interference paints. Instead, iridescent paints provide shimmering, metallic effects.

Metallic Paints

Metallic paints actually include metal particles that simulate the luster of such metals as gold, silver and bronze.

Fluorescent Paints

These appear to "glow," much like a fluorescent light tube (they absorb light of one wavelength and reemit it at a different wavelength). These paints are not lightfast and should not be used for permanent painting.

PERMANENCE

In recent decades a lot of work has been done to establish standards for testing the lightfastness of paints. Lightfastness means the ability of the paint to resist color change and fading when exposed to light. The American Society for Testing and Materials (ASTM) has developed standards that many manufacturers have adopted for testing and labeling their paints. ASTM has defined five categories of permanence, but only the top two are of interest to most practicing artists:

Lightfastness Category I (LFI): excellent lightfastness under all normal lighting conditions.

Lightfastness Category II (LFII): very good lightfastness, satisfactory for all applications except those requiring prolonged exposure to ultraviolet light—for example, outdoor murals.

Paints listed under the other categories range from moderately durable to downright fugitive colors. While they have their uses (for example, in art to be used only for reproduction), they have no place on your palette if you intend your art to last indefinitely.

Some manufacturers, such as Grumbacher and Liquitex, use the ASTM labeling scheme, but others do not. For example, labels on Winsor & Newton paints use the designations AA (extremely permanent); A (durable, permanent for most uses); B (moderately durable); C (fugitive). Winsor & Newton's data sheets, however, list both their AA, A, B, C ratings *and* the corresponding ASTM ratings. Another example: Rowney Georgian Oil Colors use a star rating system: **** (permanent); *** (normally permanent); ** (moderately permanent); * (fugitive).

There is an odd aspect of permanence that you

Many paints display lightfastness, or permanence, ratings on their labels. The American Society for Testing and Materials has established several levels of lightfastness; some manufacturers use their own rating system.

should be aware of. I learned this from Joy Luke, a Virginia artist who has devoted many years to working with ASTM to develop their standards. The *medium* has an effect on a pigment's permanence. Pigment embedded in an oil or alkyd medium, for instance, is more *protected* than that same pigment would be in watercolor or gouache. Examples: Grumbacher Red (Naphthol Red) is rated category III in watercolor, but category II in oils. Grumbacher's Alizarin Crimson is rated category IV in watercolor, but category III in oils. (Any way you look at it, Alizarin Crimson should not be used in permanent work, although old habits are hard to kick and some of us continue to use this old favorite.)

A safe way for you to choose colors for permanent work is to stick with those in the highest two categories of permanence (no matter which rating scheme is used) and avoid the others.

TOXICITY

Most modern paints pose no known health hazard, as long as you use sensible precautions in handling them (don't eat them, drink them or inhale them!). Still, *some are toxic* and pose a danger to you or others in your household if not handled properly.

Here's how you know what's what: An organization called ACMI (Art & Creative Materials Institute) conducts tests and assigns labels to art and craft materials. Paints are labeled in one of three basic ways (illustrations courtesy of ACMI, 100 Boylston Street, Suite 1050, Boston, MA 02116):

AP (APPROVED PRODUCT)
means this paint is nontoxic.

CP (CERTIFIED PRODUCT)
also means this paint is nontoxic. In addition, this product meets certain quality standards developed by ACMI and other standards organizations.

HL (HEALTH LABEL)
is used in two basic ways. If it appears without any accompanying warning statements, the paint is nontoxic. If the paint is toxic, this square label will be accompanied by an explicit toxicity warning.

Here is one example of how a health label is used: A tube of Holbein Cadmium Yellow oil paint has a health label along with the following message:

WARNING: Cancer agent by inhalation based on tests with laboratory animals.

BRUSHES

The illustration on page 15 gives you an idea of the range of brushes available. Some are general-purpose brushes, while others are used for specialized jobs. In addition to those sold for making art, there are other brushes you can use, such as those originally intended for cleaning teeth or painting houses.

You may spend a great deal of money on a big selection of brushes, only to find that you use only a few of them most of the time. In each chapter of this book where brushes are appropriate, I'll suggest a starter set—you can add more to your collection as you gain experience.

BRUSH CONSTRUCTION

Most brushes have three parts: a tuft of natural or synthetic hairs, a ferrule and a handle. The hairs that make up the business end are sorted and arranged and then cemented into a sleeve called the ferrule. The best brushes have seamless ferrules that keep solvents from leaking inside them. The ferrule is crimped by machine to fasten it firmly to the handle. Depending on the size and style of brush, there may be more hair hidden within the ferrule than exposed outside it. When animal hairs are used they are usually arranged by hand to form a sharp point or a clean edge.

Some brushes, such as those intended for oil painting, are made with long handles, while others, such as watercolor brushes, have shorter handles. The idea seems to be that watercolorists don't work at arm's length, while oil painters and others do. Choose whichever length suits you, regardless of medium.

SYNTHETIC VERSUS NATURAL

The tips of most brushes are made of hair from one or more animals. If you choose not to buy animal products, you can limit yourself to synthetic brushes and be *very* happy with your results. For almost twenty years I've bought nothing but synthetics and have never missed the sables and the oxhairs and the others. I do

continue to use the animal-hair brushes I already owned before deciding to go synthetic. If you choose carefully and take care of your synthetic brushes, they'll serve you well for a long time. A real bonus is that the synthetics are generally *far* less expensive than the others.

KINDS OF HAIR

The following types of brushes are listed roughly in descending order of cost. There is no way to know for sure which brush hairs you'll like best for painting in a particular medium, but you can heed recommendations made by other artists, including those appearing in later chapters of this book, and gradually try others on your own. The "feel" of a brush is personal, and what's right for one painter may not at all appeal to the next.

Kolinsky Sable

Made from the tail hairs of a type of mink found in Siberia, this has long been considered the best of the natural hairs. It's soft, yet resilient. It holds a lot of fluid and can be formed into a fine point or sharp edge. Used for all media, but especially the more fluid ones, this is the most expensive of brushes.

Red Sable

These hairs from members of the weasel family are not as fine or as springy as their Kolinsky cousins, but they are of high quality and much less expensive than Kolinsky. Used for all media.

Sabeline

Less costly than red sable, sabeline hairs don't come from the weasel family at all—they are the better grades of ox hair, usually dyed to look like red sable. Used for all media.

Ox Hair

Strong hairs with a good spring, they come from several varieties of cattle. Used mainly with fluid media.

Bristle

Coarse hair from hogs, used mainly for oil and acrylic.

Camel Hair

Actually hair from a number of animals, such as squirrel, goat, pony or horse—not from camels. They vary greatly in composition, quality and cost.

Squirrel

Truly made from squirrel hair, this brush is relatively inexpensive (depending on the quality of the hair) and it holds a lot of liquid . It's used for watercolor painting, especially in "mop" brushes for washes.

Synthetics

These "hairs" are made of such materials as nylon and polyester. Early synthetic brushes—those made several decades ago—were awkward and not very responsive. Modern versions more closely simulate the characteristics of fine natural-hair brushes. They can be used for all media. They are especially good for acrylic paints, because acrylics tend to be harsh and destructive of animal hairs. Synthetic brushes are relatively inexpensive and are not attractive to pests, such as rodents or bugs.

BUYING BRUSHES

If you choose your brushes at a store rather than order them from a catalog, you better your chances of being satisfied. In a particular batch of brushes, especially pointed ones, you'll find a lot of variance. In the store, dip a brush in a cup of water and squish it a few times to remove the protective gum or starch from the tuft. Then shake the brush with a flip of the wrist, and see whether the hairs come together in a sharp point—or, if it's a flat brush, wet it and see whether it forms a sharp and uniform edge. Press a brush against a hard surface to test its springiness. And finally, be sure the ferrule is tightly attached to the handle, with no wiggles.

How many *sets* of brushes should you have? Some painters have a separate set for each medium. In my case, I keep three. One set is for watercolor, egg tempera and gouache; a second is for oil and alkyd; and the third is for acrylic. If you're using synthetic brushes, you really could use the same set of brushes for oil, alkyd and acrylic. This is not a good idea if you use animal-hair brushes for your oil and alkyd paintings, because those brushes will not hold up well if used for acrylic painting.

BRUSH SHAPES

Brushes are made in a variety of shapes to serve different purposes, and the names of those shapes are fairly well standardized. The chart on page 15 shows the more common shapes and their usual uses. As a trip to the art store will demonstrate, there are dozens of variations. Also, some teachers offer their own "special" brushes, many of which are nicely suited to that teacher's style of painting. None of them is the "magic brush," the Holy Grail of artdom. The only magic you'll find is inside your head.

COMMON TYPES OF BRUSHES

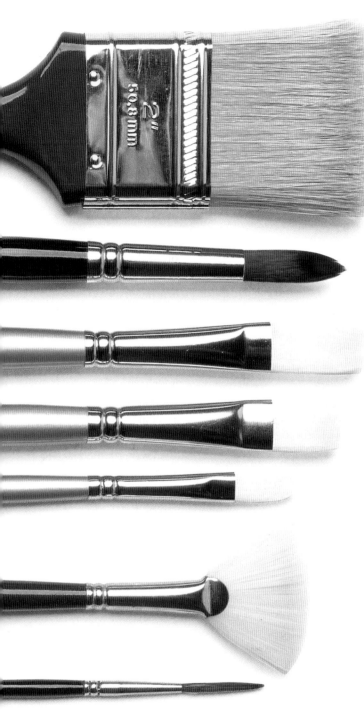

HOUSE-PAINTING

Inexpensive large brushes from a paint or hardware store have lots of uses, especially for fluid washes. Particularly useful are those called varnish brushes, two inches or so in width, but only about half as thick as other house-painting brushes. The brush shown here is a varnish brush.

ROUND

Used in all media in a wide variety of sizes for painting both broad areas and fine details.

FLAT

Used in all media for painting broad areas and sometimes, with its chisel edge, sharp lines. Large sizes used for big washes. Also called "long flat."

BRIGHT

Similar to flat, *but with shorter hairs. Fairly stiff. Also called "short flat."*

FILBERT

Like a flat, *but with rounded corners. Can produce strokes without hard edges.*

FAN OR BLENDER

Used with feather-light strokes to blend paint.

RIGGER OR SCRIPT OR LINER

Three names for brushes that look very similar, with hairs that are long in relation to the thickness of the hair bundle. Used for lettering, fine lines, and all kinds of detail work. Used in all mediums, especially watercolor.

BRUSH SIZES

In the section called "Shopping List" in each chapter, I suggest brush sizes. There's not too much mystery about *flat* brushes—the size given means the distance across the flat of the ferrule where the bristles emerge. The *rounds* are a different story. One company's "no. 0" is another company's "no. 1." Your best guide is experience that allows you to go to the store and pick out the brushes that *look* the right size and forget about their numbers.

To try to help you without confusing you, below is a set of brushes, shown actual size, along with the numbering scheme I use throughout this book. When I say no. 0 or no. 6 or whatever, these are the sizes I have in mind. If I recommend a size not shown here, just estimate—for instance, a no. 5 will be between a no. 4 and a no. 6.

Keep in mind, there's nothing sacred about anybody's recommendation concerning brush sizes. Don't let anybody tell you you've *got* to have such-and-such brush (or such-and-such anything, for that matter). All anyone can do is suggest a starting place—when you've gained a little experience you'll make your own choices with confidence.

BRUSH CLEANING AND CARE

Since brushes are your main tool for applying paint, better take care of them! Keep them from getting out of shape, protect them from pests and clean them.

Keep brushes in their proper shapes by storing them in a container with the hairs upright or laying them flat (*never* rest a brush on its hairs!). Or you can buy a fancy

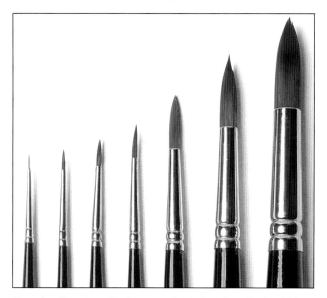

Popular Pro Arte Prolene synthetic brushes, Series 101. Sizes are (left to right): 000, 0, 1, 2, 6, 10, 14.

brush-holder with individual holes for parking each of the brush handles, hairs pointed upward.

Pests are occasionally a problem. I have heard of moths destroying expensive sables and mice chewing on brush handles. Some people scatter a few moth balls or flakes around the brush storage area or in the jars or cans and that seems to do the trick. If you keep your brushes in a closed container, be sure the lid does not press against the hairs, and provide for air circulation by punching tiny holes in the lid.

Cleaning

Clean your brushes *during* a painting session to keep fast-drying paints, such as acrylics, from hardening and ruining them. Clean them *after* each painting session no matter what kind of paint you're using.

The cleaning regimen depends on the kind of paint. For water-based paints, swish the brush through plain tap water (never hot), changing to clean water, and swishing again until no more color escapes from the brush. Then, to get at the paint hiding up high in the hairs, near the ferrule, rub the brush in some brush soap and press gently against the palm of your hand under running water to squeeze out any reluctant paint. If paint accumulates near the ferrule, the brush will become gradually stiffer and less responsive. Finish up with more clean water to remove the soap. Shape the bristles with your fingers and put the brush aside.

Some people use ordinary hand soap for cleaning brushes, and this is probably okay if the soap contains no lotions. Lotion soaps may clog the fine scales found on natural hairs, reducing the ability of the hairs to hold liquid. The safest choice is to use brush soaps specifically made for the job.

For oil and alkyd paints, follow the same procedure, but use turpentine or mineral spirits in place of water. Then finish up with brush soap and water. To avoid wasting a lot of solvent buy a product such as Silicoil or the Bob Ross Cleaning Screen. Place one of these gadgets in the bottom of a wide-mouthed jar or can and fill the container halfway with solvent. Clean a brush by gently rubbing it against the coil or screen. As paint loosens, it mixes with the solvent, but later settles to the bottom of the container, leaving clean solvent above. When the buildup of sediment reaches the screen, empty the jar and refresh with new solvent.

You can make your own arrangement using a piece of window-screen or an inverted tea strainer or an inverted can with holes punched in its bottom. Such screens work fine, but may wear out your brushes faster than smoother-finished commercial products.

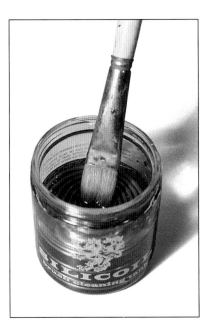

You can reuse the solvent in this Silicoil brush-cleaning jar as long as there is enough room for sediment to collect at the bottom.

KNIVES

There are two types of "knives" used in most of the mediums: painting knives and palette knives. The better knives to buy are those with offset handles that keep your knuckles out of the paint.

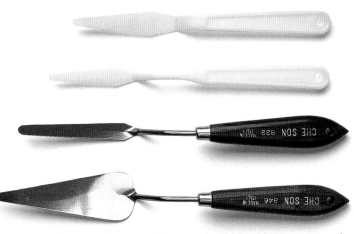

Painting *knives, used for mixing and applying paint and for scraping paint from a support or from a palette, come in a variety of sizes and shapes, and in metal or plastic.*

Palette *knives are the longer ones, used mainly for scraping paint from a surface or for mixing large mounds of paints.*

SUPPORTS AND GROUNDS

The physical material you paint or draw on is called the *support*. It may be paper, canvas, wood, hardboard, concrete, plastic, glass or anything else you choose. Specific information about supports used for a particular medium is included in the chapter discussing that medium. Here, we'll discuss supports in a more general way. A *ground* is a coating put on the surface of the support before you draw or paint on it.

PAPER

The paper you're most familiar with—that used to make this book or your newspaper or magazine or tissue or paper towel or cardboard box—is made from wood pulp. Wood pulp paper products are perfectly serviceable and relatively cheap, but they don't last long. After a short time they become discolored and brittle due to the effects of the natural acids they contain. The acids can be removed or neutralized at some expense, and the product will last much longer, but there remains another drawback: most papers made from wood pulp lack the *strength* to take the physical abuse heaped on them by maniacal artists!

Rag Content

Most of the best artist's papers today are made from cotton fibers. Cotton fabric is mixed with water and various chemicals and beaten to a pulp—literally. Either by hand or by machine, the fluid cotton pulp is formed into sheets that, when dried, become "rag" paper. The term "rag" means that the source of the cotton fibers is actually cotton cloth, or rags. (The term suggests worn-out clothes, but that's not the case. These are clean, new rags!) Papers derived from cotton can be made not only acid-free, but exceptionally strong, as well.

Some papers are made from combinations of cotton and wood or cotton and synthetic fibers. Others, mistakenly called "rice papers," are made from fibers such as mulberry (rice straw fibers are rarely used). Still others called "vellum" or "parchment" are modern papers imitating writing surfaces traditionally made from animal skins.

Acidity

Substances are either acidic, alkaline or neutral. A lemon is *acidic*, Alka-Seltzer is *alkaline*. Mix the right amount of the two together and the result is *neutral*.

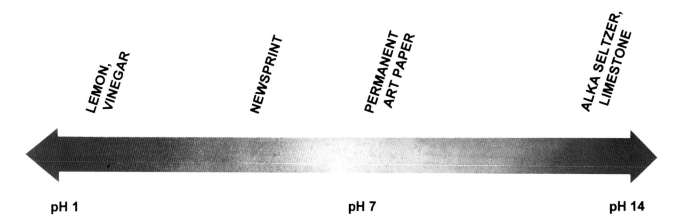

LEMON, VINEGAR

NEWSPRINT

PERMANENT ART PAPER

ALKA SELTZER, LIMESTONE

pH 1 **pH 7** **pH 14**

A pH value of 1 is highly acidic, 14 is highly alkaline, and 7 is neutral.

Scientists measure acidity and alkalinity using a scale of "pH" values ranging from 1 to 14. Although makers of quality papers usually seek a pH of 7 or slightly higher, a pH between 6 and 8 is considered "neutral" even though, technically, only pH 7 is truly neutral.

Papers are treated in various ways to counter the destructive effects of acids. Alkaline materials added to a paper to neutralize acids (that is, raise the pH) are called "buffers." Some papermakers add buffer to the fluid pulp, some only buffer the surface of the paper, and some do both. Often, extra buffer is added as a hedge against future exposure of the paper to acidic environments. Such papers are technically not "pH-neutral," but are actually slightly alkaline. The term "acid-free" better describes them.

When you buy a paper called either "pH-neutral" or "acid-free," understand this: Those labels describe the paper as it leaves the manufacturing process; there is a lot that can happen to a paper during its life that can alter its acidity. For example, if you surround a picture with mat board that is acidic or if you back a picture with acidic cardboard, the acid in the mat or backing can affect your art paper. Even if matted and framed properly, exposure to air that contains acids can affect the paper.

Choosing Papers

To obtain the most durable papers for painting and drawing, look for those that are not only "100 percent rag," but are also rated as either "pH-neutral" or "acid-free." The rag content gives you strength and beauty, the lack of acidity helps guarantee long paper life. The next best choice would be papers that have at least some rag content (for example, 25 percent) *and* are rated as pH-neutral or acid-free.

CANVAS

Canvas is a fabric woven from a variety of natural or synthetic fibers. Canvas enjoys a long reputation as an effective support for oil paintings and now, for acrylic paintings.

Fibers

The fibers most commonly used for artists' canvas are linen, cotton and synthetics. Linen enjoys a reputation as the first choice among artists, but it's much more expensive than the second choice, cotton. Gaining in popularity are synthetic fibers, such as Polyflax manufactured by Fredrix. You may safely use any of these three, provided you prepare them and handle them properly. At appropriate places in this book you'll find what you need to know about these supports; for further information, see Ralph Mayer's *The Artist's Handbook of Materials and Techniques* (Bibliography) and read material available from manufacturers. Fredrix's booklet *Artist Canvas Beyond the Brush* is full of information about how canvas is made and treated.

As you'll see when you inspect rolls of canvas at an art store, there are a number of different weaves available, from fine to coarse and from tight to loose. Choose a weave that suits your aims—a coarse weave, for example, might be suitable for rough or impressionistic brushwork or knifework, while a finer weave would be suitable for smoother, more detailed painting. Beware of too *loose* a weave found in some cheaper fabrics, for those fabrics may be so weak they sag under the weight of layers of paint.

The Ground

When you paint on canvas, you have three common choices for the ground you use: an acrylic ground, an oil-based ground or no ground at all.

Acrylic Gesso Ground. Over the past several decades, acrylic gesso has become extremely popular as a ground. It's nontoxic, easy to apply, inexpensive, flexible and permanent.

You can buy canvas already coated ("primed") with an acrylic ground. When buying preprimed canvas you'll usually have a choice of single- or double-primed, an indication of the thickness of the ground. The choice is purely aesthetic—which one looks and feels like the surface you want? Both give the canvas adequate protection. For a given type of canvas, double-primed will mean a stiffer canvas.

You can prepare your own canvas (any type of fiber) easily enough. Depending on how thick a ground you want, brush acrylic gesso, either undiluted or slightly thinned with water, onto the stretched canvas. You can apply as many coats as you wish, but one or two thin coats are usually enough. After a first coat, lightly sand the dried gesso to remove the "fuzz" before applying the second coat. There is no need to coat both sides of the canvas.

Acrylic gesso is not the same as white acrylic paint. Acrylic gesso is more porous, more textured and more absorbent than acrylic paint. It's made this way so that it provides good *tooth* for adhesion with later paint layers. The tooth provided by acrylic gesso makes it a suitable ground not only for acrylic paint, but for oil, alkyd, and other mediums as well. It is not safe to substitute acrylic *paint* for gesso as a ground for oils or alkyds. Although such a painting might last a long while without apparent problems, it's widely accepted by conservators and manufacturers that delamination of the layers may eventually occur. (For that reason, if you decide to use acrylic paint as an *underpainting* for oil or alkyd, use only the thinnest possible underpainting. The thicker and slicker the acrylic paint, the less likely is good adhesion.)

An acrylic ground dries fast and may normally be painted on with acrylic paint within an hour or so (unless for some reason you're using an unusually thick ground). But wait at least several hours before applying oil paint—the ground must be bone-dry and totally free of any moisture before applying oils. Any ground should be totally dry to the touch, without any tackiness, before you paint on it.

Oil Ground. Before the invention of acrylic gesso, most oil paintings were done on a ground made of white oil paint containing lead carbonate. Such paint is popularly known as white lead or flake white. Many oil and alkyd painters today still use lead-based grounds, although lead oil grounds have two disadvantages:

- Lead compounds are toxic and must be handled with great care.
- If applied directly to natural fibers, such as cotton or linen, the oil in such paints will eventually damage the fibers.

If you decide to use a lead carbonate ground, you must first coat the canvas with a "size," such as rabbit-skin glue. The glue surrounds the fibers and protects them from direct contact with the oil paint.

You can prepare your own canvas or buy canvas already oil-primed. An oil-primed canvas may be used for oil, alkyd, oil sticks or oil pastels. It should *not* be used for acrylic or other water-based paints because there will be imperfect adhesion between those paints and an oil ground.

No Ground at All. If you're painting in acrylics, you may paint directly on the canvas. No protection is necessary because acrylic paint doesn't adversely affect the canvas fibers. (Whether you *like* painting on raw canvas is another matter, strictly one of aesthetics.)

If you're using oils, don't paint on raw canvas if you want your pictures to last. Although many well-known experimental artists have painted in oils on raw canvas, their works require a lot more attention by conservators than paintings prepared with proper grounds.

Stretching Canvas

If you decide to stretch your own canvas, here's how to proceed.

1. Fit together four wood stretcher strips of the appropriate size. Tap the corners together tightly and use a right angle (such as a carpenter's square) to be sure all corners are square. Check squareness periodically during the stretching—an out-of-square canvas is a mess you'll have to redo.

2. Cut a piece of canvas at least two inches larger in both dimensions than the stretcher-strip rectangle. Lay the canvas face down on a smooth, clean surface and place the assembled stretcher strips face down on the canvas. (The face of the strips is the beveled side.)

Grounds for Separation

It's safe to use either oil or acrylic paint on an *acrylic gesso* ground. But if you use acrylic paint on an *oil* ground, the paint may separate from the ground.

Align the threads of the canvas parallel to the stretcher strips.

3. Starting at the center of the longer side, fold the canvas around the stretcher strip and nail or staple it to the edge of the strip. (A reasonable choice is to use a staple gun with ordinary steel staples. Use nonrusting copper or brass tacks or stainless steel staples for extra protection against corrosion.)

4. Using framer's pliers, tug the canvas tightly around the *opposite* stretcher strip, and fasten.

5. Now fasten the canvas to the center of one of the other two stretcher strips, pulling the canvas snug (but not too tight). Then fasten the canvas on the fourth side, using the pliers to pull the fabric tight. Note: Don't fasten linen canvas as tightly as you would cotton canvas, because linen fabric does not stretch as much as cotton.

6. Go back to the first stretcher strip and add staples about two inches on both sides of the first one, using the pliers to pull the canvas tight. Make sure there are no puckers between staples. Do the same with the opposite strip. In this manner, work your way from the center toward the corners until the entire canvas is fastened, taut and pucker-free.

7. Fold corners neatly and staple in place. Recheck to be sure corners are square. Then fasten the loose edges of canvas neatly to the backs of the stretcher strips.

8. When you're finished stretching, your canvas should be drum-tight, no sags, no wrinkles. Don't rely on pounding in the corner "keys" (wedge-shaped wood or plastic pegs that come with the stretcher strips) in order to finish the job. Reserve their use in case in the future the canvas should sag and need a little tightening. You can easily whack these keys in so far that you expand the total size of the stretched canvas too much to fit inside the intended frame!

Canvas Board

This is canvas glued to a sheet of cardboard. There are two problems with canvas boards. First, the cardboard may absorb moisture from the back, causing the board to warp. Warping can be lessened by gluing wood strips

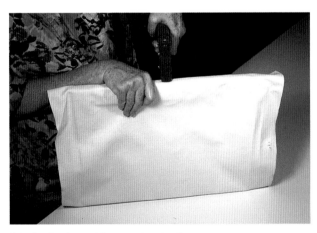

Staple the first side, starting in the center.

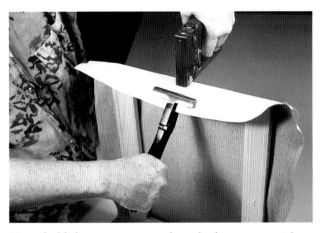

Next, hold the canvas taut and staple the opposite side.

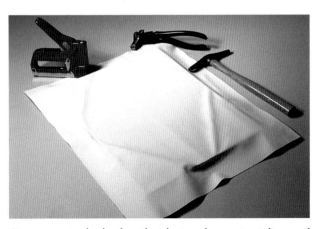

Once you staple the fourth side, you have a taut diamond shape in the middle of the canvas, with all four corners still loose.

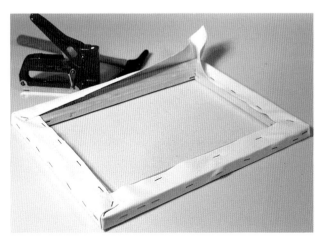

The finishing touch—staple the canvas to the back of the stretcher strips.

to the back to stiffen the cardboard and by sealing the back of the cardboard with acrylic gesso or paint. Second, no boards currently on the market use acid-free cardboard, so they can be expected in time to deteriorate (becoming brittle and flaky) as any acidic paper will. Again, coating the back with acrylic will slow the process of disintegration.

If you find a board advertised as being acid-free, you may safely use it for permanent work (provided you're satisfied with the canvas and ground used) but you may still need to take steps to prevent warping.

HARDBOARD

Hardboard is made by subjecting wood pulp to high pressure and heat so that the fibers form a hard, compact mass. The best-known brand of hardboard among artists is Masonite. It has been used for decades by painters and seems to be a reliable, permanent product.

Grades

Hardboard comes in two grades: *untempered* (also called *standard*) and *tempered*. *Tempered* hardboard contains oils that, among other things, make it resistant to water. While suitable for some uses, it is *not* to be used as a painting support because its oils make paint adhesion doubtful. Untempered is recommended.

Sizes

Hardboard is sold in two thicknesses, ⅛″ and ¼″ and in various sized sheets, commonly 4′ × 8′. The thinner board is suitable for smaller paintings; for larger ones, to avoid warping, you can either choose the thicker board or "cradle" the thinner one. (See the illustration below right.) Keep in mind that hardboard is heavy and a large painting done on ¼″ board will be much heavier than one done on stretched canvas.

Surfaces

Some hardboards have two smooth surfaces, some have one smooth and one coarsely textured. Most artists use the smooth side for painting, but you can use either.

The Ground

To prepare untempered hardboard for either acrylic or oil painting, first sand the surface with fine sandpaper to remove any oiliness and to provide some "tooth" in the hard surface. Rub both sides with a damp sponge and then with paper towels until no appreciable amount of brown comes off onto the towels.

If you intend to cradle the board (see next section), do so now. Then paint both sides and all edges (and

BOARD THICKNESS	SIZE OF PANEL	HOW TO PREVENT WARPING
⅛-inch	up to 20″ × 20″	gesso both sides
⅛-inch	over 20″	cradle back, gesso both sides
¼-inch	up to 30″ × 30″	gesso both sides
¼-inch	over 30″	cradle back, gesso both sides

cradling strips, if any) with undiluted acrylic gesso. Paint the back first, then turn the board over and rest it on some thin strips to keep the wet gesso from the table surface. The wet gesso on the back will tend to make the board warp, so paint the front surface quickly to equalize the pull. When completely dry, sand the front to the smoothness you want and wipe clean. Apply a second coat, if you wish, in the same way—back, then front. Although hardboard is acidic, the acrylic gesso ground effectively seals the hardboard and prevents its acid from migrating to the painted surface.

You can use as many coats as you wish, but two are generally sufficient. Use acrylic gesso straight from the jar for the first coat. For the second coat (and beyond) dilute it with a little water—10 percent water is about right. Do not dilute economy gesso unless instructed by the manufacturer. Work quickly—don't continue brushing after the gesso begins to "set."

Cradling

To stiffen a piece of hardboard, lay it face down on a flat surface and glue wood strips 2″ wide and ½″ or ¾″ thick to the back along each edge. If the board is longer

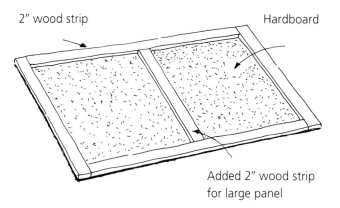

2″ wood strip Hardboard

Added 2″ wood strip for large panel

Cradling the back of a sheet of hardboard will prevent warpage of large panels.

than 36″, glue an additional strip halfway between the two shorter edges. For very large boards, glue additional strips. Use smooth, straight wood strips (not rough wood such as lath) and fasten them with Elmer's glue. Pile some heavy weights on top of the strips (or use carpenters' clamps) and leave them until the glue is *thoroughly* dry, preferably overnight.

MEDIUMS

In art, the word "medium" has several meanings. The appropriate meaning should be clear from the context in which the word is used. A medium is:

1. A basic *kind* of art—such as, painting, drawing, etching, sculpting. This book is about two such media, painting and drawing. Plural is usually *media*. OR . . .

2. The basic *material* used by the artist—such as, watercolor paint, oil paint, graphite, clay, steel. Each chapter of this book deals with one or more specific painting or drawing mediums. Plural is either *media* or *mediums*. OR . . .

3. The ingredient in paint that *binds* the pigment—such as, gum arabic in watercolor paint, linseed oil in oil paint, egg yolk in egg tempera. Plural is either *media* or *mediums*. OR . . .

4. Material, usually a fluid or a gel, that can be *added* to paint to alter some of the paint's properties. For example, some mediums change the paint's viscosity; some make the color more transparent; some change the degree of surface shine; others speed or slow drying. Some mediums are used to add binder to the paint—more oil in oils; more polymer in acrylics; more gum arabic in watercolor; and so on. These uses of mediums are amplified in later chapters.

STORAGE

No matter which art medium you use, you need storage for your paints, brushes and other tools and materials. Many artists use one or more taborets, small chests of drawers with casters for easy rolling about the studio. You can make your own from a small bookshelf—add a set of casters and a cutting-board top, and insert extra shelves if necessary. The taboret I use (see above) came from an art supply store. It was fairly pricey (about $100) but it's perfect, and it'll last forever. If you work a lot in more than one medium you may want a separate

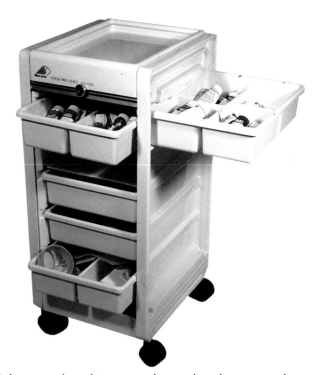

Taborets such as this one can be purchased at art supply stores or made at home with a bookshelf and set of casters.

taboret for each. Having your materials organized removes one common obstacle to getting started on a new piece of work: clutter.

You also need storage space for paper, mat board, frames and so on. For flat items, such as paper, large, flat file drawers (sometimes called map cabinets) can't be beat. New ones are expensive, but diligent searches in used-furniture stores may turn up some bargains. I have two sets of used cabinets side by side, covered with a single ¾″-thick sheet of 4′ × 10′ plywood, which in turn is covered with a thin sheet of smooth tileboard. This surface is my matting and framing area, and the paper cabinets are out of the way below.

For mat board, you can build or have built a set of vertical slots such as those you see in the art supply store. For frames, again some sort of vertical bins or slots will help you to keep order.

SHOPPING LISTS

Each chapter includes a Shopping List, intended to help the newcomer to the medium know what to buy *just to get started*. I have not included brand names except in a few rare instances, where it seemed helpful to do so. To cut down on redundancy, the following items

(almost *always* needed) are not included in the individual Shopping Lists:

BASICS	✓
easel or work table	
taboret or cabinet	
mirror	
chair or stool	
carrying case for travel	
pencil and scratch paper	
sketch books	
transfer paper	

A word of comfort about choosing art materials: Every artist you read about or talk to will recommend something different—different brands, different size brushes, different colors and so on. Within the chapters of this book you'll find seemingly conflicting advice from various featured artists. Don't panic. They're *all* right! They simply have differing experiences! There are, after all, many excellent paints, papers and so on from which to choose. One thing most professionals agree on, though: buy the best *quality* materials and tools you can. Look for "artist-quality" products and shun "student-grade."

Student-grade paints are not always clearly labeled as such, but you can get clues from catalog descriptions. Example: One manufacturer describes its *artists'* watercolors as "unmatched for purity, quality and reliability among professional artists' colors throughout the world." The same manufacturer describes its less expensive watercolors (without calling them *student-grade*) in this way: "This comparatively inexpensive selection of good quality colors includes useful traditional pigments and reliable synthetic colors instead of rare and more expensive pigments."

Similarly, for materials such as paper, the terms "pH-neutral" or "acid-free" are a must. In addition, look for rag content. If nothing is said about a paper's acidity or rag content, it's safe to assume it's not acid-free and has no rag content.

SKETCH BOOKS

The chapters that follow suggest tools and materials to use for this medium or that, and they're all different. But one tool that remains constant is your sketch book. Carry one with you wherever you go, whether on a painting trip or a trip to the grocery. Fill your books with sketches of every conceivable subject. No matter what your artistic direction, there is nothing you sketch that won't help you. The more you sketch, the more you'll train your eye and the more skillful you'll become at capturing values, shapes, details, textures, colors.

I suggest you buy sketch books in a couple of sizes, with paper whose surface appeals to you. Look for books that open flat and are easy to work in, such as the spiral-bound variety. They don't *have* to have acid-free paper—that just might inhibit you by making you reluctant to record anything but really important stuff! Record in your sketch book *anything* that trains your eye or helps you to recall a scene, a moment—even a smell or a sound.

Sketch with any tool you like—pencil, pen, colored pencil, marker—anything. Make notes to remind you of details. Write down random thoughts. Make this your visual diary. I suggest that you treat a sketch book like a diary, in fact, and keep it private—that way, you'll not hesitate to put in it anything that occurs to you. What's in there is nobody's business but yours.

May I make a final suggestion? *Keep* your sketch books. Years or decades from now you'll love having this personal and lively little history of your artistic travels. I made a big mistake with mine: Since I was caught up in making my living by selling my work, I sold everything I could, including pages from my sketch books. I'd love to have them all back.

Your sketch books are among your most important art materials.

Mirror, Mirror . . .

No matter what kind of art you do in whatever medium, frequently look at your picture (especially in the initial stages) in a mirror. We all tend to be visually biased, left or right, and seeing a picture *in reverse* in the mirror makes those biases obvious. A small, hand-held mirror is fine and it will fit your traveling tool kit. If you can, mount a larger mirror behind your work area so that you can step aside, glance into the mirror, and see your work in reverse.

EASELS

An easel is any structure that supports the painting or drawing you're working on. It may be a flat tabletop, a tilting drafting table, a folding easel or a traditional vertical easel.

Traditional easels come in an eye-popping range of prices and functions. You can pay ten or fifteen dollars and get what is essentially a skinny wooden tripod with a shelf for holding your canvas. Or you can pay around two hundred dollars and get a so-called French easel that you can use in the studio or fold up for outdoor painting. And you can pay eight hundred dollars or more for a sturdy studio easel.

Getting the right easel (or easels) is important—the right one can ease your work considerably, and the wrong one can frustrate you. Since the purchase of an easel *can* involve real money, I suggest you go about your buying decision this way:

Step One: Look over what's available in a good catalog, such as Dick Blick or Daniel Smith. Read about all the features available to help you decide what you want. For example:

- Do you want an easel that can comfortably hold large, heavy work? A skinny little tripod won't.
- If you work in pastel, among other media, do you want an easel that will hold the picture with its top tilting toward you so that pastel dust will fall to the floor or to a dust trough rather than sift over the picture's surface?
- Do you want easy-working cranks to raise and lower the picture, or are you satisfied to deal with loosening and tightening wing nuts and bolts?
- Do you want to be able to move the easel about the studio, or do you need a space-saver that fastens against a wall?
- Do you want a separate easel for use on location—that is, away from your studio—or do you want one easel for both studio and location use?
- Do you want a built-in ledge for resting your palette, brushes, etc., or do you prefer to keep those items to your side on a taboret or table?

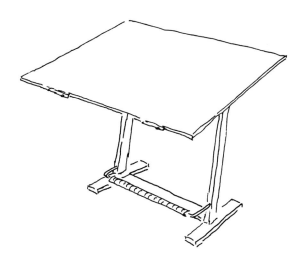

A drafting table that tilts from horizontal to an almost vertical position gives lots of room to work.

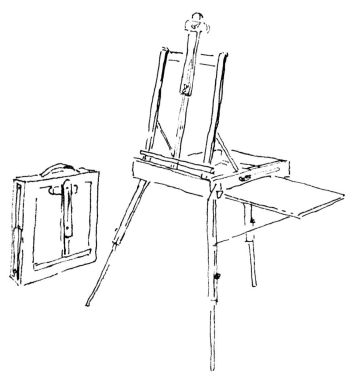

A typical French easel. Useful when painting on location, it can also be used in the studio.

Step Two: Now, armed with an idea of the features you think you want, go to a large art store and look at easels. Set them up, adjust them, test their stability. Place a board or canvas on an easel and stab at it the way you would if you were painting on it. Does it move too much with each "brushstroke"? Should you pay more for added solidity?

Step Three: Price-shop. There are enormous price differences among retailers for similar easels. You might also look for a bargain in local art club newsletters and on art school bulletin boards, if there are any near you. Your easel is an important purchase—buying the right one now can mean never having to buy another. On the other hand, if you're new to painting and unsure of what you'll eventually want, buy a cheap easel and plan to replace it in a year or so, after you've gained some experience and have a better idea what you need.

A moderately priced, fairly sturdy easel.

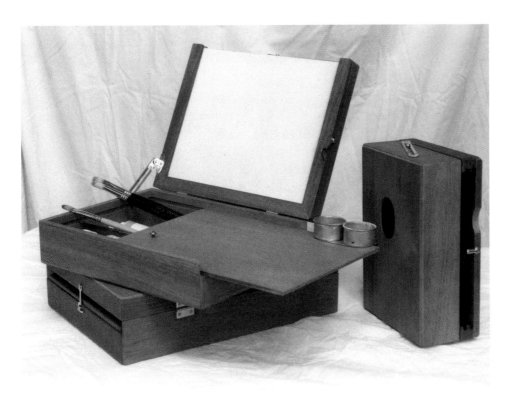

A John Bonner pochade box. A pochade box is another easel variation to consider. It's small and light enough that it's easily portable, but big enough to hold all your basic supplies and tools, including paints, palette, mediums, knives, brush-cleaner, brushes and one or more small panels to paint on. It's what Charles Sovek uses (see chapter three). A pochade box may be hand-held or attached to a tripod or balanced on your knees.

SO . . . WHAT'S NEW?

We take many materials for granted because they've been used for centuries. We have a love affair with canvas and oils, for example, despite their many problems. We can be so attached to the past that it's hard to be truly open to new materials.

By the time you read this there will be new art materials available that were not in the catalogs a year ago. Make it your business to investigate them as thoroughly as time and money allow. Not so long ago, acrylic paint was of doubtful importance and synthetic brushes were shunned—now they're staples of the art business. Less than a decade ago, mixing and cleaning up oils with water was preposterous—now we have MAX Grumbacher Artist's Oil Colors. And so it goes, at an accelerating pace.

In an old issue of *The Artist's Magazine* (June 1995) you'll find an article by Rhett Lucas called *Modern Painting Surfaces*. It's worth reading. Lucas talks about the problems associated with some traditional materials and takes a look at newer ones. It's a fascinating look at new supports, such as aluminum and synthetic fabrics, and new paints, such as Archival™ Oils, formulated to remain flexible after drying.

And not all that far in the future is computer art—images formed on a computer screen and then printed on high-quality paper using color printers. In fact, such art is with us already, but it's in its infancy and (so far) requires expensive equipment. Stay tuned!

Society Notes

Most chapters include an example of an art society or group dedicated to the medium(s) discussed in that chapter. I've included current addresses so you may write for information about their activities, especially their annual exhibitions. Some groups accept many or all mediums. One of the most prestigious of these is the National Academy of Design.

The National Academy of Design (NA) was founded in 1825 to further the development of the arts in America. Among the founders were Samuel F. B. Morse, Thomas Cole and Asher Durand. NA conducts exhibitions open to all categories of painting and graphics.

National Academy of Design
1083 Fifth Avenue
New York, NY 10128

Keeping Current

Whether you're a beginner or a professional, there are many ways to upgrade your knowledge about art materials and techniques and the business of art. You can read books; subscribe to publications such as *The Artist's Magazine*; join art societies or clubs where information is regularly shared; and join organizations whose goals are to provide information and services to artists—for example:

National Artists Equity Association
(800) 727-6232

NAEA offers information about work space, copyrights, income, health insurance, insurance for your artwork, and so on. They publish a newsletter with information ranging from the histories of art manufacturers to the latest on paint permanence and toxicity labeling.

Watercolor

This painting began wet-in-wet and finished dry. Here, as in most of her work, Porter uses a lot of negative painting.

GATHERING
Shirley Porter
Watercolor on Rives BFK printing paper
22" × 30"
Collection of the artist

WHAT IS WATERCOLOR?

Here are two common sizes of watercolor paint tubes. Paints bought in the larger tubes are typically about one-third less expensive than those in the small tubes.

Watercolor paint consists of a *pigment*, a *binder* and *water*. The binder is usually *gum arabic*, a secretion of certain trees grown in Africa, Asia and Australia. Other ingredients may be *glycerin*, to improve moistness and brushability and prevent excessive caking; *sugars* and *wetting agents*, to improve the paint's workability and smoothness; and a *preservative*.

The paint we're concerned with here is traditional *transparent watercolor*, the kind of paint actually labeled as "watercolor." It's generally applied in transparent layers that have no appreciable thickness. Other water-based paints, such as acrylic, gouache, casein and tempera, are usually applied in thicker layers and are not thought of as "transparent."

BASIC PROPERTIES

Watercolor paint dries by evaporation of the water in the paint, not by chemical change. Once dry, it can be made fluid again by reintroducing water.

To thin watercolor, you add water. To remove it from a painting, wet it and gently scrub (or "lift") it away. Some colors, especially the "earth" colors (such as Burnt Umber and Yellow Ochre) can be removed from a paper's surface almost completely, while others (such as Phthalocyanine Blue) stain the paper.

The binder in watercolor paint serves more to attach paint particles to the picture surface than to hold particles together in a continuous film. Along with the sticking power of the binder, paint particles are held in place by the fibers of the painting surface (usually paper). Because a watercolor paint film is so thin and practically without body, much of the look of a watercolor painting depends on the paper used—a rough paper gives a matte finish, and smoother papers give a satin or semigloss finish.

HOW WATERCOLOR PAINT IS SOLD

Watercolor is packaged in three forms: tubes (paste-like), bottles (liquid), and pans or cakes (solid), and in two grades: artist and student.

Tubes

Tube paint is moist and spreadable and is the most popular form sold in the U.S. Artist's grade paint is commonly offered in two tube sizes, 5 ml (.17 fluid ounces) and 14 ml (.47 fluid ounces). Some manufacturers also offer jumbo 37 ml tubes.

Once the cap is removed from a tube of paint, some air enters the tube and the paint slowly begins to dry out. If there are some colors you use infrequently, buy them in the smallest size to minimize losses due to hardening of the paint. You can do a lot to prevent paint hardening by screwing the caps on tightly, but first clean the paint from the neck of the tube to make the cap easier to remove next time.

Student-grade paints (often sold in 7.5 or 8 ml tubes) are, of course, less expensive than artist's grade, but student-grade products are generally inferior and not suitable for serious work.

Looking Back

Some people, especially in the U.S., think of watercolor as a relatively new medium, but Albrecht Dürer was painting watercolors at about the time Columbus was sailing off the edge of the earth. Watercolor paints had long been used to illustrate manuscripts, to paint preliminary studies for other (for example, oil) paintings, to record flora, fauna, people and architecture during travels, and so on. But Dürer was the first we know of who treated watercolor as a "serious" medium.

Much early watercolor was of the opaque variety, but since the sixteenth century, transparent watercolor has grown in popularity, thanks in great measure to the English watercolorists who fully exploited the medium. Until the nineteenth century, watercolor paints were available in hard, brittle cakes, but with the introduction of glycerin, the paints became less brittle, much more water-soluble, easier to use.

> "A little amateur painting in water-colour shows the innocent and quiet mind."
>
> ROBERT LOUIS STEVENSON

Pans or Cakes

More common in Europe than in the U.S., these colors come either already poured and hardened in little wells ("pans") or in individually wrapped cakes that you may insert into pans. I confess I don't have the patience to scrub around in a block of color to loosen up some paint—I prefer the instant availability of tube colors. However, pans and cakes have a real advantage if you want to do small paintings as you travel. They're compact and lightweight and the boxes that hold them usually have a lid that serves as a mixing palette. Some pans and cakes (such as Daler-Rowney's) are more densely pigmented than tube colors—that is, there's more color in one of them than there is in an equal volume of tube paint—so one of those little pans or cakes goes a long way.

Ready-poured *pans* come in sets containing as few as six and as many as two-dozen colors. Like tube paints, pans may be either artist or student quality. Individual *cakes* are commonly sold in "half-pan" size (about .5″×.6″×.25″ thick). Watercolor boxes to hold the cakes have wells for either half-pans or full-pans or both. One manufacturer offering a full range of colors in both half- and full-pan cakes is Daler-Rowney.

If you normally use tube colors, you can make your own lightweight box of "pan" colors for travel. Simply buy an empty watercolor box, squeeze tube color into the wells and let it harden. Or do the same with your regular watercolor palette if it's small enough to pack.

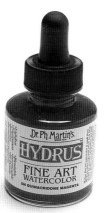

Use liquid watercolors when you want totally fluid, brilliant, transparent paint.

Bottles

Some brands of watercolor, such as Dr. Ph. Martin's Hydrus, are sold in liquid form. If you're dealing with straight liquid washes (or are using an airbrush or pen), liquid paints are a good choice. If you want to include some thickish, grainy passages, you'll have to add some white or other tube color to the liquid paint—adding white, however, will change the shade of your color.

BRAND COMPATIBILITY

You may freely intermix watercolors from different manufacturers with no adverse chemical or physical reaction. Such qualities as the paint's viscosity, the degree of fineness of the ground pigment, and the proportions of ingredients such as preservatives may differ among manufacturers, but those differences should not pose a problem. Watercolor paint may also be mixed with other *water-based* paints, such as acrylic or gouache.

PERMANENCE

When a paint fades, it's the *pigment* that fades, and not the binder. Since watercolor pigments are generally the same as pigments in other mediums, we might expect watercolors to fade no more than any other paint. Yet it seems they do. There are several possible reasons why this is so. First, watercolor paint has no heavy binder to shield the pigment from the fading effects of ultraviolet light. Second, the lack of protective binder exposes the pigment to air impurities that may have harmful effects—acid in the air, for example, will react with

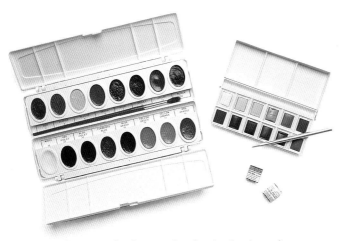

A typical watercolor box and individual cakes of watercolor, "half-pan" size; watercolor box with pre-poured pans of color.

Dr. Ph. Martin was in reality Ben Salis, not a doctor, but a chemist—he chose the name of a doctor-cousin for his products. He began developing the current line of products in the depression 1930s. His son, Larry, took over the business in 1970.

WATERCOLOR SCORECARD

CATEGORY	PRO	CON
colors available	virtually every color available in other media	
color compatibility	excellent; can intermix all colors	
brand compatibility	can freely mix brands	
strength		none; strength is all in the paper or other support
water resistance	can be rewet (carefully) to make changes	can be severely damaged if wet accidentally
permanence		more subject to fading than other mediums
drying time	rapid; depending on humidity, wetness of paper, type of paper	sometimes too fast to make many changes
resistance to damage		paper must be protected from moisture, molds, insects, rodents
yellowing	none	
adhesion	adheres well to fibrous, porous surfaces	does not adhere to oily or slick surfaces

Ultramarine Blue, causing it to bleach. Third, the very *thinness* of the paint layer means that if a pigment particle fades, there is not a lot of underlying pigment to carry on, so to speak, and maintain the overall color strength.

There are some rules to follow to give *any* painting a better chance of surviving; these rules are particularly important in watercolor: (1) Select only ASTM Category I or II colors; (2) use only the best, acid-free supports and grounds; (3) protect the painting's surface from atmosphere impurities, such as acidic air, by the use of glasses or varnishes; (4) protect the painting from intense, direct light, especially sunlight. One step many

people use to screen out the ultraviolet light responsible for so much fading is to cover a picture with glass that blocks such light. These UV glasses are widely available, but more expensive than common picture glass.

MEDIUMS AND VARNISHES

Mostly, the medium you use with watercolor is *water*. You can dilute the paint as much as you like to serve your purposes. There is no great worry about weakening the paint film, since there isn't much of a film to begin with. Special mediums are of limited use in conventional transparent watercolor painting. Still, you never know when a product might be just what you need for your particular style of painting, so by all means, experiment with these:

GUM ARABIC
This is one of the ingredients of watercolor. Sold in small bottles, diluted gum arabic may be used to lessen the creep or spread of paint on the paper when you're painting wet-in-wet. It slightly retards the drying of the paint. It makes dried watercolor paint appear more brilliant and helps keep dark colors dark (in watercolor, darker colors normally lighten as they dry).

WATERCOLOR MEDIUM
This medium contains gum arabic and water plus some mild acid. Adding it to your paint makes it dry harder and less soluble and makes it less easy to "lift" dried paint from the paper. It also helps to keep the darks dark. *There is one definite drawback with this product: the acid reacts with Ultramarine Blue and causes it to bleach.*

WATERCOLOR GEL
Sold under such brand names as Winsor & Newton Aquapasto, this is a thick mixture of gum arabic and silica. Mix it in any proportion with your paints to thicken the paint. Depending on how much gel you add, the resulting paint, when dry, will appear either translucent or opaque. Gel allows you to apply fairly thick layers of paint with little fear of cracking. It transforms your free-flowing watercolor paint into something more gooey, more like translucent acrylic paint. When dry, watercolor paint mixed with gel is harder to lift than watercolor paint alone.

Experiment with mediums such as these to see if their qualities are beneficial for your style of painting.

WETTING AGENT

A wetting agent is a substance used to break down the surface tension of water and to make surfaces more receptive to water. Gardeners are familiar with wetting agents (sometimes simply a little detergent) to make insect sprays spread uniformly over foliage instead of forming into little beads that aren't easily absorbed by the leaves. Painters use similar substances to help keep water-based paints from beading on slick surfaces, such as acetate or glass.

If you intend to paint on slick surfaces, do plenty of trials with wetting agents before adopting them for your painting. I've tried Winsor & Newton's Ox Gall Liquid and Steig's Colorflex, following the manufacturers' directions, but the results were always ambiguous. You may have to use stronger concentrations of these agents than the directions tell you to get good results.

GLYCERIN

Glycerin is one of the ingredients of watercolor paints. It's used to keep the paint moist and prevent too much brittleness in the dried paint. It improves brushability and increases the paint's solubility. If you squeeze tube paints into pans for use while traveling, a drop or two of glycerin in each blob of paint will keep the paint firm but not *too* hard, and will make it more soluble. Don't overdo it, because too much glycerin makes the paint so soluble that it lifts too easily from the paper—and that makes it difficult to apply one wash over another.

VARNISHING

Varnishes traditionally protect a painting from damage and provide a surface that can be cleaned without harming the underlying paint layers. They are also used to improve the brilliance of colors and to provide an appropriate final finish, such as matte or gloss.

The idea of varnish as protection for a *watercolor* becomes moot because watercolors are generally framed under glass anyway—that's necessary because the support (usually paper) needs protection from physical damage. Although some painters do varnish watercolors (using clear acrylic spray) most watercolors are left unvarnished.

PAINTING SURFACES

Although many people experiment with nontraditional surfaces, most watercolorists paint on some form of paper. A trip through the catalogs or a big art supply store will make you a happy but confused shopper because there are many different papers you can use.

To obtain the best papers for painting, look for those labeled not only "100% rag," but also either "pH-neutral" or "acid-free." The rag content gives the paper strength and beauty, the lack of acidity helps assure long paper life. (See chapter one for a discussion of papermaking and the meaning of such terms as "rag" and "pH.")

CHOOSING A PAPER

Among conventional watercolor papers you have three basic choices of surfaces: rough (deeply pitted), cold press (moderately textured), and hot press (smooth). Each has its own personality.

Rough and cold press papers have relatively

From bottom to top: watercolor board, rough paper, hot-press paper, a watercolor block, a pad, and a roll.

JAN KUNZ
Painting Flowers and Glass

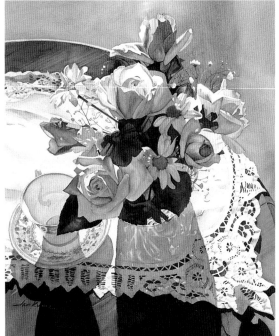

CRYSTAL GLOW
Jan Kunz
Watercolor on 300-lb. Arches cold press
22″ × 30″
Collection of Carol and Bob Boomer

After working out the drawing on tracing paper, Kunz began by glazing the white table cloth with light Cobalt Blue. When that dried, she painted the cup and the flowers. After completing the floral mass, she protected the smallest flowers with a coat of resist (Winsor & Newton colorless art masking fluid) and painted the background with a neutral gray.

Next came the tabletop. Careful painting of the parts of the table showing through and around the lace served to define the lace (a good example of "negative painting"). Then she painted the shadows, and when the surface was dry, used a stiff, damp brush to lift the bright spots in the cast shadow where sunlight flooded through the crystal vase. Finally, she looked over all the edges, sharpening some and softening others.

Like every artist, Jan Kunz has her favorite tools and materials, and among her favorites are Pro Arte Prolene synthetic brushes, which, she says, are inexpensive and hold a sharp point.

absorbent surfaces, while hot press paper has a harder, less absorbent surface. This leads to two differences in the behavior of these papers: (1) Paint dries faster on hot press (because the paint lies in contact with the air), so you have less time to manipulate the wet paint; (2) It's much easier to "lift" (scrub off) dried paint from hot press paper because the paint does not deeply penetrate the paper's fibers.

All three papers lend themselves to a variety of textured effects, but in differing ways. Using rough or cold press, you can easily paint a rough, sparkly texture by whisking a not-too-wet brush across the paper, depositing paint more on the paper's "hills" and less in its "valleys." For a more subtle texture, flood an area with plenty of paint so that more pigment settles in the paper's valleys than on the hills. In the first method, the hills are dark, the valleys (untouched paper) are light; in the second, the valleys are dark (more accumulated pigment) and the hills are lighter.

Hot press is significantly different. It has no hills and valleys to help create texture, but as paint swims freely on its surface, you can run one color into another and allow the paints to mingle and create exciting textures. The textures you get depend a lot on the combination of pigments you use and on just how wet the paints are. You can also get wonderful textures by introducing plain water from a brush or sprayer into the damp paint.

Once you become familiar with each surface, your choice will depend on (1) the nature of your subject, (2) the amount of detailing you want, (3) the kind of texture you want, and (4) your "gut feel" for one surface or another.

Choose the best papers you can afford, but remember that cheaper ones will frustrate you. They'll buckle and tear and won't take much erasing or lifting or other abuse (but they will add color to your vocabulary).

Left to right: a brushload of paint on Arches rough, cold press, hot press paper.

COMPARING PAPERS

SURFACE	PAPER TEXTURE	ABSORBENCY	LAYERING, OR GLAZING	LIFTING
ROUGH	heavily pitted	high	fairly easy	difficult
COLD PRESS	moderately textured	moderately high	easy	moderately easy
HOT PRESS	smooth	low	difficult	very easy

SIZE, OR SIZING

Size (or sizing) is an ingredient that makes paper less absorbent. Size may be added either to the paper pulp or to the surface of the paper, or both. Depending on the amount of size used, papers vary enormously in the absorbency of their surfaces. Some are blotterlike, while others seem to repel paint. The only way to get the feel of a particular paper's absorbency is to try it.

I often use Arches 300-lb. cold press paper, but it has a bit more size than I like. To get rid of some of it, I soak the paper in cool water for several minutes, lay it out on my painting board, and *gently* dry the surface with soft paper towels. That removes enough of the surface size to make the paper a bit more absorbent. The longer you soak, and the more you rub, the more size you'll remove. To avoid scratching the surface with the towels, use good quality, soft paper towels and *never* bear down and rub hard.

You may occasionally want to *increase* the amount of size in your paper to make it less absorbent. For this purpose you can buy *prepared size*, a gelatin product that you warm and then brush onto your paper.

Paper Selection

In watercolor, results depend as much on your paper as on your paints or brushes. Because there are huge differences among papers, you should try many of them rather than settle early on a particular one. Some are soft and blotter-like, while others are nonabsorbent. Some dry faster than others and some allow more scrubbing, erasure, and general abuse. Because each paper has its own personality, you'll probably select different ones for different kinds of paintings.

PAPER DIMENSIONS

Watercolor papers come in a relatively few standard sizes. Some retailers cut up the standard sheets and offer smaller sizes. Here are the usual papers you'll find:

22″×30″	"Imperial," more often called a "full sheet" by artists. It's probably the most common size used; often cut in halves or quarters for handy smaller sizes.
20″×30″ 30″×40″	Common sizes for watercolor boards or illustration boards.
29½″×41″	"Double Elephant." The exact size varies slightly among manufacturers.
40″×60″	Not all types of watercolor paper are made this large, but there are enough to satisfy those who need the large format.

BLOCKS, PADS AND ROLLS

There are many papers sold in *tablet* or *pad* form. Some are good quality papers converted from larger sheets, but most of them are lightweight and of inferior quality. They're intended to be handy to carry around, especially for students on the go, but they're not all suitable for serious, permanent work.

A better traveling choice might be watercolor *blocks*. These are stacks of watercolor paper bound together around all four edges (with a small unbound space left so you can insert a knife and separate the top sheet after painting it). You can easily find blocks of the same high quality as individual sheets. Whatman, for

example, offers 15-sheet 140-lb. blocks, either rough or cold press, in sizes ranging from 9″×12″ to 18″×24″. If you work very wet, you might find blocks unsuitable because the expanding wet paper cannot spread out laterally (because it's bound on all sides). Instead, it buckles and forms hills and valleys you might find annoying while painting. As it dries, however, the paper will flatten to its original shape.

If you're doing mural-sized paintings, several manufacturers offer paper on rolls long enough to satisfy almost anybody's needs. For example, Arches offers a number of rolls, including:

140-lb. paper 44.5″ wide, ten yards long; 100% rag, pH-neutral, with two deckled edges; rough, cold press and hot press surfaces.

156-lb. paper 51″ wide, ten yards long; 100% rag, pH-neutral, with two deckled edges; rough, cold press and hot press.

130-lb. paper 52″ wide, ten yards long, called "En-Tout-Cas," 25% rag, acid-free, with two deckled edges; cold press on one side, slightly rougher on the other.

PAPER "WEIGHTS"

A common way of referring to papers of different thicknesses is to state the weight in pounds of a ream (500 sheets) of that paper. If a ream of 22″×30″ paper weighs 300 pounds, we refer to a sheet of that paper as "300-lb." The system is a confusing one because *that same thickness of paper* made in a larger sheet, say 29½″×41″, would be called "555-lb." That is, a ream of that larger paper would weigh *555* pounds. The following three papers have the *same* thickness:

Arches 300-lb. 22″×30″

Arches 555-lb. 29½″×41″

Arches 1114-lb. 40″×60″

An *un*ambiguous way of describing papers of different thicknesses is by stating the gm/m²—that is, the *weight in grams per square meter* of the paper. Each of the three papers above weighs 640 gm/m². More and more catalogs are listing papers in this way so that even-

tually we may drop the clumsy "pound" system—probably at the same time the U.S. discards miles in favor of kilometers!

SHEETS VERSUS BOARDS

Besides textures and sizes and weights, you'll need to choose between individual, flexible sheets and stiff boards. A board is simply some type of cardboard with watercolor paper glued to its surface.

If you dislike fooling with the wrinkles a sheet can develop as it becomes wet with paint, you may like the idea of painting on a board that stays flat. Try both. For many painters, the virgin sheet of watercolor paper, unattached to any other support, provides much of the thrill of painting in this medium. There is a tactile pleasure in handling unmounted paper, a sort of sensuousness, that you might miss when working with boards.

The tables on pages 35 and 36 list some popular papers and boards. Keep in mind that these tables offer only a sampling of available brands and sizes.

HANDMADE, MOULDMADE, MACHINE-MADE

"Handmade" means that each sheet of paper is made individually by settling pulp (a soupy mixture of beaten fibers, water, buffering and other materials) over a wire mesh surrounded by a wooden frame (a "deckle"). The mould is held level and shaken to settle the fibers until the water drains through the mesh. The damp layer of fibers dries to become a single sheet of paper. Some pulp seeps under the deckle and is caught there, resulting in irregular ("deckled") edges.

"Mouldmade" once meant handmade, but now refers to a refined machine process that simulates handmade results. The paper is made on a so-called Cylinder machine that moves slowly enough to allow pulp fibers to settle into a mat (similar to the random settling of fibers in the handmade process).

"Machine-made" is a less sophisticated machine process that produces papers with more mechanical, less random, textures. The machine used, called a Fourdrinier machine, lays down a mat of fibers along a fast-moving belt. The fibers mostly align in the direction of movement of the belt, rather than in random directions. If you tear a piece of such paper, it will tend to tear along the direction of the fibers rather than randomly.

Deckled edges, which are natural to handmade papers, are simulated by papermaking machines.

SOME POPULAR 100% RAG, ACID-FREE WATERCOLOR PAPERS

NAME OF PAPER	HOW MADE (HANDMADE, MOULDMADE, MACHINE-MADE)	PAPER SIZES	WEIGHTS in lbs. and [gm/m^2]	SURFACE TEXTURE	NO. OF DECKLED EDGES
Arches	mouldmade	22″×30″	90 [185], 140 [300], 300 [640], 400 [850] 90 [185], 140 [300], 300 [640]	rough cold press hot press	4
Arches	mouldmade	29½″×41″	555 [640]	rough cold press	2
Arches	mouldmade	40″×60″	1114 [640]	rough cold press	2
Fabriano Artistico	mouldmade	22″×30″	90 [185] 140 [300], 300 [640]	cold press rough cold press hot press	2
Fabriano Esportazione	handmade	22″×30″	147 [315], 300 [600]	rough cold press	4
Lanaquarelle	mouldmade	22″×30″	90 [185], 140 [300], 300 [640]	rough cold press hot press	4
Lanaquarelle	mouldmade	29″×41″	555 [640]	cold press hot press	2
Strathmore 500 Series Imperial	machine-made	22″×30″	72 [154], 140 [300]	rough cold press hot press	2
Twinrocker	handmade	22″×30″	186 [400]	rough cold press	4
Waterford T.H. Saunders	mouldmade	22″×30″	90 [185], 140 [300], 300 [640] 90 [185], 140 [300]	rough cold press hot press	4
Whatman	handmade	22″×30″	90 [185], 140 [300], 200 [430] 90 [185], 140 [300]	rough cold press (also called "not") hot press	4

Numbers in brackets [] are approximate grams per square meter *equivalents for* pounds. *See the discussion in the text on page 34.*

SOME POPULAR WATERCOLOR AND ILLUSTRATION BOARDS WITH 100% RAG ACID-FREE SURFACES

NAME OF BOARD	SIZES	USABLE SIDES	SURFACE TEXTURE	CARDBOARD CONTENT	TOTAL THICKNESS (approx.)
Crescent Watercolor Board (#112, 114, 115)	20″×30″ 22″×30″ 30″×40″	1	cold press, hot press	not acid-free	.130″
Crescent No. 1 Cold Press Illustration Board	15″×20″ 22″×30″ 20″×30″ 30″×40″	1	cold press	not acid-free	.130″
Crescent Premium Watercolor Board (# 5112, 5115, 5117)	15″×20″ 20″×30″ 30″×40″	1	rough, cold press, hot press	acid-free	.112″
(# 85117)	40″×60″	1	rough		
Strathmore 500 Series Illustration Board	20″×30″ 30″×40″	2	regular (slight tooth) plate (smooth)	high-quality white cardboard, not acid-free	.080″
Whatman Water Media Board	20″×30″ 30″×40″	1	rough, cold press, hot press	acid-free	.125″

"Illustration" boards are general-purpose, intended for many mediums, such as pencil, ink, watercolor and acrylic, while "watercolor" boards are specifically intended for watercolor. Both are suitable for watercolor painting.

At Twinrocker Papers, Travis Becker has dipped a hand mould into a vat of pulp and is "throwing the wave" of pulp off the top of the mould to control the thickness of the sheet he is forming. The fibers settle in a dense mat against the wire mesh at the bottom of the mould as the water drains out. The frame around the edge of the mould is called the deckle.

OTHER SURFACES

You can paint on any surface you like, of course, whether it's intended for watercolor, or not. There are dozens of papers, for example, made for *printing* that lend themselves well to watercolor painting. Try some of the many "rice papers" available, too. You can paint on fabrics—some artists paint on stretched silk using combinations of traditional watercolor and oriental mineral color (similar to gouache).

Many artists like to paint with opaque acrylic or gouache on 100% rag mat board. Watercolorists sometimes use mat board, too, but you may find such surfaces much too absorbent. You can coat these surfaces with thinned acrylic gesso or a commercial starch sizing to make them less absorbent.

Whatever surface you choose, pay attention to its archival qualities. Why spend time and energy on a painting you're not sure will last! If you can't find the acidity of a paper listed, but really want to try it, you can almost always track down the information you need by writing or calling the manufacturer.

TOOLS AND ACCESSORIES

Watercolorists collect lots of brushes and other tools over the course of their careers, but you can get by nicely with a small number of inexpensive items. Here are tools to consider:

BRUSHES

In the Shopping List on page 39 I suggest a set of seven brushes as a starter. Synthetic brushes work beautifully, but you may want to invest in the more traditional (and more costly) natural-hair brushes many watercolorists prefer (see the discussion of brushes in chapter one).

There are at least three criteria artists use in selecting watercolor brushes. First, a brush should hold a lot of fluid. You should be able to make strokes on your paper without having to dip back into the paint too often—running out of paint in mid-stroke is not only frustrating and time-consuming, but may hinder you in completing the stroke smoothly. Second, a brush should have sufficient "spring" in its hairs to maintain a sharp point or a firm edge, depending on whether the brush is a round or a flat type. Nothing is quite so frustrating as a brush whose hairs are so limp that the brush doesn't hold its shape—typically, the hairs of such brushes will splay and form a ragged edge as soon as you apply any pressure against the paper. Third, a brush purchase should not require a second mortgage on the house.

You'll find lots of diversity of opinion on what brushes best fulfill these criteria. My opinion is that you can happily use good synthetic brushes for all your needs. Others, including many prominent watercolorists, insist that nothing can touch a Kolinsky. My suggestion is that you begin with synthetic brushes, which adequately satisfy all three of the selection criteria mentioned above. Synthetics will get you started inexpensively and, provided you choose the best synthetics, they won't disappoint you in their handling. As you become familiar with the medium, experiment with the various natural-hair brushes.

KNIVES

Painting knives and palette knives are not particularly useful to the watercolorist except to scrape the palette clean or to mix paints. I don't include them in a basic list of tools, but if you prefer to use them, any palette knife and a 2″ painting knife should serve you well.

PALETTES

A palette with a lid is best so you can close it and keep your paints moist overnight. I like a palette with one large mixing area surrounded by little compartments for the paints—the John Pike palette is a good example. Others prefer to have several small wells for each pure color, and adjacent to each well, a larger one for mixing a fluid version of that color. If you paint by laying down washes of pure color (instead of mixing colors on your palette), the latter type is suitable.

Sometimes moist paints left covered on a palette develop mold. When this happens (the mold will be clearly visible), wash the entire palette, paints and all, under a stream of hot water until all the mold is gone. You'll waste some paint, of course, but that's better than transferring moldy paint to your picture and giving a colony of mold a foothold in your painting!

EASELS

Some watercolorists work with the painting more or less vertical. In that case, any artist's easel will do. Most watercolorists work with the paper horizontal on a tabletop so wet paint doesn't run to the bottom of the picture. The handiest arrangement is a *tilting* table, such as a draftsman's table, so you can work on a horizontal or a vertical surface, or at any angle in between.

For outdoor work, folding contraptions ("French" easels) are excellent. They allow you to tilt from horizontal to vertical, and have compartments to hold your paints, palette and the rest of your paraphernalia.

You'll find a wide variety of watercolor palette styles to choose from.

MISCELLANEOUS TOOLS

These items are important and, happily, they are inexpensive.

Painting Board

Unless you're working on stiff, mounted watercolor paper, you'll need a board on which to attach your paper while painting. Hardboard, such as Masonite, cut to accommodate the sizes of your papers works well. For paintings smaller than 22″ × 30″, the ⅛″ thickness should suffice; for larger work, you may need ¼″ hardboard to keep the board from warping.

You can use either tempered or untempered hardboard. The *tempered* kind has an oily substance in it that makes it less absorbent, so it will suck less water from your paper. When new, wash the board with detergent to get rid of any excess surface oils, and the board will be suitable for use. If you choose the more absorbent *untempered* board, you may need to seal it with a coat of acrylic gesso (a) to prevent it from draining too much water from your paper, and (b) to keep its brown fibers from staining your paper.

Other choices are wood, such as drawing boards, and products such as ³⁄₁₆″ foamboard or corrugated cardboard—you can glue a couple of layers of these together to give you the rigidity you need. If you use cardboard, coat both sides with acrylic gesso to make the board waterproof and to keep the acids in the board from leaching into your watercolor paper.

Water Containers and Sprayer

Use two containers, one for cleaning brushes as you work, the other for clean water for mixing with paints. Use a spray bottle filled with plain water to keep your palette and your painting damp; you can also use the sprayer to introduce texture into paint that's not yet dry on your paper.

Masking Tape or Fluid

To protect an area of your paper from receiving paint, cover the area with a mask of drafting tape or a fluid such as Maskoid, Miskit or rubber cement. Drafting tape is better than masking tape because it's less sticky and easier to remove from your paper without damaging the paper. Don't leave liquid mask on the paper too long, or it may not come off. See page 44 for more information on using masking products.

Scrapers

Use them to scratch out lines or broader areas in a painting for a variety of textural effects. You may use single-edged razor blades, plastic bowl-scrapers, credit cards, ice picks, brush handles—practically anything that will make a mark. The back end of an Aquarelle brush is made for scraping.

Sponges, Paper Towels

Both may be used for dabbing into paint for textured effects. Paper towels are indispensable for general cleanup. A damp kitchen sponge is a handy blotter—use it to drain excess water or paint from a brush.

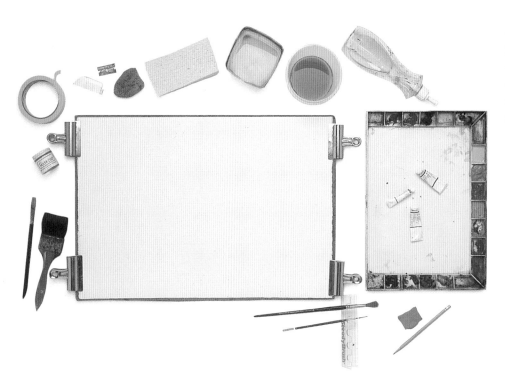

A typical watercolor painting setup includes two water containers, a sprayer, sponges and scrapers, masking agents, and kneadable erasers.

WATERCOLOR SHOPPING LIST

BASICS	✓
PAINTS (TUBES):	
Ultramarine Blue	
Phthalocyanine Blue	
Cobalt Blue	
Phthalocyanine Green	
Cadmium Red Medium	
Cadmium Orange	
Cadmium Yellow Light	
Yellow Ochre	
Raw Sienna	
Raw Umber	
Burnt Sienna	
Burnt Umber	
WATERCOLOR PAPER, 22″ × 30″	
sheets	
rough	
cold press	
hot press	
BRUSHES	
2″ flat (varnish brush)	
1″ flat	
½″ flat	
no. 10 round	
no. 6 round	
no. 1 round	
rigger	
PALETTE	
TWO WATER CONTAINERS	
SPRAYER	
PENCIL, MEDIUM-SOFT	
KNEADABLE ERASER	
PAPER TOWELS	
PAPER CLAMPS	
PAINTING BOARD	

OPTIONAL	✓
TUBE OF CHINESE WHITE	
PAINTING AND PALETTE KNIVES	
SPONGES: KITCHEN AND NATURAL	
DRAFTING TAPE	
MASKING FLUID	
SCRAPERS	

Clamps

These work well for holding your paper flat on the board. You may use only one on each corner or, as I usually do, place clamps all the way around the paper. Place them so that they grip only the outer quarter-inch of paper—the jaws leave marks in the paper that you'll later cover with a mat.

Pencil and Eraser

Use a medium-soft pencil and a kneadable eraser. Draw lightly on watercolor paper with a pencil that is not so hard or sharp that it gouges the delicate surface; likewise, do your erasing gently with kneaded rubber by patting or gently dabbing the surface. Ordinary erasers are too harsh for most watercolor papers.

Brush Rest

Use any arrangement that gives you a place to put your paint-filled brushes between uses to keep them from sticking together or sticking to your tabletop. You may simply lay them on a couple of thicknesses of paper towels, or on a piece of corrugated cardboard (the ridges keep the brushes from rolling around), or you can buy or make a gadget with notches for holding brushes.

Electric Dryer

This is no frill, for it will save you many precious hours. A 1000-watt hair dryer works well. Hold it far enough away from your wet painting that the stream of air *dries* the paint but does not *disturb* it, like a helicopter hovering over a lake and churning the water. If you work a lot in water-based media, you should eventually build a better dryer. The illustration on the next page shows the arrangement I stole from John Pike in the 1970s. This is a wonderful accessory.

Health Tips

1. Look for health warning labels on paints—you'll find them on the cadmiums and Naples Yellow, for example.

2. When using watercolor (or any other paint) in a spray gun or airbrush, use proper ventilation and wear a mask to avoid inhaling the vapors.

3. When using a heavy hardboard or wood board under your watercolor paper, the constant lifting can give you back and shoulder pain. Try using lighter-weight foamboard or cardboard. Another lightweight possibility is tacking or stapling your paper to canvas stretcher strips.

Here is a handy setup for drying water-based paint. This is a kitchen exhaust fan with a pair of 600-watt heating coils added. The fan blows air past the heating coils and down onto the painting. The vertical pipe rotates in the clamps so that the whole rig swings easily out of your way when not in use. If you're electrically knowledgeable, you can easily add a rheostat to control the fan's speed. Cover both ends with wire screen to keep hands and other objects away from the fan and heating coils.

GETTING STARTED

Most watercolors begin with a pencil drawing and then follow one of two basic methods of applying paint: *wet-in-wet*, or *dry*.

DRAWING

If you're working nonobjectively (that is, without a real, physical subject), you may need no drawing at all. Most painters start with at least a simple drawing, and some start with a detailed drawing. While you may certainly draw directly on your watercolor paper, it's safer to draw first on other paper, such as inexpensive newsprint, and then transfer the drawing to the painting surface. If you draw directly on your watercolor sheet, you run the risk of damaging the surface by erasures. Erasing can leave scuff marks on the paper that will show up immediately and disastrously as soon as paint hits the paper!

To transfer your drawing to your painting paper, place a sheet of transfer paper between the newsprint

and the watercolor paper and trace over the drawing with a ballpoint pen or any similar, rounded point that won't tear the paper. Press just hard enough to get a faint impression, not hard enough to gouge the watercolor paper. For your transfer paper don't use regular typist's carbon paper—it's too dark and the lines it leaves will have a "greasy" quality that may repel water-based paint. Instead, use a product such as Sally's Graphite Transfer Paper, or make your own by covering one side of a sheet of newsprint or other fairly thin paper

Transferring a drawing to watercolor paper.

with graphite from a medium soft pencil (no. 1 or no. 2 office pencil or HB drawing pencil).

Use a kneadable eraser to lighten or remove any unwanted lines or smears from your watercolor paper. *Press* with the eraser rather than *rub*, so that you don't scuff the paper's surface.

PAINTING WET-IN-WET

Painting wet-in-wet means first soaking your water-color paper and then painting on that wet surface. Painters use this method for a number of reasons: (1) To get the soft edges that result as the paint crawls along the wet paper, (2) to take advantage of the beautiful effects attainable when paints are allowed to mingle on a wet surface; (3) to establish a soft-edged background painting that will later be finished "dry."

Controlling the spread of paint on a wet surface is exciting, something like jumping off a cliff. If the paper is too wet, the paint will spread too far too fast and will dry too light. If not wet enough, the paint stays put and dries with perhaps unwanted, pronounced edges. With some trial-and-error, you'll find out what is the "right" wetness.

Soaking the Paper

After transferring your drawing to dry paper, soak the paper thoroughly in cool water, either by dunking it in a tub of water, or by brushing water onto both surfaces. Your objective is to *saturate* the paper—meaning that it's holding all the water it can. The soaking time varies with the brand and the thickness of the paper—a sheet of 140-lb. paper, for example, should be saturated after soaking for about five minutes. If you're brushing the water on, you'll have to flop the sheet over a number of times, constantly brushing more water onto both sur-faces. Lift a corner of the paper and see how the sheet

Thoroughly wet paper should be limp and flexible.

responds. When it has lost all its crispness and is com-pletely limp, it's ready for painting. Thicker sheets of paper, of course, will take longer to soak, but the same limpness test applies.

When the paper is soaked, lay it on your painting board. Lift the paper and make sure there are no dry spots underneath—both board and paper should be en-tirely wet. Spray or brush water onto any dry spots. Tilt the board over the sink and let excess water drain off.

Surface Wetness

Although you want the paper to be soaked all the way through, you need to control the wetness of the *surface*. If you paint into a pool of water still lying on the sur-face, you'll have almost no control over the paint. Proper wetness is usually just after the glisten has disap-peared from the surface—usually a few minutes. You can control the surface wetness of your paper by gently blotting or wiping off excess water with a *soft* paper towel or tissues or a soft sponge. Be careful with new sponges—they often are gritty and hard. If you need

PUT DRAIN IN CORNER, OUT OF THE WAY

Rather than use the bathtub or sink, you can construct a soaking tray. This is a simple wooden box covered with vinyl swimming-pool liner or other waterproof material. The tray is only about two inches deep and a couple inches larger than your paper, with a drain in one corner.

Society Notes

The American Watercolor Society (AWS) was founded in 1886. One of its charter members was Winslow Homer.

American Watercolor Society
47 Fifth Avenue
New York, NY 10003

more water, you can brush more on (as long as you haven't yet put paint on the paper) or carefully mist the surface with your sprayer.

Paint Thickness

Remember, there's already a lot of water in the paper, so don't brush on paint that is too watery—keep your paint on the thick side. Thin paint mixtures dry light, thicker ones dry comparatively darker.

Color Mixing

Beautiful and partially uncontrollable things happen when you introduce one color into or adjacent to another on wet paper. The effects can vary a lot, depending on which colors you're using and how wet you're working.

Texturing

When paint is in between soupy wet and bone dry (just after the glisten has disappeared from the surface) you can achieve lots of textural effects:

1. Spraying. Carefully squirt droplets of water into the air above your painting and let them fall gently into the paint where they'll produce little starry blotches. Don't squirt directly *at* the paper.

2. Scraping. Using various tools, such as plastic cards or knives or brush handles, you can scrape through an area of thick paint and partially expose the paper texture.

3. Sprinkling coarse salt, sand and other granules into the wet paint will give you a variety of blotchy effects as the paint dries.

4. Dabbing into the paint with crushed tissue or other paper will give you random textures.

Use a sprayer to introduce splotchy texture into damp paint; use it also to rewet dry areas.

Keeping the Paper Flat

If you continually brush water under the painting so that the board and the underside of the painting remain wet, the paper will remain flat and you can keep painting indefinitely. When you are finished painting, secure the paper around the edges with paper clamps or by some other means so that as the paper dries it remains flat.

Continuing the Painting

After beginning the painting wet-in-wet, you may choose to finish up on the dried surface. If you want to *resume* wet-in-wet, even though you've allowed the

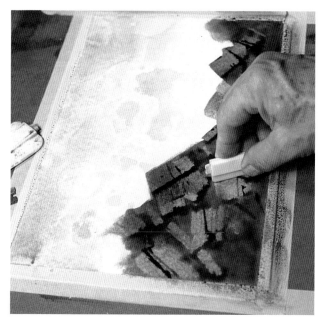

Use a variety of edges to scrape aside thick wet paint and reveal underlying colors and textures. Dip the edge of a scraper into thick paint and press it to the paper to make dark lines.

You'll see textures and color variations when you work wet-on-wet that are difficult to achieve on dry paper.

Sprinkling salt, sand or similar materials into wet paint will produce a variety of textures, depending on the kind of material you sprinkle, the wetness and thickness of the paint, and the texture of the support. Here, salt on the left and sand on the right, thin Winsor Blue paint, hot press surface.

painting to dry out, you have two options:

1. Turn the dry painting over onto a clean, dry surface and carefully wet the backside with water, making sure no water crawls around to the painted surface. Do this repeatedly until the paper is saturated from the rear. Turn the painting over and place it on your board, with lots of water between board and paper. Now spray the painted surface with the sprayer (gently) until the surface is soaked. Pour off the excess water (a little loosened paint will go with it) and resume painting. Or . . .

2. Make sure the painting is *bone-dry*. Slip it into a tub of cool water for a minute or so. Slide a painting board under the paper and carefully lift board and paper out of the tub. Tilt to drain off excess water (and again, a little loosened paint) and resume painting. How much paint becomes dislodged under this treatment depends on how thick the paint is, which pigments you've used, and how long you soak the painting. Try this out on a few failed paintings first!

Whichever resoaking method you use, don't expect the painting to behave the way it did in the beginning, before it was allowed to dry. The paints won't flow and intermix quite as they did when originally wet.

PAINTING DRY

If you're painting on dry, unmounted paper, you may paint a section at a time. The paper will expand wherever it becomes wet, resulting in annoying hills and valleys that can interfere with your painting. Three ways to avoid this problem: (1) use thicker (300-lb. or heavier) paper that stays reasonably flat, (2) stretch your paper, or (3) use mounted paper.

STRETCHING

Stretching means first saturating the paper with plain water to make it expand, and then "capturing" the expanded paper so that it cannot shrink back to normal size as it dries. Once captured in its expanded size, you can freely apply paint without producing annoying bumps (because the paper has already expanded as far as it can).

Soak the paper as described under painting wet-in-wet. With the paper lying on a board, tilt the board and let all excess water run off into the sink or tub. At this point, your paper is fully expanded and it will lie perfectly flat *as long as it remains internally wet.*

If you're painting *wet-in-wet*, you can go ahead and paint. If you plan to paint on *dry* paper, you'll need to "capture" the paper in its stretched, expanded state before drying its surface. There are several ways to do this:

Clamping

Put clamps with three-inch jaws all the way around the edges of the saturated paper to hold it fast to the painting board in its expanded state. The board should be slightly larger than the expanded paper—for instance, if you're painting on 22″×30″ paper, your board should be about 23″×31″. This method works well, but the clamps will leave marks where they bite into the paper, so place the clamps so they intrude only ¼″ or so onto the paper. Later, matting will cover those marks. Put the clamps adjacent to one another, leaving no portion of the edges unclamped, and your finished, dried painting will be perfectly flat. (This requires buying lots of clamps, but they'll last forever.)

Tacking or Stapling

Instead of clamps, you can use thumb tacks or push pins or staples all around the edges of the paper. However,

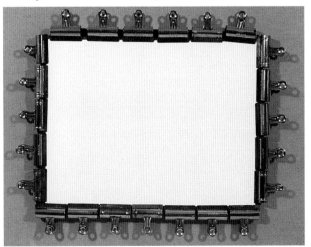

140-lb. paper clamped to a piece of hardboard.

To make taping work well takes some practice. For the self-sticking tapes (such as masking tape) the paper's edges must be very dry.

your board must be of some material soft enough to accept these fasteners—wood, for example. Removing the tacks or pins or staples is not as easy as removing clamps—however, they are less in your way than clamps while you work.

Taping

Tape the soaked paper to a board that is a couple of inches larger than the paper. Use brown packaging tape (the kind you wet) or self-sticking tapes, such as wide masking tape or plastic packaging tape. Whichever type of tape you use, use a paper towel to dry the edges of the wet paper enough to make the tape stick.

Commercial Stretchers

You'll find a variety of stretching gadgets in the art stores and catalogs. I don't know of one that works better than clamping.

No Fasteners

If you dislike the presence of fasteners while you're painting, here's a way out, my favorite way of working: Soak the paper, lay it on a soaked board, pour off the excess water, and dry the surface thoroughly with *soft* paper towels. The surface will feel cool and damp because just below the surface there's plenty of moisture, but it will be essentially dry for painting. As long as the paper remains wet underneath (and internally), it will lie flat. As the paper begins to dry, the edges will curl. Lift a corner at a time and brush more water onto the board. Pat the paper back down against the wet board and continue painting.

WATERCOLOR AND ILLUSTRATION BOARDS

If you're using watercolor boards or illustration boards (paper glued to stiff cardboard) you won't need to do any stretching, of course. Good-quality boards will resist warping quite well (although not perfectly) as you wet their surfaces with water or paint. The thicker the board, the less warping will occur. I find it handy to fasten watercolor or illustration boards to a piece of foamboard with four paper clamps to provide extra protection against warping. If you're painting quite wet, you'll notice the entire watercolor or illustration board will belly slightly upward; counteract this by brushing water onto the underside of the board.

MASKING

Watercolorists traditionally "paint" whites by leaving the white of the paper. You need to protect white areas (or even lightly painted areas) from being painted inadvertently. This means you must plan ahead for where those areas are going to be and take care not to paint over them by mistake. You can reclaim the white of the paper reasonably well (especially on a hot press surface), but sometimes you'll damage the paper in scrubbing away unwanted color. To save white areas, either paint around them or *mask* them with pieces of tape or masking fluids.

If you use tape, use *drafting* tape instead of *masking* tape—masking tape sticks too well and its removal can tear away layers of your delicate watercolor paper. Even when using drafting tape, remove it slowly to avoid damaging your paper. Some artists press tape over the general area they want to protect and then, guided by their pencil drawing showing through the tape, cut the tape to the desired shape and remove the excess. Use a very sharp knife (such as an X-Acto or a mat knife) and take care to cut only through the tape, not into the watercolor paper. If you cut or score the watercolor paper, wet paint will later be sucked into the cuts, leaving dark lines impossible to remove. A way around this is to cut the tape to shape *before* applying it to the paper. Keep in mind that when you use tape, a little paint will seep under its edges.

If you use a masking fluid, paint it over the areas to be preserved and let it dry. Those areas will repel paint. To remove the mask, rub it gently with your clean, dry finger or a pencil eraser or a rubber cement "pickup" (a rubbery substance that pulls the masking away from the paper). If you mask over an already-painted area, you'll remove some paint when you take up the mask—this will be especially noticeable where

SHIRLEY PORTER
Wet-in-Wet Technique

NOBLE CROW
Shirley Porter
Watercolor on Rives BFK printing paper
22″ × 30″

This is a *wet-in-wet* painting. After soaking and draining excess water from the paper, Porter applied strong, thick paint mixtures. She was after the "energy" of the bird, rather than a realistic likeness. Lifting pronounced, sharp-edged forms from the damp paint helped suggest energy and action.

PHIL METZGER
Dry Painting Technique

SUNDAY MORNING COMMUTERS
Phil Metzger
Watercolor on Strathmore 500-Series
illustration board, regular surface
22″ × 30″
Collection of Gaithersburg, MD City Hall

This is a traditional *dry* treatment, but sections such as the sky were worked quite wet. I mostly painted the sky around the buildings, but did use drafting tape to mask the distant white building (a mill). I kept the clouds and bands of color in the sky horizontal in order to suggest a quiet mood. Since linear perspective is important in this picture, I worked out the architecture in detail first on newsprint, then traced it onto the Strathmore board. I used Winsor & Newton tube watercolors, including Alizarin Crimson, Ultramarine Blue, Winsor Blue, Winsor Green, Raw Sienna, Burnt Sienna and Cadmium Red Deep.

ARNE WESTERMAN
A Planned Approach to Watercolor

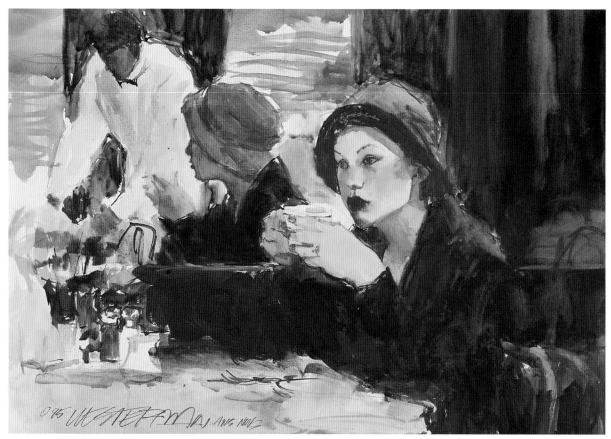

MARCH, 1935
Arne Westerman, AWS, NWS
Watercolor on Lanaquarelle hot press paper
21" × 29"

"I work in stages rather than attack a final version first. I like to know before I begin the painting that I have a good design and exciting color development. I take a number of photographs and combine them or use elements from several photos to get the material I need.

"First, I abstract the material into shapes and work those into a design I'm satisfied with. For this I pencil out small rectangles on a sheet of typewriter paper, working in three values—black, gray and the white of the paper. Everything is fluid. I might try a vertical or a horizontal format. I erase, add to, alter borders, etc., until I find a workable solution.

"I then translate my black-and-white sketch into a larger color version. I may choose colors suggested by the photos, or more likely change or enhance the colors to get a more exciting end result.

"The last stage is the final painting. I lay on colors, starting with the largest area, and while that is still wet I might blend in other colors. I don't paint light to dark. I use darks at any time. That helps me see contrasts as I develop the painting.

"I work almost exclusively on Lanaquarelle hot press 90- or 140-lb. paper. I do a lot of lifting, washing and scrubbing, and this paper takes it beautifully. I simply tape the paper down on all four sides with masking tape to a lightweight board called Gatorfoam and when the painting dries, it's usually flat enough to mat and frame. I have a number of Gatorfoam boards cut to fit quarter-, half- and full-sheet paintings so I can work on four or five at a time. I use only permanent watercolors and my favorite brushes are Golden Fleece, inexpensive synthetics from Cheap Joe's."

Masking materials.

you mask over dark paint. Two commercial masking fluids are Art Maskoid and Miskit, and you can also use rubber cement. Maskoid and Miskit are colored so that you can see where you've applied them—they may leave a faint stain on your paper.

To apply masking fluids, use old, worn-out brushes or cheap dime-store brushes and clean them immediately with soapy water. Don't use a good painting brush—masking fluids are difficult to clean completely from a brush.

MASKING

If you're working on dry paper, use drafting tape or masking fluid to protect areas from paint, or hold a piece of paper over an area while you spray or brush paint onto an adjacent area. When you paint over a mask, watch out for puddles of paint that accumulate along the edges of the mask—soak up the puddles with a damp brush. Here I've used both tape and Miskit (tape is easier for big areas). I've peeled away the Miskit from a branch and partially peeled the tape from the trunk.

LIFTING PAINT

In varying degrees, you can remove ("lift") paint from a paper either while still wet or after it has dried. Lifting is most successful when using harder-surfaced papers (such as hot press) and papers with a lot of sizing. The rougher or more absorbent the paper, the more the paint settles into its fibers and the harder it is to lift successfully.

If the painting is still wet, blot up paint with a tissue or towel or a slightly damp brush. If it's dry, *gently* scrub the paint free with a stiff, damp brush, such as a synthetic or bristle brush. Scrub a little, blot, then clean the brush and scrub some more until you've removed all the paint you want to. *Don't* keep on scrubbing without cleaning the brush—this will grind the loosened particles of paint deep into the paper's fibers! Often you can lift paint cleanly enough to expose fresh, near-virgin paper; at other times, especially if you've used staining colors such as the phthalocyanines, you'll have less than perfect success.

Rather than send your old brushes to the dump, save them for such chores as lifting. Shorten the bristles on a couple of old brushes (to make the remaining bristles stiffer) and keep them for scrubbing.

LIGHT TO DARK?

Although you can paint areas in any order you wish, it's usually prudent to proceed from light areas to dark (Arne Westerman, not being prudent, usually ignores this rule). In transparent watercolor, you can cover a light passage with a darker one, but not vice versa.

LIFTING

Use a damp, stiff brush to loosen dried paint. Repeatedly clean the brush as you do this until you've removed as much paint as you wish.

GLAZING

Glazing means painting in layers of transparent paint—it's what most traditional watercolor painting is all about. Usually you wait for one layer of paint to dry thoroughly before going over it with another layer. The danger is that in applying a glaze, or layer of paint, you'll loosen and disturb the paint underneath. To avoid this, work with the largest brush reasonable for the area and brush on the new layer quickly, with a minimum of brushstrokes. The fewer strokes, the less the likelihood of loosening existing layers of paint. (Here is where acrylic paint has an advantage over traditional watercolor—once dry, it's waterproof and you can paint any number of layers without picking up what's underneath.)

If you're painting in thin layers, try liquid watercolors such as Hydrus. Pour appropriate quantities from the bottles into clean, individual wells on your palette or into paper cups. Dip into the paint with only a *clean* brush, to avoid unintentional color mixing.

When glazing large areas, be sure to have enough paint mixed to cover the entire area. If you have to stop to mix more paint, you risk letting the first paint dry with a hard edge you may not want.

WHAT ABOUT WHITE PAINT?

Arguably, the most beautiful whites in a watercolor are the whites of the paper. Yet there are places where the introduction of opaque white paint (either soluble Chinese white or insoluble acrylic white) makes sense. Usually opaque whites are used in a watercolor for corrective purposes or as relatively small accents.

BACKWASHES
The hard line of pigment you see here is a backwash. It happens when two unequally wet areas of paint touch one another—the wetter paint pushes into the less-wet paint. In this case, I left a puddle of wet paint on the board at the edge of the watercolor paper. As the paint in the paper began to dry, the puddle moved into the paper, pushing pigment ahead of it. To avoid this, mop up the puddles around the edges of the paper with a paper towel.

I'm sure there are purists around who argue *never* to sully a watercolor with opaque white! My feeling is that whatever works, works. Always feel free to break the "rules."

CHANGING VALUES

Here's something you'll quickly notice about watercolor paint: As most colors dry, they lighten, sometimes substantially. At first, this can drive you batty, but you'll soon get used to it. You'll need to judge how much *darker* to paint a passage in order for it to be just right when it dries and lightens. The thicker the paint, the less it will lighten as it dries.

WASHES
Use a large flat brush to lay down a wash over a large area. To keep hard edges from forming at the bottom of each stroke, wet the entire area first with clear water before applying color.

CHANGING VALUES
Here are two color swatches of Payne's Gray, wet and dry. Both were done from the same puddle of paint. Note how the value changes as it dries.

MARGARET KRANKING
An Example of Negative Painting

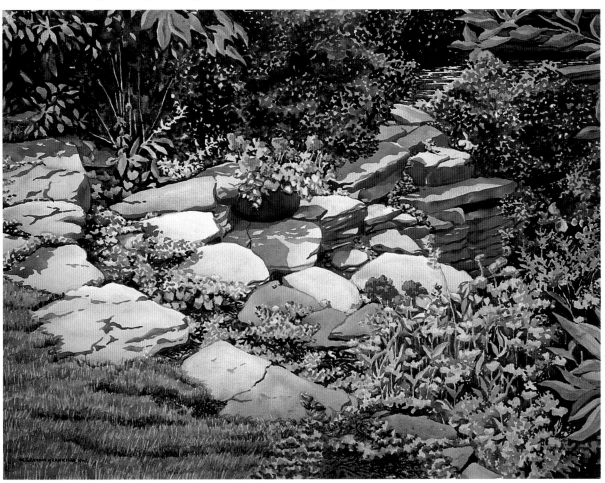

GARDEN WALL, CATSKILLS
Margaret Kranking
Watercolor on Arches 140-lb. cold press
22" × 30"
Private collection

You might think this picture called for lots of masking—indeed, that would be one way to proceed—but Kranking used none. Instead she did a great deal of negative painting, painting the spaces around objects to give the objects their form. She painted "dry," wetting individual areas as she worked. She often wet an area (such as one of the stones) and dropped colors into the wet, letting them spread and combine. Many areas began as light washes that were dried and were then gradually built upon with darker, less fluid paint—the foreground grasses, for example, began with a yellow-green undercoat and then the darker strokes were added with the edge of a half-inch flat brush.

Watercolor Wet-in-Wet
by Zoltan Szabo

For this wet-in-wet demonstration, Szabo used an 11″ × 15″ sheet of 300-lb. Arches watercolor paper. His colors were Maimeri brand tube colors: Raw Sienna, Quinacridone Violet, Phthalocyanine Blue and Green and Cadmium Green. His brushes were 1″ and 2″ slanted flat hog bristle brushes, 1½″ and 2″ flat soft slanted brushes, a ¾″ Aquarelle and a no. 3 rigger. The slanted brushes are his own design (available from him—see his listing in the back of the book).

Szabo's colors.

1 *Using a 2″ brush, Szabo wets the paper and applies a colorful sky impression. He uses plenty of paint, knowing the color will lighten as it dries.*

2 *With a 2″ hog bristle brush he "paints" the frosty trees by lifting some of the drying, but still damp, paint. Using the same brush loaded with rich paint, very little water, he paints the dark evergreens, just touching the damp paper with the edge of the brush. Then he uses smaller brushes to do more lifting and more painting. All this took about ten minutes, with the paper still damp. Once dry, he lifts a few more tree shapes with a barely damp 1″ slanted bristle brush.*

3 Szabo uses a rigger for details on the main tree trunk and branches. He uses an Aquarelle brush to lift the rolling mist and to paint a blue-gray wash over the middle-ground snow.

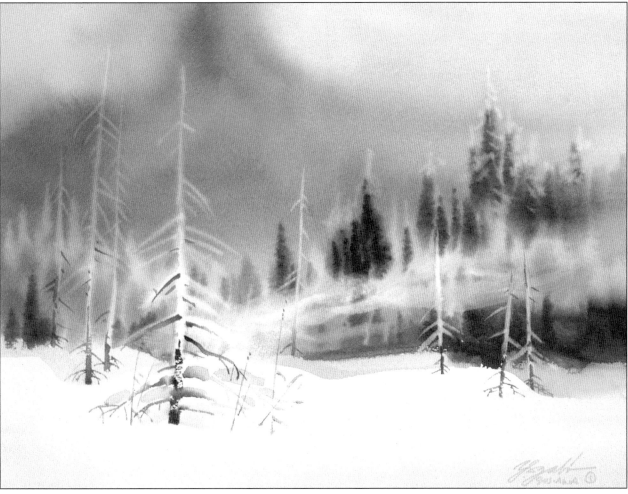

4 Szabo rewets the foreground and lays in some pale blue color. When dry, he paints a few weeds around the base of the large tree. To finish, he glazes very lightly with Raw Sienna over the snow behind the big tree to echo the warm light in the sky.

UNTITLED DEMONSTRATION
Zoltan Szabo
Watercolor on 300-lb. Arches cold press
11″×15″

Watercolor on Dry Paper
by Michael Rocco, AWS

Rocco sticks with a few favorite papers, like this 140-lb. Arches cold press, because he feels it's important to "understand" your paper—how it takes a wash, how color reacts on it, how much abuse it can handle. He uses Winsor & Newton tube colors and Utrecht brushes that are blends of red sable and synthetic filaments.

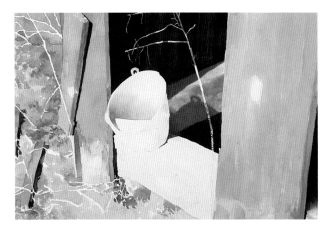

1 Rocco wets and stretches his paper on a plywood board, fastening it with 2"-wide gummed paper tape. With a small brush he masks the large twig with Winsor & Newton masking fluid. He roughs in the ground area (no. 12 round brush), the barn siding (1" flat) and the inside of the bucket. When the masking is dry, he paints the dark shed interior behind the twig.

2 When the paper is dry again, he peels away the masking with a rubber cement pickup. He textures the ground area with deeper values, color changes and shadows. Using dry-brush technique—that is, relatively stiff, dry paint lightly brushed on—he details the wood grain and scrubs away color to represent saw marks and ridges in the wood. This is done with a no. 6 round brush.

3 He finishes the bucket and the large twigs and works more texture into the ground. He uses a stencil knife to scratch away color for some dry grasses. Finally, he paints the pale shadows cast onto the siding. "These are important," says Rocco. "They tie the composition together."

OLD BUCKET
Michael P. Rocco, AWS
Watercolor on 140-lb.
Arches cold press
14½" × 21"

CHAPTER THREE
Oil and Alkyd

SUMMER LIGHT
Edward Gordon
Alkyd on hardboard
21" × 17"

WHAT IS OIL PAINT?

Quality oil paints are available in a variety of tube sizes from many manufacturers.

○il paint is a mixture of *pigment* and a vegetable oil *binder*. The usual binder is linseed oil, but sometimes poppyseed or other oils are used either instead of, or along with, linseed oil. The amount of oil required to make each pigment smooth and brushable varies widely from one pigment to another. As a result, there is a wide range of drying times for oil paints—Burnt Umber dries rapidly, for example, compared to Alizarin Crimson. Manufacturers try to limit the range of drying times by adding *driers* to speed up the drying of some colors.

Another possible ingredient is a *stabilizer*, used to change a "stringy" paint mixture to one that has a more "buttery" feel.

BASIC PROPERTIES

Oil paint may be thinned with a medium and applied in thin layers (glazes), or it may be brushed on straight from the tube. It "dries" to a tough film by oxidation, a chemical reaction, rather than by simple evaporation, and it dries much more slowly than other media (overnight or much longer if it's applied thickly). New layers may safely be added either while the last layer is still fresh ("wet") or after it has thoroughly dried, but not during in-between time when the paint has begun to dry and has become tacky. See more on painting in "layers" (and the "fat over lean" rule) and painting "alla prima" on pages 66–70.

While vegetable oils are obviously soft, flowing materials, once dried they are not very flexible. A thoroughly dry oil paint film is less flexible than, say, an acrylic paint film. A trip to any museum to look at old (and some not so old) oil paintings, with their networks of cracks, illustrates the brittle nature of dried oil paint.

HOW OIL PAINT IS SOLD

Oil paint is sold in tubes, jars and cans, and in artist and student grades. Student grade paints are inferior in quality and should not be used for serious, permanent work.

Tubes

Typical sizes are 37 ml (1.25 ounces) and 120 ml (3.45 ounces). There are also 20 ml, 35 ml, 40 ml, 150 ml and 200 ml tubes, depending on the brand you choose. Most manufacturers offer white paint (Flake White, Titanium White and Zinc White) in the larger tubes, but other colors are commonly sold only in smaller tubes.

Jars or Cans

Several manufacturers offer black and white paints in containers as large as pints, quarts and gallons. One catalog, Daniel Smith, lists its own brand of oils in quarts, in more than twenty colors besides blacks and whites. If you use paint from large containers, you should take steps to keep the surface of the paint from forming a film where it lies in contact with air inside the top of the container. You can buy "skin papers"

WHITE PIGMENTS

	TITANIUM	FLAKE	ZINC
TOXICITY	None	High (lead compound)	None
OPACITY	Very high	High	Low
FILM	More brittle than Flake White	Tough, flexible	More brittle than Flake White; it's the white in Chinese White
DRYING	Slow	Fast	Slow

Profile of white pigments used in oil and alkyd painting. In areas of your painting where you use pure white, or near-white, don't mix linseed oil with the paint. Its tendency to yellow may soon ruin your whites. Manufacturers often use poppyseed oil in their white paints rather than linseed oil because poppyseed oil won't yellow much. Unfortunately, poppyseed oil is very slow-drying.

Looking Back

Oil paints have a long and gradual history—they were not an overnight discovery by any one known artist. Old records show oil paint being used for decorative purposes as early as the 1200s, but it was during the 1500s that oil painting for artistic purposes (easel paintings) became fully exploited. Since about 1600, oil paints have been in continuous use.

(Daniel Smith catalog) you push down into the container on top of the paint to separate it from the air. Other alternatives: turn the closed paint container upside down so any skin that forms will be on the *bottom* of the paint when you turn it right side up; or transfer paint to smaller containers that allow less air to come in contact with the surface of the paint.

Sticks

Containing pigment, oil and wax, crayonlike oil sticks come in several sizes and shapes. They're commonly 4″ to 6″ long and about ½″ to 1¾″ thick. You use them on any conventional oil-painting ground and thin them with the usual oil paint thinners and mediums. Although used mostly for sketching, they can be used for permanent work, and may even be mixed with conventional oil paints. Some brands available are Winsor & Newton's Oilbar, Shiva's Paintstik and Sennelier's Extra-Fine Oil Stick.

Oil sticks are wrapped in paper sleeves that you peel back as you use up the stick. You can keep the exposed end of a stick from drying out by covering it with a piece of kitchen plastic wrap.

OIL PAINT SCORECARD

CATEGORY	PRO	CON
colors available	all	
color compatibility	excellent; can intermix all colors	
strength	tough film	gets brittle with age
drying time	long; allows time for careful reworking	(1) can't always resume painting next day because paint is still tacky (2) *complete* drying can take weeks or months, delaying varnishing and framing (3) not all colors dry at same rate because they are made with different amounts of oil
resistance to damage		canvases must be protected from moisture, mold, physical damage (puncture)
yellowing		linseed oil yellows over time, especially in the dark (e.g., while in storage)
adhesion	excellent on porous, fibrous surfaces	
health risks		paints, mediums, varnishes pose numerous risks

Greasy Kid Stuff

If a batch of paint seems too oily, squeeze as much as you need onto a sheet of bond paper and let it sit until enough of the excess oil has been absorbed by the paper.

BRAND COMPATIBILITY

It's all right to mix different brands of oil paint, as far as permanence and stability are concerned. However, there are significant differences in paint *consistency*—that is, the "feel" of the paint. Some paints are oilier, some are pastier. Other things being equal, the oilier paints dry more slowly than stiffer ones.

PERMANENCE

Provided you purchase only colors rated as permanent (see chapter one), you should have no problem with fading. However, while the *pigments* remain quite stable, the *oil binder* may yellow over time. The greater the concentration of linseed oil in your paint, the more likely it is to yellow.

Health Tips

1. *Many* oil and alkyd painting materials, including paints and solvents, carry health labels. Pay attention!

2. A number of paints, including those containing lead, cadmium, nickel or cobalt, are poisonous. Never get them on your skin, or if you do, wash them away immediately with soapy water. Don't wash with solvents. They are toxic and help to drive the diluted pigments into your pores.

3. Don't hold brushes or other tools in your mouth.

4. Don't eat while painting.

5. Use varnishes and solvents only in a well-ventilated environment; do not inhale the fumes. Wear a breathing mask, especially when using *spray* varnish.

6. Most varnishes and solvents are extremely volatile, a dangerous fire hazard. Never use them near any sort of flame or spark, including a lit cigarette.

7. Many materials, such as solvents, may irritate your skin. Wash off with soap and water.

MEDIUMS

Many artists paint with oils straight from the tube, seldom using a medium of any kind. Others add a variety of products to alter the paint in specific ways—making the paint thinner or thicker, faster-drying, creamier in consistency or suitable for glazing. Following are some of the mediums you can make or purchase. In this list, I'm using the word "medium" loosely to mean any fluid you add to oil paint to change its properties.

DAMAR MEDIUM

Damar is a substance produced by certain trees. It's long been used in mediums and varnishes for oil painting. Here is an all-purpose damar medium you can make yourself and then mix with oil paint to modify its consistency, using a little or a lot depending on what you're about to do. This is a popular recipe, taken from Ralph Mayer's book (see Bibliography):

> damar varnish—1 fluid ounce
> stand oil—1 fluid ounce
> pure gum turpentine—5 fluid ounces
> cobalt drier—about 15 drops (optional)

If you're glazing, add as much medium as needed to thin the color sufficiently to form a transparent layer. For regular painting (not glazing), mix small amounts of medium with your paint to make the paint's consistency just the way you like it.

You may make all kinds of alterations to the basic Mayer recipe as you gain experience with its use. Some artists eliminate the drier, since driers have the potential for causing later cracking of the paint film.

You can make the varnish in this recipe by dissolving 1¼ pounds of damar resin in one quart of turpentine. You won't find the resin in all stores or catalogs, but at least one catalog (Daniel Smith) lists it as "gum damar crystals." If you don't choose to mix your own medium, try the various damar mediums available at the art stores.

OILS

The oils used as binders in oil paints may be purchased in several forms and mixed with paint to get a variety of effects.

Linseed Oil

Squeezed from ripe flax seeds, this is the most common binder in oil paints. When pressed using extreme heat

and pressure, the oil is called *hot-pressed*; when done with less heat and pressure, the result is *cold-pressed*. Cold-pressed linseed oil is considered superior to hot-pressed because it yellows less and resists cracking with age but it's much more expensive. *Alkaline-refined* linseed oil is heated and filtered through an alkaline substance to reduce the acidity, thus reducing yellowing.

Stand Oil

Stand oil is linseed oil heated to a high temperature in the absence of oxygen for a number of hours. Because it is thick, it's not suitable for *making* oil paint, but it can be thinned with turpentine and used as a medium or combined with varnish to make a medium, as in the Mayer recipe shown on the facing page. It has three qualities that make it a good base for a medium: it *yellows much less* than raw linseed oil; it's an excellent *leveler*—that is, it helps paint that it's mixed with to dry to a smooth finish without brush marks; and it increases the luminosity of the color.

Although there are dozens of oil mediums and solvents available, you can get by with just a few.

Yellowing

When oil paintings yellow with age, it's the *linseed oil* that yellows, not the pigments. When you add linseed oil mediums to your paints, you're increasing the chances of yellowing. Use only the amount of oil-containing medium you need to achieve the effect you want, rather than routinely dip into the medium with each brushstroke.

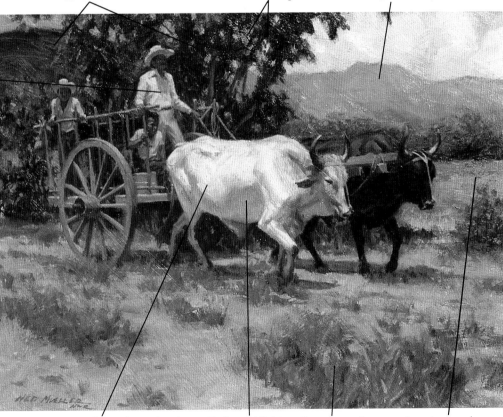

Dark masses frame center of interest

Light openings in foliage

Mountains cool and light for depth

Center of interest placed off-center

OAXACA OXCART
Ned Mueller
Oil on gessoed
Masonite
12″ × 16″
Collection Mr. and
Mrs. Kent Davies

Modeling of oxen kept simple to emphasize form

Reflected light from ground

Grass mass to anchor bottom of picture

Less texture in distant grasses

CHARLES SOVEK
Painting on Location

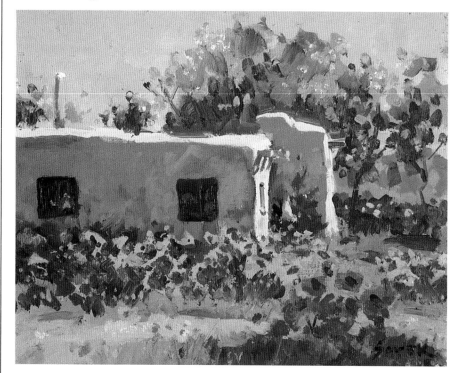

POPPIES AND DAISIES
Charles Sovek
Oil on acrylic-gessoed
Masonite
12″ × 15″

Sovek paints mostly on location—he claims he hardly needs a studio except to store stuff! His traveling equipment is light and easy to manage. He uses a small pochade box (a box that doubles as storage and easel) attached to a metal photographer's tripod. For fast setup he attaches the box to the tripod using a quick-mount device, available at photo supply stores.

In place of the wooden palette that comes with the box, he uses white Plexiglas. Because he generally paints on a white surface, he likes to mix his colors also on a white surface to lessen confusion between the way a paint mixture looks on the palette and the way it looks on the canvas.

Inside the pochade box he carries a dozen bristle brushes, a small sable (called the Charles Sovek Sun-Chaser, available from Cheap Joe's), one painting knife, a palette scraper, two 35mm film canisters filled with mediums, tubes of paint, and his brush-cleaning jar. His paints are Permalba or Utrecht White and Grumbacher Pre-tested tubes of Thalo Red Rose, Cadmium Red Light, Cadmium Orange, Cadmium Yellow Medium, Cadmium Yellow Pale,

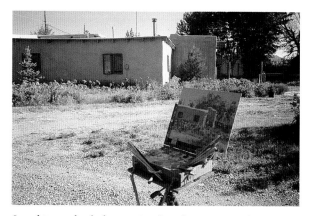

Sovek's pochade box, tripod and painting subject.

French Ultramarine Blue, and a green that he mixes using two parts Viridian and one part Thalo. Although this is his current palette, he expects it to change from time to time. For his mediums, Sovek uses pure stand oil for thicker mixtures and diluted stand oil for looser ones.

He loves to paint with pure, clean color and he likes to paint small. He completed this lush little beauty in about two and a half hours.

THINNERS (SOLVENTS)

The usual thinners or solvents for oil paints are turpentine and mineral spirits. *Turpentine* is a clear liquid made by distilling pine tree sap (the thick residue remaining is called rosin). The product you should look for is called by a number of names: *pure gum turpentine, pure spirits of gum turpentine, rectified turps* and so on. A product used by some artists as an ingredient in glaze recipes is called *Venice turpentine*— it's essentially the raw sap from the larch tree, and is not to be confused with regular turpentine.

Mineral spirits is made by distilling petroleum. It's an excellent substitute for turpentine, costs less and has a less disagreeable odor. It's sold as *mineral spirits* or *turpentine substitute*. A variant is called *odorless thinner*. One use for which mineral spirits is *not* suited is in mixtures with damar varnish—it may not be substituted for turpentine in the damar medium recipe on page 56, for example.

For either turpentine or mineral spirits, use only artist-grade products. Cheaper versions sold in hardware stores contain additives that you should not introduce into your paint mixtures.

There is a newer thinner (solvent) derived from citrus fruits. Grumbacher markets such a product under the name Grumtine (pronounced teen). It may be used in all the ways turpentine is used; it's a stronger solvent than turpentine, and instead of turpentine's odor, which is disagreeable to many people, it smells of citrus.

COMMERCIAL MEDIUMS

The art store shelves are full of mediums that differ from one another in many ways. When you try a new medium, read about it and understand the manufacturer's claims for it. (To get information about mediums or other products, call or write manufacturers and ask for their product data sheets and catalogs. Addresses are listed in the back of this book.)

Two useful nonyellowing mediums are Grumbacher Alkyd Painting Medium and Winsor & Newton Liquin. Both are alkyd products and both are usable for either oil or alkyd painting. Mix either with your paint to get the consistency you want. For glazing, use as much of either medium as necessary to get a thin, smooth, transparent mixture. Other popular mediums, each useful in different circumstances, are Res-n-Gel, Wingel, Grumbacher GEL and Grumbacher ZEC. Still another, Oleopasto, is used to build up stiff paint mixtures for impasto painting in oil or alkyd.

As you experiment with mediums, keep in mind these guidelines:

- Use the minimum amount of medium to serve a particular purpose. Conservators seem in agreement that oil paintings done with straight paint (no mediums except a little thinner) form the strongest, most permanent films.
- When using gobs of oil-containing gel mediums to build up texture, there is significant danger of yellowing.
- Yellowing is sometimes rapid and pronounced when a painting is left in darkness; the yellowing will gradually lighten as the painting is exposed to normal daylight.
- Mediums containing *copal* varnish are likely to darken significantly. I found this out early in my career when I routinely mixed copal medium with my paints—I noticed darkening within a year or so. I no longer use copal.

DRIERS

Among the materials used by oil painters to accelerate the drying of paint, the one most popular now is *cobalt drier*. Driers tend to weaken paint films and make them brittle prematurely, so they should be used sparingly, if at all. They're sometimes added to glazing mediums to speed up the drying of the thin layer of glaze. It's risky to use them in thick paint layers because the outer skin of the paint (exposed to air) tends to dry much more rapidly than the inner paint.

Simplify Life

You may be tempted to buy everything you see in the art store, but the stores are full of products in fancy packages that are only minor variations of other products. I walked the aisles in one store and counted forty-three oil mediums!

Start with basic materials recommended by artists you trust and whose work you like, and build from there carefully. Learn to read and understand labels. You don't need every jar or tube or gadget on the shelves.

VARNISH

Varnishes suitable for use with oil paints are made from either natural or synthetic resins. The natural resin most used is *damar*, a secretion of certain trees in Malaya and Indonesia. The synthetic resin used is *acrylic* resin. In either case, the resin is made into liquid form (in the case of damar, by dissolving the hard damar resin in turpentine) and applied to a painting either by brushing or spraying. Modern acrylic varnish is displacing damar in popularity because it seems not to yellow with age.

Varnishes serve two purposes in oil painting, aside from their use as an ingredient in some mediums: retouching and final varnishing.

RETOUCHING

As a painting progresses, some areas look dry or dull while others look wet and glossy. A light coating of *retouch varnish* at the beginning of the next painting session will perk up the dull areas and enable you to make better color judgments. Retouch varnish is generally the same as final varnish, but with a much higher proportion of solvent (that is, less resin), so it leaves a thin film and dries more quickly.

You can either dilute regular damar picture varnish with turpentine or take the easy road and buy retouch varnish already formulated. Brush it lightly over the areas that need it, but be sure the paint is dry; do not overbrush. Even simpler, buy retouch varnish in spray cans. Spray it *lightly* across the offending area, just enough to get rid of the dull look. Spray outdoors (if it's not humid or cold) or well away from your work area—*don't* inhale the stuff!

FINAL VARNISHING

A final, or picture, varnish is a tough, transparent film covering the painting and protecting it from environmental damage, such as accumulation of dirt. It provides a surface that can be cleaned without damaging

the paint underneath it. At the same time, a coat of final varnish gives an added glow to the painting and provides a uniform finish. Some varnishing tips:

- If you're new to varnishing, practice first on a throwaway painting.
- You can buy either gloss or matte varnishes. If you want an in-between look, not too glossy and not too flat, experiment by mixing the two.
- Use a clean varnish brush two or three inches wide—too small a brush provides more chances for visible brush overlap marks. Try to cover in one or two long strokes—avoid fussing with the varnish as it begins to set.
- If you're spraying the varnish on, lean the painting at an angle against a wall and hold the spray nozzle far enough away (at least twelve inches) to deposit a thin, uniform film. Keep the nozzle moving. Let each thin film dry before applying the next. Don't try to varnish too fast or you'll end up with excess varnish running down the painting.
- Always varnish a *dry* surface in a *dry* environment. The slightest amount of moisture may cause the unsightly whitish mess called "bloom."
- Lean toward thin, not thick varnish. You can always add a second coat after the first is thoroughly dry, but you can't easily remove a coat you put on too thickly.
- The paint film must be thoroughly cured (dry throughout) before varnishing so that no appreciable expansion and contraction is going on in the paint layers. How long this takes is tough to quantify, but most sources agree on something like this: about six to twelve months for thin to normal paint films, one to two years for heavy films.
- Make the varnishing environment as dust-free as possible. A small room or a cardboard enclosure you can seal off and use only for such operations as varnishing would be ideal.

Varnishes can be brushed or sprayed on. Damar varnish has long been a favorite, but acrylic varnishes have become popular.

PAINTING SURFACES

The most common supports for oil paintings are canvas and hardboard. You can also paint on slicker surfaces, such as metal or glass, provided you roughen those sur-

faces first by sanding or etching. Any surface you paint on must have some "tooth" to grip the paint. Other things being equal, paint will not adhere as well to such surfaces as it will to textured, porous ones. Chapter one includes discussions of painting supports and grounds.

TOOLS AND ACCESSORIES

BRUSHES

In the Shopping List on page 63 is a set of brushes that will get you started nicely. Many oil painters like brushes made of hog bristles—they're relatively stiff and they're especially useful for manipulating thick paint. Various kinds of sables are good for thinner paint. Both bristles and sables are popular and effective, but you might start out using synthetics—they're also effective and they're inexpensive.

While the brushes listed will satisfy many painters, your painting style may dictate quite different brushes— for example, much larger or smaller ones. There are other choices: (1) You could substitute "brights" for "flats" if you prefer shorter, firmer tufts. (2) If you can, buy more than one of each size to lessen the number of times you need to clean a brush before dipping into a different color. (3) If you like fine blending, you might add one or more fan-shaped blenders to your arsenal. (4) Many oil painters like the control they get with *filbert* brushes—they're like flats with slightly rounded edges.

KNIVES

There are two types of knives: palette knives and painting knives. A *palette* knife is long and flexible and is generally used for mixing large gobs of paint and for scraping paint from the palette or painting surface.

Painting knives are shorter and flexible, and they come in several shapes, most of them trowel-like. They're used for mixing paints and for applying paint, either alone or in conjunction with brushes. You can get by nicely with two painting knives and one palette knife, unless, of course, you're a knife-painter. In that case you'll want knives in a variety of shapes, sizes and flexibilities (see chapter one).

PALETTES

You may choose a palette that you hold in your hand or one that rests on a nearby taboret or table. An advan-

Here is a variety of palettes: hand-held, enameled tray, disposable paper.

tage of a hand-held palette is that as you move about the studio looking at your work from different angles, you can continue to mix paint. If you find it uncomfortable to hold the palette for long periods, rest it on your taboret or choose a palette that always sits on the taboret. Since switching from a hand-held palette to a white-enameled butcher's tray, I've stopped painting my thumb!

There are differing opinions about palette color. Some painters choose a brown or gray palette because they like a more neutral background for mixing colors. Others like to mix against a white background.

If you dislike cleaning a palette, but do like starting with fresh color each painting session, you might like disposable palette papers. Whenever one is too messy to suit you, scrape off any usable blobs of color onto a fresh paper and continue painting. Some painters *never* clean their palettes, preferring instead to let a crusty mass build up. To some this is arty; to others it's a disgusting mess.

Whichever kind of palette you choose, you can save your oil paints easily overnight by pressing a sheet of kitchen plastic wrap firmly over the entire palette (down *into* the paint to keep air away from it). Very thin films of oil paint on the palette can't be saved in this way, but thicker paint can. Alkyd paint, which dries faster than oil, may also be saved in this manner, but for a shorter time.

EASELS

Although we generally picture an oil painter working at an easel that holds a canvas more or less vertically, many painters prefer horizontal surfaces. There's no reason you can't place your painting on a tilting table-top, such as a drafting table, the kind of arrangement favored by watercolorists. See chapter one for a discussion of easels.

KURT ANDERSON
Big Brushes, Cheap Paint

A WOMAN WIPES THE
FACE OF JESUS
Kurt Anderson
Oil on canvas
28″ × 22″

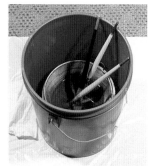

Kurt Anderson's brush-cleaning bucket.

"One of my favorite pieces of advice to students is to 'use cheap paint and waste it.' There was a point in my career when this notion completely transformed me as an artist. Until then I had always purchased expensive little 37 ml tubes of Winsor & Newton oils. The amount I put on my palette was always too small and I found I worked on only a tiny portion of the picture at a time.

"I discovered that by switching to giant 200 ml tubes of Winton and 225 ml tubes of Rowney I was more willing to put huge globs of paint on my palette. (While this paint is economical, it is stable and colorfast.) Using this paint, in turn, allowed me to use much larger brushes. Now I usually start a portrait with a no. 12 or larger bristle filbert and I get the canvas covered early on with large unified masses of color. I then add variations of value and more detail with progressively smaller brushes.

"An efficient way to clean large brushes is to use a wire colander set in a gallon plastic ice cream bucket, which in turn is placed in a taller bucket with a lid. I fill the gallon bucket with enough paint thinner to cover the bristles of my brushes when I dip them in. I swirl the brushes against the colander and then wipe off the excess thinner on a rag. The big bucket catches any splashes."

BRUSH CLEANING JAR

To clean a brush of oil or alkyd paint *during* a painting session so you can use the brush for a different color, simply clean it with turpentine or mineral spirits solvent. To clean brushes at the *end* of a painting session, swish them repeatedly through the solvent until no paint is visible in the hairs. Then clean them again with warm (never hot!) soapy water. You can use brush soap or ordinary bar soap and twirl the brush against the bar to get it thoroughly soaped (don't use bar soaps that contain lotions). Then rinse with plenty of water until all the paint and soap are removed. Shape the bristles with your fingers and put the brushes aside until your next painting session.

To avoid wasting a lot of solvent, buy a product such as Silicoil or the Bob Ross Cleaning Screen. Place one of these gadgets in the bottom of a wide-mouthed jar or can and fill the container halfway with solvent.

Miscellaneous painting tools and supplies.

Clean a brush by gently rubbing it against the coil or screen. As paint loosens, it mixes with the solvent and settles to the bottom of the container, leaving clean solvent above. You can reuse the solvent as long as there

OILS SHOPPING LIST

BASICS	✓
PAINTS (TUBES): Titanium White, Ivory Black, Cobalt Blue, Ultramarine Blue, Phthalocyanine Blue, Phthalocyanine Green, Cadmium Red Light, Cadmium Red Medium, Cadmium Orange, Cadmium Yellow, Yellow Ochre, Raw Sienna, Burnt Sienna, Raw Umber, Burnt Umber	
CANVASES (ALREADY PRIMED) two 16″×20″ stretched cotton duck, two 18″×24″ stretched cotton duck	
BRUSHES (synthetic) 2″ flat (used only for applying gesso), 1″ flat, ¾″ flat, ½″ flat, ¼″ flat, no. 20 round, no. 10 round, no. 6 round, no. 1 round	

BASICS	✓
KNIVES long palette knife with offset handle, 1″ painting knife, trowel shape, 2″ painting knife, trowel shape	
LIQUIN MEDIUM	
PALETTE OR PALETTE PAPERS	
BRUSH CLEANING JAR OR CAN	
TWO METAL CUPS OR PAPER CUPS	
ODORLESS THINNER	
PAPER TOWELS	

OPTIONAL	✓
SECOND SET OF BRUSHES	
WORN BRUSHES	
SMALL NATURAL SPONGES	
SPRAY CAN OF DAMAR RETOUCH VARNISH	
FINAL VARNISH, DAMAR OR ACRYLIC	

is enough room for sediment to collect at the bottom. When the buildup of sediment reaches the screen, throw out the sediment and solvent and refresh with new solvent.

You can make your own arrangement using a piece of window screen or an inverted tea strainer or an inverted can with holes punched in its bottom. You might use a wire colander, as Kurt Anderson does. Homemade gadgets work fine, but remember that the rougher the rubbing surface, the faster it will wear out your brushes.

MISCELLANY

You'll need a couple of small cups to hold medium and clean solvent. There are metal cups that clip to the edge of a hand-held palette (if you're none too steady, you'll have them spilling all over the place). Paper cups are handy because you can discard them after a painting session rather than clean them. If you use paper cups that are too small, they'll be unstable and can easily be knocked over. It's better to use a larger cup with a broader bottom and cut off the top half so that the cup is not too deep to dip into comfortably.

Use paper towels or rags for wiping excess paint from a brush or knife before dipping it into a cleaning jar. It's a good idea to have a trash receptacle with a lid for disposing of smelly paint rags and paper towels. A collection of paint rags can be a fire hazard, so store and dispose of them with care.

WHAT IS ALKYD PAINT?

Like any paint, alkyd consists mainly of *pigment* and *binder*. The binder in this case is something called an *oil-modified alkyd resin*.

Natural resins are secretions of various plants—for example, damar resin, used with oil paints, comes from certain trees. *Alkyd* resin, however, is synthetic. It's made by combining alcohols and acids, from which

came the early name "alcid," later changed to "alkyd." An oil, such as linseed oil, is added to this synthetic resin, and that combination becomes the binder in alkyd paints.

Alkyd paint has long been recognized as superior for industrial and house-painting purposes. More recently it's been formulated for use by artists. Here are some of its features:

- Alkyd dries much faster than oil paint and much slower than acrylic. Depending on paint thickness, alkyd paint remains workable for two to six hours and dries in twelve to twenty-four hours. You can paint glazes as little as two hours apart—depending on the proportions of solvent, medium and paint in your glaze mix.
- Some oil colors (such as Burnt Umber) dry *much* faster than other oil colors. Alkyd colors all dry at the same rate.
- Alkyd is compatible with, and can be mixed with, oil paint. Mediums used in oil painting can be used in alkyd painting and vice versa.
- An alkyd painting can be varnished much sooner than an oil—in as little time as one month, depending on paint thickness.
- Although it's too early to be certain, alkyd films appear to yellow less than oil films. They appear also to be tougher and less likely to crack than oil films.

ALKYD MEDIUMS

Oil-based mediums may be used with alkyd paint, but it probably makes better sense to use an alkyd-based medium because alkyd mediums speed the drying of the paints with which they're mixed. Alkyd mediums are available from several manufacturers, including Grumbacher and Rowney. Winsor & Newton lists three alkyd-based mediums for use with their Griffin line of alkyd paints: Liquin, Wingel and Oleopasto. Liquin is an all-purpose liquid medium used to make alkyd tube paint more fluid; it's an excellent glazing medium. Wingel is a thicker medium that adds body and translucence to the paint. Oleopasto is similar to Wingel, but contains an additional ingredient, silica, to provide "body" for use in impasto paintings.

Alkyd mediums may safely be used with oil paint (notice that Liquin is listed as a medium in the Oils Shopping List) and may be expected to accelerate the drying of oil paint, depending on the proportion of medium used.

Alkyd paints and medium.

EDWARD GORDON
A Master of Alkyd Painting

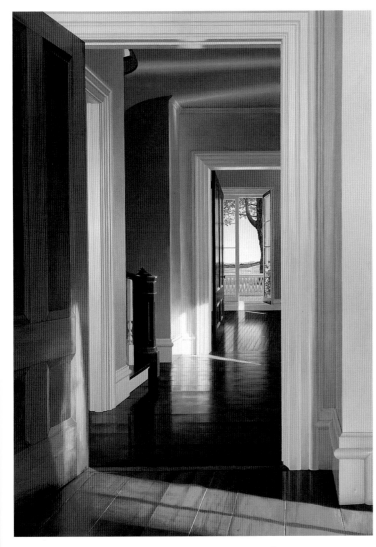

GREEN PASTURES
Edward Gordon
Alkyd on hardboard panel
34″ × 24″

Gordon uses a paint roller to apply four or five coats of acrylic gesso to the rough side of a piece of ¼″ standard Georgia-Pacific hardboard. He sands the surface with 60- or 80-grit sandpaper, then applies two or three coats of gesso with a wide trowel. He sands again with coarse sandpaper or a sanding screen and finishes with 400-grit paper for a surface that is eggshell-smooth. Preferring to paint on a surface that's not glaring white, he coats the surface two or three times with thinned gray alkyd paint, and sands with 600-grit paper after each coat. He transfers his drawing to the panel using graphite paper and a ballpoint pen.

To achieve the light glow in his work, Gordon builds up his painting in thin, translucent layers, us-ing a bit of Liquin to make the paint more workable. Between coats he sands lightly with 600-grit paper.

To help achieve a glass-like finish, Gordon uses Golden brand MSA (Mineral Spirit Soluble Acrylic) varnish as a final varnish. This varnish contains ultraviolet light filters and stabilizers. The satin MSA varnish is too dull and a little too thick for his needs, so he dilutes it by mixing roughly three parts MSA with three parts Winsor & Newton gloss varnish and one part mineral spirits. He brushes on a coat of varnish with a fine 2″ varnish brush and, when dry, repeats with one or two more coats. He sands *very* lightly between coats with 600-grit paper, seeking a smooth, bright finish that is not high gloss.

PAINTING WITH ALKYDS

Everything in this chapter, unless otherwise noted, applies to both oil and alkyd painting. The most obvious differences have to do with drying times, as already mentioned.

SHOPPING LIST FOR ALKYDS

Use the Oils Shopping List, except that, of course, you'll substitute alkyd paints for oil paints. At this writing, there is only one brand commonly available: Winsor & Newton's Griffin Alkyd Colours in 60 ml tubes. The Shopping List includes a medium, Liquin, specifically made for use with alkyd paint but also fine for oil paint.

WHAT ARE WATER-MISCIBLE OILS?

Grumbacher offers a patented line of oil paints called MAX. It's an oil paint that mixes with water, so it can be thinned and cleaned up with water! Although you *may* use traditional solvents, such as turpentine or mineral spirits, you don't need them at all. Here are the highlights of MAX Grumbacher:

- Water substitutes for the traditional solvents used with conventional oil color.
- Can be mixed with conventional oils. Two parts *MAX* to one part oil, and it will clean with water. Stronger mixtures become less water-friendly and require brush soap to clean brushes.
- Has roughly the same drying times as conventional oils. You can speed this up by using Grumbacher alkyd painting medium.
- Brushes clean using only soap and water.
- Available in about sixty nontoxic colors.

These paints brush on beautifully. They are too new to be truly time-tested, but of course they have been subjected to the manufacturer's accelerated testing. Some people will hesitate to depart from conventional oils, but then, many artists hesitated to use acrylics when they were new. I see no reason to hesitate to use this paint if eliminating smelly, toxic solvents appeals to you.

GETTING STARTED IN OIL OR ALKYD

When painting in oils and alkyds you should pay attention to the time-honored "fat over lean" rule. What it says is that you should not cover a layer of paint with a less flexible layer. Always paint flexible ("fat") layers over less flexible ("lean") layers. If you ignore the rule and do the reverse, it's like having a chocolate pudding with a "skin" on top—any flexing of the "fat" pudding underneath will cause the "lean" skin to crack.

Oil or alkyd paint becomes "fatter" when you add to it an oil painting medium, such as linseed oil or damar medium. The paint becomes "leaner" if you dilute it with turpentine or mineral spirits.

If you paint wet-in-wet using only straight paint and no oil-containing mediums, you lessen your chances of violating the "fat over lean" rule. However, you would be in violation if you paint a turpentine-thinned layer of paint over a layer of straight paint.

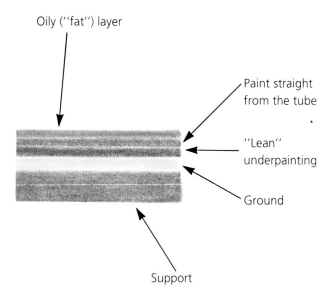

Oily ("fat") layer

Paint straight from the tube

"Lean" underpainting

Ground

Support

A safe order for paint layers is (from the bottom up): support, ground, thinned "lean" paint, paint straight from the tube, oilier "fat" paint.

> There once was a painter named Pat
> Who painted lean over fat;
> She was taken aback
> When her paintings did crack—
> Now she paints in watercolor.

GREG ALBERT
Painting With MAX

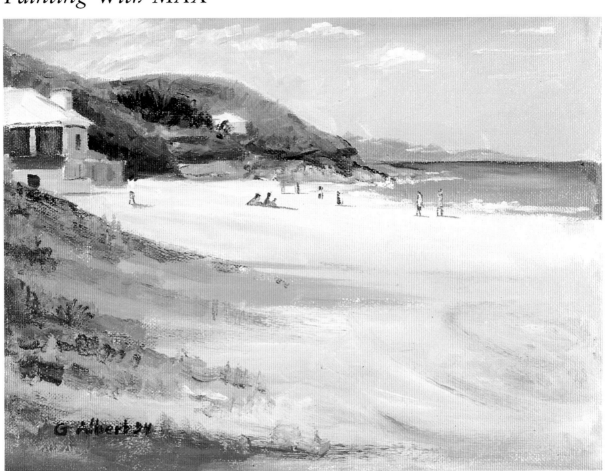

BERMUDA BEACH
Greg Albert
MAX Grumbacher oil on canvas board
9″ × 12″

"The new water-miscible oil paints by Grumbacher are everything they are claimed to be: they work just like traditional oils, they have bright, strong pigmentation, there are no noxious odors, they dry just like traditional oils, and they clean up quickly.

"Sometimes we're too lazy to wipe or clean our brushes as we work. It's too much trouble or it requires big containers of messy, smelly turps. We get into bad habits, with muddy colors as the result. But because cleanup with MAX is a snap, I find that truly clean colors are possible. I keep a big pot of water at my easel for cleaning brushes easily and often. I don't dip a dirty brush into clean paint and I don't dip a clean brush into dirty turps or mediums. My paintings are brighter and purer as a result.

"Use water to thin MAX paints on the palette in the same quantities you would use turpentine or other solvents. Just a few drops will thin the paint to a creamy consistency. But you can't use MAX like watercolor, mixing a lot of water with the paint to make a wash. There would not be enough binder in the resulting paint to form a strong paint film."

THE GROUND

Although most grounds are relatively smooth, many painters like a *textured* ground to give them a leg up in texturing the painting. Whether you use acrylic gesso or white lead (see chapter one) as your ground, you may texture it all you want by spreading and smearing the ground material with coarse brushes, painting knives or other tools. When dry, the ground is ready for your drawing.

DRAWING

You may draw on your ground with anything that won't repel the paint. Don't draw with waxy substances, such as crayons. Charcoal, pencil, ink and paint diluted with solvent are all okay. If you use charcoal, blow off any excess so you don't have loose charcoal under your first paint layer. If you're concerned about charcoal mixing with and messing up your paint, spray the drawing *lightly* with a little retouch varnish or charcoal fixative—just enough to "glue" the charcoal in place.

How detailed you make your drawing is a personal matter. Some painters start with a detailed drawing, others with only a line or two, and still others, with no drawing at all.

UNDERPAINTING

Many painters lay in a loose underpainting to get rid of the glaring white of the ground. The simplest way to underpaint is with oil or alkyd paint diluted with solvent. Such a diluted mixture will dry rapidly and it will start you "lean." For even faster drying, provided you have an acrylic gesso ground, you may underpaint using thin *acrylic* paint. Don't underpaint with a thick acrylic

Underpainting by toning the entire canvas with either a "warm" tone (here, Burnt Sienna) or a "cool" tone.

layer because adhesion between oil paint and a thick acrylic underpainting may be inadequate.

There are at least four different approaches to underpainting: toning the ground with a single color; laying in colors that are *complements* of the final colors; roughing in colors that are the *same* as the final colors; and carefully working up the entire picture in shades of monochrome, such as grays (this "grisaille" technique is sometimes the starting place for a painting that is to be built up in a careful series of glazes).

Except in the last case (underpainting in monochrome as a base for glazing) underpaintings can be done loosely and rapidly. The looser they are, the more freedom you have to continually redraw as you paint. If your inclination is to plan and draw more carefully and then paint without making many changes to your drawing, then of course, you'll underpaint carefully. By all means, suit yourself—there is no "right" way.

A ground, such as this acrylic gesso, textured with coarse brushes and painting knives will give you a head start on a textured painting.

Underpainting with colors that are complements of the final colors—here, orange for the blue sky and purple for the yellow meadow.

Underpainting with colors that are the same as, or close to, the final colors.

PHIL METZGER
Underpainting in Alkyd

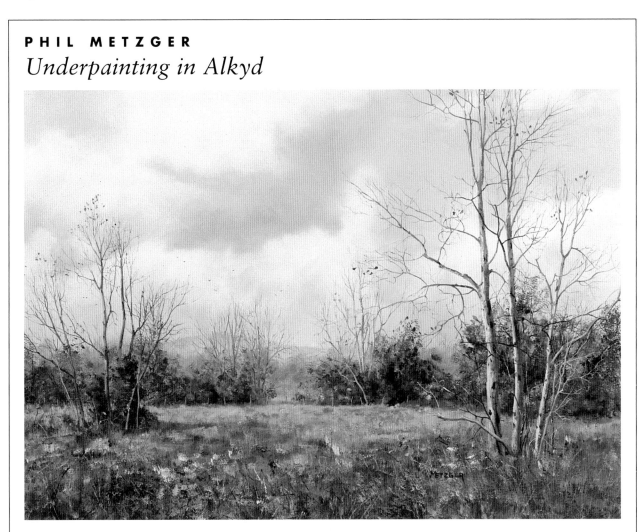

Sometimes I underpaint with colors approximating the final colors, as I did here, but often I simply tone the canvas. I really can't claim to use one method or another according to some clear artistic aim—mostly it's a matter of what appeals to me on a particular day. I painted this picture in about six hours, the alkyd paint staying wet enough to allow plenty of changes during that time.

SKY AND MEADOW
Phil Metzger
Alkyd on canvas
20″×28″

PAINTING *ALLA PRIMA*

This term (literally, "at once") usually implies painting directly, opaquely and finishing in one painting session, as opposed to painting in carefully built-up layers. It may be done with or without an underpainting. You may use or ignore mediums, as you wish. Since there is no layering, there is little concern with the "fat over lean" business. This is the technique that should pose the fewest problems of paint film permanence.

IMPASTO

This imprecise term means thick application of paint. Although this can be done by any means, it often involves the use of painting knives. The thicker the paint, the longer the drying time, of course, and the higher the potential for eventual cracking.

LAYERING

Many painters build a painting in layers as they home in on the result they're after. Sometimes layering is used because painters find the technique methodical and satisfying; sometimes, because time runs out and the painting can't be finished all in one day. Many painters work for days, weeks, months in this way, often with more than one painting underway at any time. This method requires attention to the "fat over lean" rule.

GLAZING

Glazing, in any medium, simply means painting a transparent layer over an existing layer of paint. In oil (and to a lesser degree in alkyd) it also means a considerable waiting period between successive glazes. To avoid ugly messes, a surface must be thoroughly surface-dry before glazing.

To mix a glaze, add some medium, such as damar medium or Liquin, to your paint until you get the right amount of transparency. Try to reserve the fattest (oiliest) glazes for the latest layers.

Some painters build up entire paintings as a series of glazes, often beginning with a monochrome underpainting as their map. Others use glazes only in limited areas of an otherwise opaque painting—that may result in an uneven gloss over the picture's surface, but a coat of retouch varnish or an eventual coat of final varnish will even things out.

More Fat over Lean

It's generally accepted that you may paint in oil or alkyd over *acrylic* paint or *acrylic gesso grounds*. But when all the layers are dry, the acrylic layer is more flexible than the others, so there is an apparent violation of the "fat over lean" rule. All that can be said at this point is that after decades of such usage, this does not appear to be a problem. One reason for this *may* be that acrylic underlayers (including acrylic gesso grounds) are generally kept quite thin.

Society Notes

In 1992, an organization called Oil Painters of America was formed to encourage *representational* oil painting in the United States. Its address:

Oil Painters of America
601 South Lincoln Avenue
Park Ridge, IL 60068

CHARLES SOVEK
Painting Alla Prima

BOATS ON FIVE-MILE RIVER
Charles Sovek
Oil on canvas
9″ × 12″

Sovek ducked into the shade of a porch to paint this scene. He put on Walkman headphones and tried to look unapproachable so that passersby would let him paint in peace. He loves talking to his classes, but prefers not to be interrupted when he's out painting.

He completed this picture in one and a half hours—everything just clicked. "I went to that same place a month later," he says, "and painted a bomb!"

Sovek tries to travel light. His canvas in this case was mounted to a lightweight lauan wood panel with Elmer's glue. Such panels (as well as hardboard panels) are thin enough that he can carry many of them on a trip. They fit into a wooden carrying case in slots spaced far enough apart that he can carry freshly-painted panels without their touching one another. His carrying box is about 9″ × 12″ × 18″, small enough for carry-on luggage when he flies.

LOUISE DEMORE
Painting on Location

OLD EUC
Louise DeMore
Oil on canvas
20″ × 24″

"I did Old Euc on location between 9:00 A.M. and noon. I used a Fredrix stretched canvas to which I applied three coats of Liquitex gesso. I stained the canvas a light gray-blue because I find it easier to judge values on a toned canvas than on a white one (especially outdoors in the sunlight).

"I use a fairly simple palette, mostly Grumbacher Pre-tested, Liquitex or Utrecht brands. My colors are black, Thalo Blue, French Ultramarine Blue, Permanent Green Light, Cadmium Yellow Light, Alizarin Crimson, Yellow Ochre, Burnt Sienna and Titanium White. My favorite brushes are Grumbacher Edgar Degas short filberts.

"I began Old Euc by drawing with a no. 6 brush, using diluted black paint. I used a paper towel and a little turps to erase and make changes. I scrubbed in the darks and then laid in simple flat spots of color, primarily in the middle values, working up to the lights. I always avoid details until I'm satisfied with color relationships. Next I gave the trunk, branches and masses of leaves form by blending or by working in transition color between the light and shadow sides, gradually using more paint. Finally, I added a few leaves, using very thick paint, and then some dark accents to finish."

TOM BROWNING
Paying Attention to Edges

THISTLES AND ONIONS
Tom Browning
Oil on linen canvas
34″ × 32″

Browning always takes care to include a variety of edges in his paintings—some so soft that forms melt into one another, some barely suggested and others hard and crisp.

"For a long time I had wanted to paint the teasels (stiff, prickly herbs) that are supposedly unique to the region where I live. Under a single light source (a warm 200-watt bulb) I set up my composition, trying different arrangements of teasels, pots, onions and so on. It helps to set up the still life in the light source you're going to be using, so that when things fall into the right position, you'll know it immediately.

"I used a medium-toothed acrylic-primed linen, but added some texture by roughly brushing on more gesso with a stiff brush. I smoothed the areas that were to be very dark to avoid ridges that would reflect light in a way making the painting difficult to view.

"With a large bristle brush and thinned paint in a medium tone I drew in the composition. Again using the large brush, I laid in the shadowed sides of all objects to establish form. Next came the background to create the value contrasts that first grab the eye of the viewer. I did almost the entire painting with bristle brights ranging from no. 4 to no. 12. The only other brushes were a sable flat for blending and a small red sable round for details, such as the stems and sharp points of the teasels.

"When I thought I was finished, I hung the painting in another room to dry. As I looked at it during its drying time, I felt something was missing. The teasels seemed to shoot out of the vase like rockets. I added another type of thistle to the arrangement and they were just what the painting needed to loosen things up a bit and keep the grouping of teasels from appearing so compact."

DEMONSTRATION

Painting Textures in Oils
by Warren Allin

1 *Working on an acrylic gesso ground, Allin uses thin paint to quickly establish his main shapes. He uses a four-inch brush to stipple the sky area and then carries the warm sky color down over the ground area to help assure color unity. He stipples Phthalo-cyanine Blue over the pink sky color to form the distant mountain.*

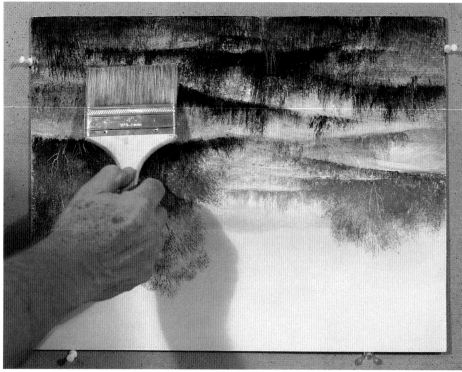

2 *With the picture upside-down, he uses the four-inch brush to lay in dark color. He mixes a little Turpenoid and some Perma-Gel with his paint to get the consistency he needs, and gently presses the bristles of the loaded brush against the wet underpainting to get the textures he wants.*

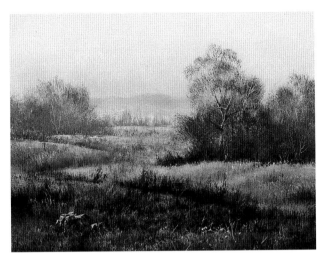

3 *Still working into wet paint, Allin develops the middle ground and foreground and establishes the zigzag pattern that leads the eye into the picture.*

A couple of Allin's favorites, a four-inch and a one-inch bristle brush. He deformed the smaller one by hacking at it with a razor blade to give him the irregular bristles he needs for such textures as grasses. To further deform it, he lets it stand in a jar of thinner so that the bristles are permanently curved. He uses these brushes a lot in landscape painting, along with smaller brushes and a painting knife, to get a variety of textures.

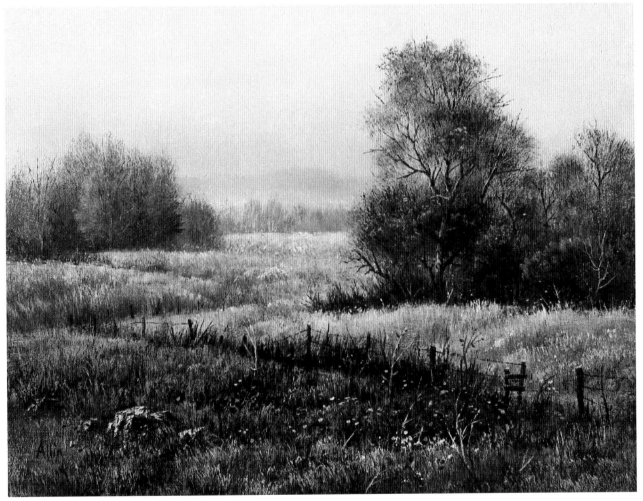

4 *In this stage, Allin pushes the right-hand trees farther up into the sky. From the start, he had had in mind adding a fenceline, but wasn't sure where to put it. As the picture developed, the fence fell into place naturally. He found the foreground too dark, so he enlivened it with opaque touches of light paint representing wildflowers and light grasses. For these tiny spots of color he used small brushes and the tip and edge of a painting knife.*

FENCELINE
Warren Allin
Oil on hardboard
14″ × 18″

CHAPTER FOUR
Acrylic

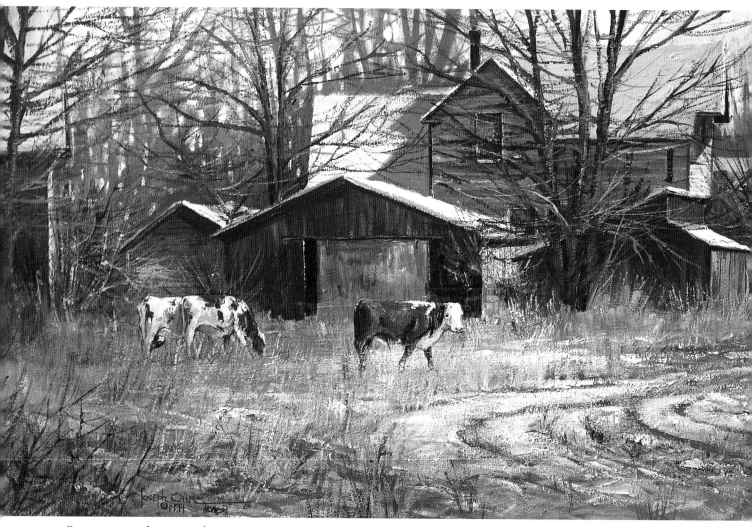

Orr uses a combination of Winsor & Newton synthetic brushes and various painting knives. He prefers Liquitex paint, which he feels is a little slower-drying than others, thus allowing a bit more time to manipulate the paint. His support in this case is Fredrix primed, acid-free cotton canvas. He developed this picture from back to front, adding the cows late in the painting process to strengthen the composition—they were not included in his original sketch.

OLD HOME PLACE
Joseph Orr
Acrylic on canvas
16″ × 32″

WHAT IS ACRYLIC PAINT?

Acrylic paint has three basic ingredients: *pigment*, *binder* and *water*. The *binder* is a synthetic material called acrylic polymer emulsion—by common usage we've settled on the shorter term, "acrylic."

BASIC PROPERTIES

As the water in acrylic paint evaporates, the paint dries to form a tough, chemically stable, flexible film of pigment and binder. Unlike oil paint, dried acrylic paint is not brittle, so it won't crack or flake or shatter. It does not shrink over time and it's unaffected by normal changes in temperature and humidity. It's been around for more than fifty years and is clearly a permanent paint.

Acrylic paint dries fast. If you paint thinly, it dries about as fast as watercolor. Thicker paint takes a little longer, anywhere from one to several minutes (or much longer if the paint layer is very thick). You can increase drying time by using some of the mediums to be discussed later, but the time is still short, relative to the drying time for oils. Dried acrylic paint cannot be removed from most surfaces with water, nor can it be scraped or sanded easily. Sanding a thick layer of acrylic requires plenty of elbow grease, or even an electric sander.

THE LOOK OF ACRYLIC

You can get just about any "look" or "finish" you want in an acrylic painting. Acrylic "watercolors" look just like traditional watercolors and opaque acrylics are often indistinguishable from oils (sometimes I have difficulty deciding whether one of my own paintings, done years ago, is an oil or an acrylic).

You may have heard comments that acrylic paintings look too garish or the opposite, too dull and flat. Those are foolish notions based on how some painters *use* the paint rather than any quality inherent in the paint itself.

Looking Back

Artists' acrylic paint has been around since the mid-1950s. It was one of the many offshoots of a family of synthetic resins first developed by Otto Röhm in Germany in 1901. Another familiar product from this family is Plexiglas, a product of Rohm & Haas.

ACRYLIC SCORECARD

CATEGORY	PRO	CON
colors available	virtually every color that comes in other mediums	
color compatibility	excellent; mix any combination	
brand compatibility	may freely mix brands	
strength	extremely tough, flexible paint film, unlikely to crack and will not shatter when struck or dropped; highly resistant to scratching	hard to sandpaper or scrape down for corrections
water resistance	once dried, paint film is waterproof	tough to clean dry paint off brushes, carpets, clothes; when used as watercolor, dried paint cannot be easily "lifted"
drying time	(1) minutes or hours depending on paint thickness (2) fast drying allows addition of glazes within minutes of one another (3) all colors dry at same rate	too fast to allow fine blending as with oils; can be slowed some with retarders or gels
yellowing	none	
adhesion	adheres strongly to rough or porous surfaces	does not adhere well to slick or oily surfaces or shiny surfaces such as glass

HOW ACRYLIC PAINT IS SOLD

Acrylics may be purchased in either tubes or jars. Tube paint has roughly the consistency of oil paint, and is more commonly used than jar paint. The more fluid jar paint is often used for brushing or *pouring* large quantities of paint at a time. Many painters working on abstract or nonobjective pieces, or on a large scale, like the convenience of jars.

Tube sizes vary among manufacturers. A common size is 2 fluid ounces (59 ml). Some colors are also sold in 4.65 fluid ounce (138 ml) tubes and 7 fluid ounce (207 ml) tubes. Not every manufacturer sells each of its colors in the larger tubes.

Although large tubes are more economical, stick to smaller ones if you work outdoors—the weight and volume of large tubes can be a burden. The most common purchase in larger tubes is Titanium White, often-used for mixing with other colors as well as for white passages.

Jars of acrylic paint come in a variety of sizes, including 2-ounce, 8-ounce, 16-ounce and even quart and gallon sizes. If you use lots of paint even more fluid than jar paint, you'll need some containers for mixing so that you can further thin your paint with water or medium.

In the case of either tubes or jars, screw on caps or lids firmly after use to keep the exposed paint from drying out. It's a good idea to wipe the tube or jar neck clean of paint so that the next time you unscrew the cap or lid you won't need a wrestler to help you. Dried acrylic paint is an excellent adhesive!

Many manufacturers offer less expensive grades of paint that often cost about half as much as artists' grade. If you're serious about your art, use only artists' grade paints right from the beginning. Purge your mind of worries about inferior materials and concentrate on the work itself.

Acrylic in jars is more fluid than that in tubes. Jars are an economical way to buy if you use large quantities of paint or if you like to pour paint over a surface.

To keep a jar lid from sticking, put a piece of kitchen plastic wrap or waxed paper between the lid and the jar.

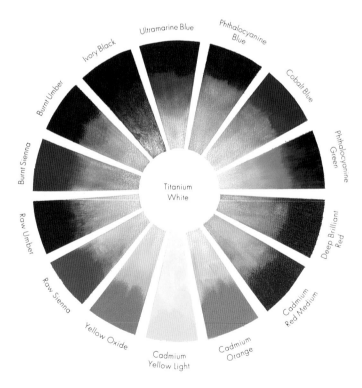

A sampling of the 148 colors in the Liquitex line.

Popular tube acrylics come in a variety of sizes. The paint has roughly the consistency of oil paint.

OTHER FORMS OF ACRYLIC PAINT

Acrylic is such a popular medium that varieties other than regular acrylic paint are constantly being added. Here are some of them:

Iridescent Colors

These are paints that simulate the look of metals such as gold, silver and bronze. They can be intermixed with other acrylic paints and mediums.

Interference, or Refractive, Colors

These paints "change" color when viewed at different angles, much like the plumage of certain birds or a slick of oil on water. Typically, at one angle you'll see the paint's labeled color, such as red, and from another angle, its complement, green.

Airbrush Colors

These are watery-thin. Their pigments are finely ground to avoid clogging the airbrush. An example of such paints is Dr. Ph. Martin's Spectralite Acrylic Airbrush Colors, offered in over three dozen colors. Spectralite comes in small bottles (one fluid ounce) with an eye-dropper cap. A similar product is acrylic ink, intended for use in pens.

BRAND COMPATIBILITY

The acrylic medium is a fairly standardized formula, so you may mix one brand of acrylics with another. However, there *are* relatively minor differences—one brand's yellow oxide pigment may not be ground to the same degree of fineness as another's, for example. For that reason, it's a good idea eventually to settle on a brand and stick with it.

PERMANENCE

Many manufacturers have adopted the ASTM (American Society for Testing and Materials) standards discussed in chapter one. For permanent work, select only ASTM Category I and II paints—these ratings are printed on paint labels and listed in manufacturers' brochures. If a system other than ASTM is used by the brand of paint you choose, become familiar with that system and select only permanent paints.

MEDIUMS AND VARNISHES

The basic medium for thinning acrylic paint is *water*. However, adding water can somewhat weaken the acrylic film, while adding a prepared medium does not. Water also increases the drying time, and causes the acrylic to dry matte. There is a growing variety of specialty mediums available. You need not worry about compatibility between these products and your acrylic paint—since paints and mediums are derived from the same basic plastic resin, they happily coexist.

GLOSS MEDIUM

Mix this in any proportion with your paint to thin the paint to a lighter brushing consistency. By adding a lot of medium, you thin the paint enough that it can be used as a glaze. When you thin with medium rather than water, the paint will retain a more buttery, less watery, consistency. Adding this medium makes acrylic paint more glossy and more transparent.

You can use gloss medium to seal a surface before painting on it. You might use it in this way if the painting surface is too absorbent or if you simply like the feel of the surface better with the coating of medium. Gloss medium can also be used as a varnish.

Mixing acrylic paint and gloss medium.

<div style="border:1px solid">

Health Tip

Some colors carry a health warning label—they have some degree of toxicity. Each may be replaced by a nontoxic paint. Example: "Cadmium Orange Hue" is a nontoxic substitute for "Cadmium Orange." For *every* paint you buy, look for health warning labels.

</div>

MATTE MEDIUM

Use matte medium if you want to create a flat, non-shiny finish. Like gloss medium, matte medium increases the transparency of the paint. By mixing the right proportions of matte *and* gloss mediums, you can get a soft, satin finish. This will take some experimentation—keep track of the proportions of each you're mixing so that when you get a result you like you'll be able to repeat.

Unlike gloss medium, matte medium should *not be used* as a varnish because it may produce a cloudiness over dark colors. In collage, this medium is a powerful adhesive for gluing pieces of paper, cloth and other materials to the picture's surface. We'll have more to say about the use of acrylic medium in collage in the last chapter.

GEL MEDIUM

Gel mediums are mixed with paint to increase the transparency and brilliance of the color. There are a number of different gel mediums available, depending on which manufacturer you buy from. Regular gloss and matte gel mediums are the same consistency as tube paints, so paint mixed with them handles in a manner similar to straight paint. Some manufacturers also offer *heavier* gels that increase transparency and brilliance and stiffen the paint. Use heavy gels when you want to do impasto or knife work or when you want to lengthen the drying time of the paint.

RETARDING MEDIUM

This gooey concoction slows down the drying of acrylic paint, but not much—minutes, not hours. I don't use it because I don't like the feel of the paint after the retarder is mixed with it, but of course it may suit you quite nicely. Retarder is sold in tubes.

Squeeze some of it into a mound of paint and mix thoroughly. Pay attention to the manufacturer's directions and don't add more retarder than the maximum called for—otherwise the paint film may shrink. One brand, Liquitex, says in its handbook, *The Acrylic Book*: "Do not add over 20% [retarder] medium by volume to the paint or shrinking, poor adhesion or the forming of paint skins may occur."

GLOSS VARNISH

The material discussed earlier called gloss *medium* may also be used as a *varnish*. Some manufacturers, such as Liquitex, in fact label their jars as "gloss medium and

NAME OF PRODUCT	CAN BE USED AS	POROUS?	REMOVABLE?
Liquitex Acrylic Gloss Medium and Varnish	both medium and varnish	yes	no
Liquitex Acrylic Matte Medium	medium only	yes	no
Liquitex Acrylic Matte Varnish	varnish only	yes	no
Liquitex Soluvar	varnish only	no	yes (mineral spirits or turps)
W&N Acrylic Gloss Medium	both medium and varnish	yes	no
W&N Acrylic Matte Medium	medium only	yes	no
W&N Acrylic Gloss Varnish	varnish only	no	yes (W&N Acrylic Varnish Remover)
W&N Acrylic Matte Varnish	varnish only	no	yes (W&N Acrylic Varnish Remover)

A variety of mediums helps you to modify your acrylic paint to suit your needs.

Examples of varnishes and their uses. Other manufacturers, such as Golden and Grumbacher, offer similar, equally effective varnishes.

SHIRLEY PORTER
Corrections Made Easy

SILENT SENTRIES
Shirley Porter
Liquitex acrylic on Pearl 5000 cold-press illustration board
22″ × 32″

Porter transferred a detailed pencil drawing from newsprint to the board. She chose not to coat the board with gesso. Taking advantage of acrylic's covering power, she painted some areas from dark to light, and some, light to dark. She made radical changes well into the painting process, painting out two heads with Titanium White and repositioning and repainting them. The brushes she used were all Robert Simmons synthetics, both flats and rounds.

varnish." This type of varnish is not removable—it's made from the same basic ingredients as the paint it's covering and the varnish effectively becomes a part of the painting.

As a varnish, gloss medium gives a uniform shine and enhances the depth and brilliance of the colors underneath. You can brush or spray on successive thin coats, building up the sheen you want. When spraying, let each thin coat dry before spraying on the next—usually only a matter of minutes. If you apply varnish with a brush, work rapidly with a wide (2″ or so) brush. Never go back and brush the varnish once it has begun to dry, or you'll have a gummy mess on your hands. If you don't completely cover the surface you intended before drying begins, *stop*! Let it dry thoroughly and then apply the varnish to the next area. If you're varnishing a picture for the first time, make a couple of trial runs on an old painting you don't mind ruining.

SHIRLEY PORTER AND JOSEPH ORR
Two Different Approaches

Here, Porter uses acrylic paint in a flat manner, with no modeling. The success of this kind of picture depends on an effective arrangement of colors, shapes and values.

Porter first establishes the surrounding floral design, and then paints the figure with colors that work well with the background colors. Acrylic paint's opacity allows her to make changes easily and to overpaint details such as the veins in the leaves without any masking.

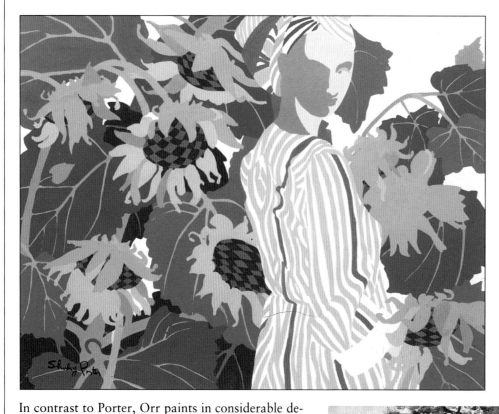

SUNFLOWERS
Shirley Porter
Acrylic on 100% rag
mat board
21″×27″

In contrast to Porter, Orr paints in considerable detail and models all forms realistically. He prepares his panel with three coats of Liquitex acrylic gesso on the front, one on the back. After working out his composition on paper, he transfers a rough outline to the gessoed panel, and (in a reversal of Porter's procedure) begins his painting with the figure, which is to be the center of interest. He allows the figure to suggest how the surroundings should be handled.

Next, he paints in the sky, background and barn, working toward the foreground with a variety of brushes. At the end, Orr uses a painting knife to suggest texture in the tree foliage and in the garden vegetation.

GARDEN GREENS
Joseph Orr
Acrylic on ¼″ untempered Masonite
12″×22″

MATTE VARNISH

Don't use matte *medium* as a varnish because it may cloud dark colors. Instead, look for products labeled as matte *varnish*. Matte varnish will give your picture a satin finish, something like the look of nonglare glass. Apply it in one or two thin coats. *Additional coats, or too heavy a coat, may cause a cloudiness in the underlying colors, especially the dark ones.*

REMOVABLE VARNISH

The problem with using the acrylic varnishes just discussed is that, *like acrylic paint*, these varnishes are porous. Dirt eventually settles in the pores and there is no effective way to remove the dirty varnish.

There are *removable* final varnishes that seal the pores and protect the painting from the environment. The Liquitex version of such varnishes is called Soluvar Picture Varnish. It's acrylic-based and comes in gloss and matte variations. It's nonyellowing, noncracking, and water-resistant. The varnish layer can be removed with mineral spirits or turpentine. Winsor & Newton offers removable varnishes called Acrylic Gloss Varnish and Acrylic Matte Varnish. They are different in composition from other brands—instead of removing with mineral spirits or turpentine, you use a Winsor & Newton alkali solution called Acrylic Varnish Remover. Grumbacher also offers a removable acrylic varnish which is removed with mineral spirits. It can be used on acrylic paintings as well as oil paintings.

OTHER ACRYLIC PRODUCTS

MODELING PASTE

This is a claylike material that can be used to build three-dimensional objects. It dries rock-hard, and you

Acrylic varnishes come in both removable and nonremovable varieties.

would ordinarily use it on a rigid support, such as a wood panel. It can be made less brittle and suitable for applying to a nonrigid surface by mixing it with a roughly equal amount of gel medium or heavy gel medium. You may tint modeling paste by mixing it with acrylic color; you may also paint it once it has cured. Depending on the thickness you use, modeling paste may take as little as a day or as long as several weeks to dry.

TEXTURED GELS

These are gels with sandy or fibrous or other textures. They can be used as base coats for overpainting or you can mix paint with them.

FLOW ENHANCERS

Usable with any water-based paint, ink or dye, these products are wetting agents—they reduce the surface tension and beading of water, making it easier to paint on slick surfaces. They are called by such names as Golden Acrylic Flow Releaser and Liquitex Flow Aid.

PAINTING SURFACES

Oil paint (which is acidic) cannot be applied directly to most of the traditional supports, such as canvas, wood, hardboard or paper because the oil in the paint will damage the fibers in those supports. But acrylic paint (which is alkaline) is stable and nondestructive. There is no technical reason (although there may be aesthetic

Beware!

Manufacturers have named some products in confusing and ambiguous ways, as the examples in the table on page 80 show. Your only defense is to read the labels and literature carefully and become an informed consumer. When trying a product, especially a varnish, for the first time, *Experiment First!*

reasons) not to paint *directly on* the support. Let's look at how the most common supports for acrylic painting are used.

CANVAS

The most common canvases are cotton duck or linen, stretched and fastened to a wooden frame, as described in chapter one. Many artists use silk and fabrics made from synthetic fibers, such as nylon, acrylic and polyester. The synthetics seem to hold certain advantages over cotton and linen: they tend to be more stable under varying conditions of heat and humidity, and they are not subject to rot, as are cotton and linen. I have used polyester canvas made by Fredrix and have had no problem with it.

If you're going to stick with today's most common canvases, your choices are cotton or linen. Cotton is somewhat inferior to linen in several ways (strength, resistance to rot and humidity), but it's much cheaper than linen and will really do quite nicely.

After stretching your canvas, you may paint directly on it if you like the look and the color and the feel of the surface. Otherwise, coat the surface first with acrylic gesso (see chapter one).

HARDBOARD

A popular support for acrylic painting is hardboard, made by compacting wood fibers under heat and pressure (again, see chapter one). Most brands, such as Masonite, come in two types: tempered and untempered. Don't paint on tempered board because it contains oily substances that make the surface unreceptive to acrylic paint.

Untempered hardboard is sold in two versions: smooth on both sides or smooth on one side and textured on the other. Although you can use either side, many prefer the smooth side because they find the textured side too coarse and its texture too mechanical.

Hardboard is strong and permanent, but it has one serious drawback: In larger sizes, it's heavy—especially if you use the ¼″ variety. Add cradling and a pound of gesso and paint, and then a frame, and you'll be visiting your chiropractor for your sore back! It pays to stay with the ⅛″ thickness if you can.

PAPER

Acrylics may be painted on illustration board, watercolor paper, rice papers—any paper you choose (see discussion of papers in chapter one). You may paint directly on untreated paper or you may first coat the paper with acrylic gesso. If your intention is to paint an acrylic *watercolor*, don't use gesso. Unless applied very thinly, gesso will destroy the feel and absorbency of the paper that is so vital to painting most watercolors.

If you're painting on thin watercolor paper, follow the advice in the watercolor chapter about keeping the paper from curling and warping. If you're painting on paper mounted on cardboard, as in Shirley Porter's painting, *Silent Sentries*, you may paint directly without gesso, as she did. If you make a mistake or decide to change something, you can cover an area with either acrylic gesso or acrylic paint and rework that area.

OTHER SUPPORTS

Despite the apparent smoothness of acetate and Mylar, acrylic gesso and paint will adhere well if you use the matte versions of those plastics. Other smooth surfaces are more problematic: It's unsafe to use acrylics on shiny, nonporous surfaces such as metal and glass without first treating those surfaces to provide some "tooth." Sandpaper or sandblast these surfaces until they appear matte and wipe them clean of dust. Then you can paint directly on them or apply a coat of gesso first. In the case of Plexiglas, you'll get good adhesion even without sanding, but adhesion will be better if you sand and/or coat the surface with gel medium.

When painting in acrylics on any surface other than canvas, hardboard or paper, it's wise to test the surface before committing a painting to it. Prepare a sample of the material by sanding it and then paint the surface. Allow the paint to dry for a couple of days. Then crisscross the painted surface with razor-blade cuts. Press masking tape firmly over the paint, then slowly lift the tape. If any paint lifts off with the tape, adhesion was insufficient for permanent painting. Film adhesion and integrity can also be checked by soaking the painted surface with water and looking for any loosening.

GESSO

When most artists use the term "gesso" today, they mean *acrylic* gesso. *True* gesso is an ages-old mixture used as a ground for tempera and oil paintings—more about that in chapter seven.

Unlike true gesso, acrylic gesso is strong, flexible and not subject to cracking or shattering. Acrylic gesso is made of the same tough stuff used in acrylic paints and it's a perfect ground for acrylic as well as other paints.

Whether you're painting on canvas, hardboard, paper or whatever, you may paint directly on the support. However, many acrylic painters prefer painting on a gesso ground rather than directly on the support. The

If you're painting on canvas, work the gesso firmly into the weave by pressing with a painting knife or stiff brush. Be careful not to damage the canvas with the edge of the knife. If you want to paint on a rough surface, spread the gesso roughly to create the effect you want. Random texturing of the gesso ground can help you to achieve beautiful texture in the paint that follows.

To sand gesso, use fine sandpaper wrapped around a block of material (such as Styrofoam) that is not hard and rigid. Rigid blocks are more likely to produce "dents" or slight depressions in the gesso.

choice depends mostly on the feel of the coated versus the uncoated surface and on the color of the support. You may prefer painting on a white gessoed surface rather than the brown surface of hardboard or the tan surface of linen. If you're painting on paper, you may coat the paper with gesso if you wish, but if you're doing an acrylic *watercolor* you'll usually paint directly on the paper without gesso.

When you gesso a surface, you may use one or several coats depending on the type of surface you want. If you want a smooth painting surface, apply two or three coats of gesso, sanding with fine sandpaper after each coat has dried. To make gesso flow more freely, you may thin it up to 50 percent with a 50-50 mixture of water and either gloss or matte medium (matte is preferred). Do not thin gesso too much with water alone because that can weaken the gesso and cause cracking and poor adhesion.

TOOLS AND ACCESSORIES

BRUSHES

Natural hairs are damaged by acrylic paint, so synthetics are the better choice for acrylic painting.

Acrylic paint is much harder on brushes than are other paints, especially if you don't take care to clean your brushes thoroughly. *Never* let acrylic paint dry in a brush. If you lay a brush aside for more than a couple of minutes while painting with another brush, either clean it or put it in a container of water to keep the air from drying it out. Replace the brush water frequently. When finished for the day, clean all your brushes thoroughly. Swirl and dab them in a sink of running water or in a large container of water. Continue until the water appears clean. Use cool or slightly warm water. Hot water may damage the bristles and loosen the glue inside the ferrule (the metal sleeve that holds the bristles).

Next, work some brush cleaner (such as Loew Cornell Brush Cleaner for Acrylic Paint) deep into the bristles. You'll see evidence of paint that was hiding up high in the bristles near the ferrule. Rinse with plain water, then repeat until no more color appears. Finally, shape the bristles with your fingers and put the brush aside. All this may sound like a lot of work, but it pays off: Your brushes will last longer and remain in excellent shape for their next use.

Like many painters, I've accumulated lots of brushes, but I use only a few of them most of the time. Experience will tell you *which* brushes are right for you. For generally opaque work, I suggest the brushes in the Shopping List. For acrylic watercolors, try the same set of brushes recommended in the watercolor chapter, or better, an equivalent set that you use only for *acrylic* watercolor.

Never throw away a brush. Old or damaged ones are useful for building textures, such as grasses or foliage.

EARL GRENVILLE KILLEEN
Painting With a Sander

CHAMBERED NAUTILUS
Earl Grenville Killeen
Acrylic on linen
41″ × 50″

Killeen's approach to acrylic painting is, to say the least, unconventional. He loads on the paint, sands it like crazy, paints some more and sands some more. As he exposes portions of lower layers with his flat power sander, he begins to draw out of the picture all kinds of exciting and often unpredictable textures. He makes those textures an integral part of his painting. He uses several layers of paint, mixed with various acrylic mediums, and uses his fingers and palms, in addition to painting knives and brushes, to work the paint around.

This painting was done on portrait linen (a fine-textured linen) glued to a sheet of material ¾″ thick called MDO (medium density overlay) available at lumber yards. Even in large sizes such as used here, MDO has little tendency to warp. Killeen has his panels prepared by a framer, who has the expensive heat-seal equipment needed for what follows. The framer first covers both sides of the MDO with acid-free paper, using Fusion 4000 as an adhesive. Fusion 4000 is a plastic heat seal applied by using a large vacuum press. Then he glues the linen to the front surface, again using Fusion 4000. He wraps the linen neatly around to the back and staples it in place. He doesn't frame the finished painting.

KNIVES

There are two types of knives: palette knives and painting knives. A *palette* knife is long and flexible and is generally used for mixing large gobs of paint and for scraping paint from the palette or painting surface. Buy one with an offset handle to keep your knuckles out of the paint.

A *painting* knife is shorter, flexible and comes in a variety of shapes, most of them trowel-like. They're used for mixing paints and for actually applying paint, either alone or in conjunction with brushes. You can get by nicely with two painting knives and one palette knife, unless, of course, you're primarily a knife-painter. In that case you may use a dozen or so knives of different sizes and shapes—some metal, some plastic—and few brushes.

PALETTES

Choose a palette with a hard, smooth surface that can be easily cleaned. Some painters use a sheet of glass with a piece of white or colored paper or cardboard underneath—tempered glass would be best, to avoid breakage. Cover any sharp edges with tape.

My own palette is a white-enameled 11″×15″ "butcher's tray." It's sturdy and easy to scrape and wash clean. If you like to *hold* your palette rather than place it alongside you on a table, you'll need something lighter with a hole or handle for gripping. There are a couple of types of *disposable* palettes made for holding—some

made of paper, some made of fiberboard. There are also permanent palettes you hold that are made of wood or plastics, such as Plexiglas.

An arrangement a lot of acrylic painters use is this: Place several layers of wet (damp, but not soaked) paper towels in a tray, such as your plastic watercolor palette or a butcher's tray. Place one or two sheets of paper from a pad of paper palettes on top, and squeeze your paints onto those. The water from the paper towels underneath keeps everything moist for a long while. Two commercial versions of this idea use a large, thin sponge in place of the towels: Daler-Rowney's Stay-Wet palette and the Masterson Sta-Wet palette.

Whatever palette you choose, you can save paint overnight by spraying it lightly with water and covering it with plastic kitchen wrap. Press the wrap lightly down *into* the paint—the idea is to prevent air from coming into contact with the paint.

MISCELLANEOUS
Easels

Your choice of easel depends on whether you're painting opaquely or in watercolor fashion, and on whether you prefer to sit or stand. See chapter one for a discussion about choosing an easel.

Water Containers

Fill two containers, around quart-size, with water from the cold-water faucet. Plastic food storage containers are perfect. Swirl your brush around in the first container to get off most of the paint and then in the second container to finish the job. The aim is to keep the second container clear so that you can also use that water when thinning your paints. If that doesn't work, use a third, smaller, container for *really* clean water!

Sprayer

Convert a window-cleaner spray bottle to a water sprayer. Use it to dampen the paint on your palette every

An enameled butcher's tray makes a good palette. Cover it snugly with plastic wrap to preserve paints overnight. To clean, scrape off heavy paint, then soak in water and rub clean with a sponge or paper towel.

You can buy inexpensive spray bottles or wash out an empty spray bottle of glass cleaner.

Choose a couple of sponges with different shapes and textures for cleaning up and for texturing.

few minutes to keep it from drying out. Use it also to wet an area of your painting to keep the paint there workable and to dampen a dry area of your painting to lessen the drag on your brush as you apply more paint to that area.

Sponges

An ordinary kitchen sponge is handy for mopping up messes. A couple of natural sponges are excellent for texturing, especially if your paintings are landscapes and you do grasses, trees, rocks, and so on. *Don't* let acrylic paint dry in them!

Scrapers

In addition to painting and palette knives, other scrapers are useful—plastic kitchen bowl-scrapers, single-edged razor blades, special brushes that come with sharply tapered ends on their handles, plastic credit cards.

Masking

Use either liquid friskets (such as Maskoid or Miskit) or drafting tape to cover parts of your painting. Use the tape also to mark off the edges of your image area so that when you're finished painting you can remove the

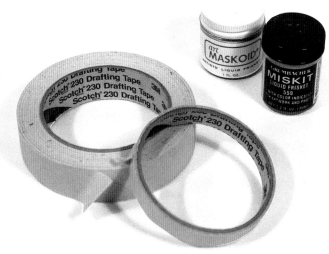

Use masking fluid or drafting tape to cover parts of your painting or to create clean edges.

tape and be left with a clean edge. Use *drafting* tape rather than *masking* tape, because it's less likely to peel the paper when you remove it.

Brush Rest

If more than a few minutes pass before you pick up and use a brush again, either rest the brush head in water or clean it. Don't let paint dry in the brush. But if you're using several paint-filled brushes and rapidly switching from one to another, then buy or make a simple gadget like this to keep your brushes from sticking to your taboret or table. Handy for any medium, this is especially helpful in acrylics because the paint begins to dry and get sticky quickly.

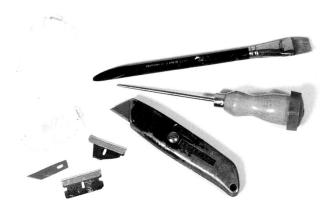

A variety of scrapers can be used to expose lower layers of paint or create texture.

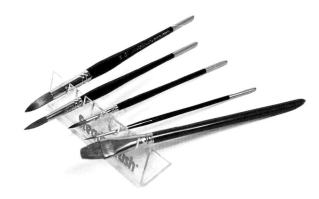

A brush rest keeps brushes separate from one another and helps keep handles clean.

ACRYLIC SHOPPING LIST

BASICS	✓
PAINTS: 2-OUNCE TUBES OF:	
Titanium White	
Ultramarine Blue	
Phthalocyanine Blue	
Cobalt Blue	
Phthalocyanine Green	
Deep Brilliant Red	
Cadmium Red Medium	
Cadmium Orange	
Cadmium Yellow Light	
Yellow Oxide	
Raw Sienna	
Raw Umber	
Burnt Sienna	
Burnt Umber	
GLOSS MEDIUM: 8-OUNCE JAR	
THICK WATERCOLOR BOARD, 20″ × 30″	
BRUSHES (synthetic)	
2″ flat (used only for gessoing)	
2″ flat (for painting)	
1″ flat	
½″ flat	
¼″ flat	
no. 20 round	
no. 10 round	
no. 1 round	
PAINTING KNIFE: 2″ BLADE	

	✓
GESSO: SMALL JAR	
BUTCHER'S TRAY PALETTE: 11″ × 15″	
WATER CONTAINERS, TWO OR THREE	
SPRAYER	
PENCIL OR CHARCOAL	
KNEADABLE ERASER	

OPTIONAL	✓
MATTE MEDIUM: 8-OUNCE JAR	
GEL MEDIUM: TUBE	
RETARDER: TUBE	
SOLUVAR VARNISH	
ADDITIONAL PAINTING KNIVES	
SPONGES: KITCHEN AND NATURAL	
DRAFTING TAPE	
MASKING FLUID	
SCRAPERS	
BRUSH REST	

GETTING STARTED

Take a hundred painters in acrylic, and you'll find a hundred different approaches to using this versatile medium. This section is intended to get you off the ground by showing you some of the basic acrylic painting techniques. After that, you can read in-depth treatments of the medium and, more important, do your own exploring. Except where noted, the following assumes you are doing an opaque acrylic painting, not an acrylic watercolor.

DRAWING

You may draw on your painting surface using pencil, dilute acrylic or any medium that is not oily. If you like working with only a loose drawing, that's fine because acrylic paint's covering power and fast drying allow you many changes of mind. Except in pictures that involve some fussy architecture or a complex still life, I often draw only a few basic lines using a pointed brush and diluted paint. If I'm dealing in realism, I generally also draw a light line defining the eye level so that I can relate all perspective lines properly (see *Perspective Without Pain*, North Light Books).

YOUR PAINTING SURFACE

Whether you're painting on canvas, hardboard, paper, or other support, you may choose the degree of smoothness of your surface. If you want a smooth surface, apply one or more coats of acrylic gesso and sand each coat to the smoothness you like. If you prefer a rough surface, lay on a coat of gesso and, while wet, roughen it with brushes, painting knives, sponges or whatever else gives you a satisfactory result.

Main masses sketched in using diluted paint.

Rough approximate colors laid in. There are many variations. You may, for example, lay in colors complementary to what your final colors will be.

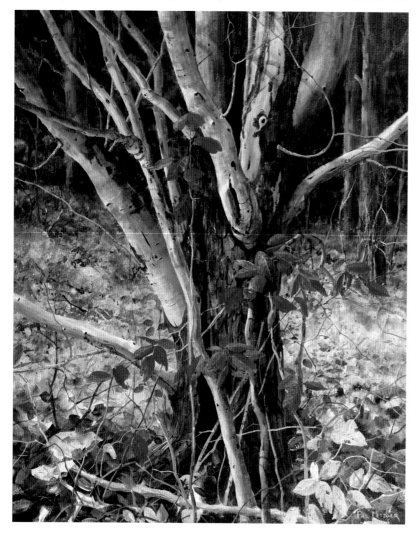

This is the base of a scraggly red maple at the edge of some woods. What attracted me as much as anything were the bright red and yellow leaves on some vines and brush surrounding the tree. Early in this painting I laid in the darks and painted light branches and leaves and twigs over the darks.

RED MAPLE
Phil Metzger
Acrylic on canvas
30″ × 24″

LAY-IN

Again you have a choice—whether to lay in all the areas of the painting in approximate colors and values, or go directly to painting. You can do a rapid lay-in with colors diluted with water or medium. Another option is to paint your entire surface with any tone you wish, rather than work against a white surface.

LIGHT-TO-DARK OR DARK-TO-LIGHT?

In acrylic, it doesn't matter which direction you choose, since any color can be covered by any other color (although it may take considerable thickness of paint to cover in some instances). You may choose one approach in one painting and a different approach the next time. Sometimes I like to establish large areas of middle-value paint first, and then work in both directions (toward the lights and toward the darks) from there. Often (as in *Red Maple*) I can't resist putting down the darkest darks first, because I love strong value contrasts.

If you're painting a realistic scene, as opposed to an abstract or nonobjective work, it's often easier to start with the most distant areas in the scene and work your way forward. If there's a sky in the picture, for example, it's the most distant part of the scene and it's easy to paint it first and then overlay it with the next closer area (some mountains, say) and then to overlay that area

Painting from rear to front in a realistic scene is a natural progression. The sky is overlapped by the mountains which are overlapped by the hills which are overlapped by the barn which is overlapped by the tree. It's easier to paint objects on top of one another than it is to paint around them, but be careful not to leave noticeable ridges of paint that will show through later layers.

with something closer (maybe some trees)—and so on, until you've painted right up to your feet.

SURFACE CHARACTER

How do you want your painting's surface to look? Smooth and blended? Rough? Quiet? Active? The character of your brush strokes or knife strokes will do a lot to determine that look. In acrylic you may pile on the paint and let the brush and knife leave their marks—or you may smooth the paint to get rid of the marks. That's up to you. If you want to smooth your strokes, you'll find that easier if you mix plenty of medium with your paint—either gloss or matte or gel. You'll get a little more working (and smoothing or blending) time if you use plenty of gel. You can also help keep your paint from drying too fast by periodically spraying it with a little water from your spray bottle. Be careful not to spray so hard that you puddle the paint.

BLENDING

As mentioned above, you can keep your paint from drying too fast by adding gel or heavy gel medium to it and by gently misting it with water from your spray bottle. You can also use retarder medium, provided you like the feel of the paint with retarder added. Be careful not to add more retarder than the manufacturer advises.

No matter what you do, acrylic paint will probably dry faster than you sometimes want (and if you're painting under a hot sun, forget it!). There are some techniques you can adopt to help blend the paint and get the appearance of soft edges: (1) Work on a small area at a time. (2) Use small, overlapping strokes between adjacent areas of paint. For example, if you're painting blue sky adjacent to white clouds and you don't want too hard an edge, paint tiny strokes of blue across into the white and tiny strokes of white across into the blue. (3) Stipple the paint. Use a blunted round brush or a worn bristle brush to "stab" at the painting, depositing many tiny dots of paint with each stab. Dip the stippling brush into first one color, then another. Using this method (and exercising some patience) you can create, for example, beautiful, soft, sky-and-cloud effects. To keep the stippled paint from forming a rough, pimply surface, use paint with lots of gloss medium in it.

GLAZING

Glazing can be a time-consuming chore in oils, but not in acrylics. As soon as the surface you want to glaze is dry, brush (or pour or spray) thinned paint over the area. Thin the paint with medium, gloss or matte. How much to thin it depends on the effect you're after, of

Stippling is a good way to get blended, soft-edged effects. Use stiff, worn brushes to stab paint onto the surface, first one color, then another until you get the blend you want.

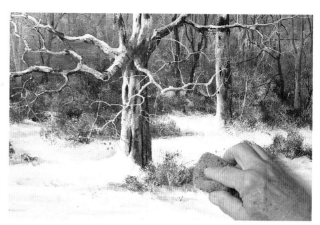

Use a natural sponge to dab paint on. First spread the color(s) you want fairly thinly on your palette so you don't pick up too thick a glob when you dip the sponge into it. Experiment with sponges of differing textures.

course. Err on the side of too much thinning, because you can always add more layers until you get the result you want. A glaze will dry in a short time, usually a few minutes, and then you can immediately glaze again.

TEXTURING

You can create texture in many ways, including dabbing with sponges or wadded paper, using worn, rough brushes, spattering, scraping and sanding.

Glazing Phthalo Blue over Cadmium Yellow. Be sure the surface is absolutely dry before applying a glaze, otherwise you may get an ugly smear. If you want a smooth glaze, use a wide brush and work quickly.

"TEMPERA" TECHNIQUE

In the discussion of egg tempera painting in chapter seven, we see a traditional painting style that involves the methodical laying down of thousands of tiny paint strokes, often in a crosshatched manner. The painting is slowly built up in layers of translucent paint that take on a satisfying "glow."

You can get similar results in acrylic. You begin with a smooth gesso ground on any support (usually hardboard or a mounted paper). In this case you would use *acrylic* gesso rather than true gesso. Using fairly fluid paint (tube paint mixed with a little water and gloss medium), and small, pointed brushes, work a small area

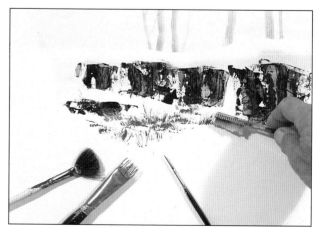

A worn paint brush, a fan-shaped blender, a rigger or a toothbrush can deliver a variety of textures (a) by stroking, (b) by stabbing. I have a couple of old bristle brushes from which I've cut out many bristles to give a comblike effect, useful in painting such things as grasses. Even an old pocket-comb can be used in this way by dragging it through wet paint.

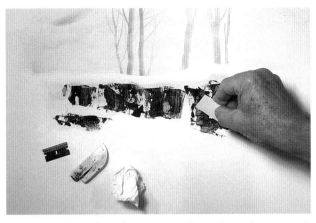

Suggest rock surfaces by scraping through thick paint. Additional texture can be created by dabbing at wet paint with wadded tissue.

at a time and paint short strokes side-by-side or cross-hatched, whichever suits you. Brushes should be in the no. 1 and smaller range.

If you prefer not to work on a white surface, you may, of course, first lay in some approximate tones, using diluted paint. Take care not to underpaint so heavily that you destroy the effect of the light ground showing through your later delicate paint layers.

ACRYLIC UNDERPAINTING FOR OTHER MEDIA

Centuries ago, tempera was often used as an underpainting for oils. Many artists today use acrylic to do an underpainting for some other medium. Pastel painters sometimes develop their paintings first in acrylic and then layer pastel over the acrylic. Oil painters often do the same. Note that it's safe to paint oil over acrylic, but not acrylic over oil—oil will adhere to the dry, porous acrylic surface, but acrylic will not adhere to an oily surface, even one that seems "dry."

Most often, underpaintings are used to establish general colors and values, so they are generally painted thinly. If you paint thickly, of course, the texture of the underpainting will greatly affect your finished painting. If you're finishing up with pastel, you'll probably want to avoid losing the texture and "grip" of your painting surface by using too thick an underpainting.

NOTE: If you're using acrylic as an underpainting for oil or alkyd, it's best to keep the acrylic thin. The thicker the acrylic, and the glossier its surface, the poorer the adhesion will be between the oil and the acrylic.

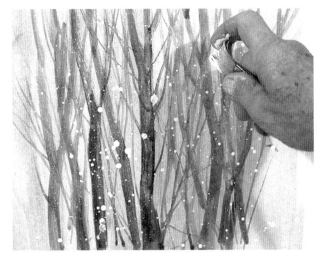

As in other media, you can get random textures by spattering paint in a variety of ways: by riffling the bristles of a paint-laden toothbrush or bristle brush; by snapping your wrist and flicking paint from a brush; by tapping a paint-filled brush gently against your finger; and even by dipping your fingers in paint and flinging it at your painting.

ACRYLIC WATERCOLORS

Acrylic paint, appropriately thinned with water, may be used exactly the same as traditional watercolors, with one exception. Acrylic paint dries waterproof, so you can't easily "lift" or scrub out passages as you might with watercolor. Provided you're using a good, tough paper that won't easily shred, you can scrub out *very thin* washes, but that's all.

You can gesso over a section of an acrylic watercolor and attempt corrections, but you'll find the gessoed area looks and feels different from the virgin paper, and the result may not be satisfactory. You may also try a correction by sandpapering an area and repainting, but again, the results may not be acceptable.

Society Notes

Joseph Orr, whose work appears in this chapter, was a founding member of:

National Oil & Acrylic Painters' Society
PO Box 676
Osage Beach, MO 65065

PHIL METZGER
Acrylic, Thin and Thick

WINTER
Phil Metzger
Liquitex acrylic on stretched cotton canvas
36″ × 48″

For a canvas this size, I use heavy-duty 4″ stretcher strips to avoid warping. The canvas was factory-gessoed. Because I wanted the whites to be cool and bright, I added a coat of Titanium White to cover the warmer and duller gesso. I made a fairly detailed drawing on newsprint. Using a sheet of graphite transfer paper, I transferred only the main shapes to the white canvas.

I wet the entire background with water and floated in the blurry woods shapes in watercolor-fashion. I laid in the distant tree shapes with paint diluted with gloss medium and water. Next I roughly laid in the larger trees, using a watery Burnt Sienna-Ultramarine Blue mix. With major shapes now placed, I concentrated on the big barn. I roughed in all the nonwhite area, still in watercolor fashion, and then concentrated on painting the details. I did all of the painting from this point on—trees and barn—in opaque acrylic, mostly Burnt Sienna, Ultramarine Blue, Cobalt Blue, Deep Brilliant Red, Yellow Oxide and Raw Umber. I made corrections by painting out several small areas with Titanium White.

This is one of a series of paintings in which I leave whites flat, unmodeled—just because I like the effect—and in which I draw some objects with ink and leave them unpainted. I draw most of the inklines about midway through the painting.

DEMONSTRATION

Painting Boldly in Acrylics
by William Hook

(The photographs in this demonstration originally appeared in *Acrylics Masterclass*, by Sally Bulgin, London: HarperCollins 1994.)

This is William Hook's painting setup. His palette, a butcher's tray, hooks onto the shelf of a sturdy easel. At the right is a TV cart for his paints, brushes and so on, and behind that is a slide viewer he uses while composing his images. He does not project an image onto his canvas, but uses the slides for reference while he draws.

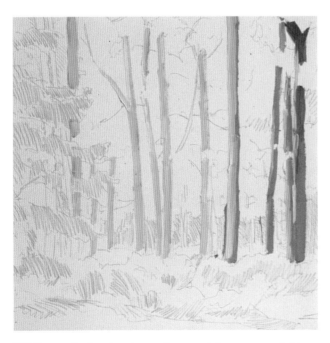

1 *Hook sketches basic shapes with a water-soluble pastel pencil and then begins painting by blocking in some of the tree trunks.*

2 *Here he adds contrasting colors to the aspen tree trunks and then frames them with an L-shaped dark passage, the dark evergreen and the foreground green. He uses thick, buttery strokes of paint that won't dry as fast as thinner strokes would and this gives him some time to blend paint. The bold, thick strokes are in keeping with the painterly effect he likes his work to have. Hook avoids using small brushes (and doesn't use rounds at all) to keep from becoming too fussy with the painting's details. He prefers synthetic brushes, both flats and brights.*

3 *Hook adds the darks of distant evergreens behind the aspens, and these darks begin to give form to the aspens—an example of negative painting. Then he begins laying in the aspen foliage in broad passages, working from darks to lights. The darker yellow-greens are a mixture of Yellow Oxide, Permanent Green Light, and Medium Magenta. The lighter yellows are Yellow Oxide mixed with Cadmium Orange.*

4 *He paints the intense blue of the upper sky areas. The strong contrast between the blue of the sky and the yellows of the backlit leaves establishes the mood of this bright, humid day.*

5 *Across the broader strokes of the aspen foliage, Hook paints a contrasting network of branches and twigs. He repeats some of the blue of the sky (but a less intense blue) lower in the picture. These blue patches keep the blue at the top of the picture from seeming too isolated; they also help to define the aspen shapes.*

For more visual interest he builds up a fairly heavy impasto in areas such as the left-hand tree and the darker aspen foliage and trunks—this impasto makes a nice contrast with the smoother sunlit yellow leaves. Finally, he adds brighter, broken greens to break up the dark mass of the foreground and to help balance the brightness of the blue sky at the top of the painting.

FOREST SCENE
William Hook
Acrylic on canvas
40" × 36"

Pastel and Oil Pastel

The light gray paper Campbell is using has a sanded coating with a lot of tooth, so instead of using his softest pastels, such as Sennelier, which will quickly fill the surface, he chooses the slightly harder Grumbacher, Holbein and Yarka pastels. He lays in base color for each object and then paints, and essentially finishes, the cactus blooms. Finally, he paints the leaves, logs and background, ignoring their true "local" colors and choosing instead colors and values that work well with the blooms.

ACCENTS IN ORANGE
Hugh Campbell
Pastel on Sabretooth paper
10½" × 11½"

WHAT IS PASTEL?

Pastel is a combination of *chalk*, *pigment* and a *binder*, such as gum tragacanth (tra' jeh kanth), obtained from various plants. The ingredients are mixed, formed into rectangular or cylindrical sticks under pressure, and allowed to dry. The harder pastels contain higher proportions of binder. The binder holds the particles of pigment together, but it does little to attach the pastel pigment to the support. Mostly, the pastel is trapped by the texture of the support.

Pastel goes on dry and stays dry, so there is none of the color or value change that many fluid paints exhibit as they dry. The way the stroke looks when you first put it down is the way it will remain. You may place layer over layer to build up the effect you want, but there is a limit to how much pastel can be "held" by the surface you're painting on. It's common to use four or five layers of pastel; seven or eight layers seems to be the limit for most pictures. You may intermix brands of pastels with no problems.

TYPES OF PASTEL

Pastels come in three forms: hard pastel, soft pastel and pastel pencils. We'll look at *oil* pastels, a wholly different breed, in a later section.

Hard pastels are usually sold as tough rectangular sticks, while the much more fragile *soft* pastels are either cylindrical or rectangular and are usually wrapped in a paper sleeve to protect them from breakage. Pastel *pencils* are hard pastels encased in wood, resembling colored pencils. All three types of pastels can be bought either in sets or in individual pieces. Many painters begin with small sets of hard, soft and pencil pastels, and then add individual pieces as they gain familiarity with the medium.

You'll find great differences in softness/hardness from one brand to another, partly because of the amounts of binder used. Even *within* a given brand, there are differences in the "feel" of the pastel stick from one color to another. After a time, you may well select colors from a variety of brands—a common practice.

COLOR RANGE AND PERMANENCE

Each manufacturer has a chart describing its pastel colors and their permanence. If you can't find such a chart for the colors you decide to use, write to the manufacturer. As an example, Sennelier prints a chart that shows color swatches for all its pastel sticks and a chart telling you how each is rated for permanence: ★★★ very good light resistance; ★★ good light resistance; ★ adequate light resistance. I would ignore one-star colors for permanent work.

If you're painting in oil or watercolor, you'll find a hundred or so colors available. In pastel, there are many more. Sennelier, for example, lists 525 soft pastel colors! The reason is this: In other media, you expect to *mix* the different tints, or shades, of color you want—by mixing in some white paint, for example, or by diluting a paint with water or some other medium. While you can do that in pastel, too, by adding strokes of white or black or other colors, it's not necessary because the manufacturers have prepared shades of colors *for* you. Again using Sennelier as an example, Ultramarine Blue is listed in *eight* shades, Raw Sienna is listed in *six* shades, and so on.

If you're rich or crazy or both, buy all 525 colors. But, cost aside, you can imagine the difficulty trying to paint with so many colors spread before you. A sensible way to begin is to select a set of, say, two or three dozen sticks. Use them, learn their characteristics, and then add other colors gradually. Or, instead of buying individual sticks, buy a small boxed set of soft pastels and one of hard pastels, along with a few pastel pencils.

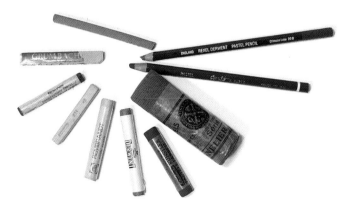

Several manufacturers offer various sizes of soft pastels, hard pastels and pastel pencils.

PASTEL BRANDS	SOFT/HARD
STICKS	
Sennelier	soft
Schmincke	soft
Rembrandt	soft
Rowney	soft
Grumbacher	soft
Holbein	medium soft
Derwent	medium soft
Conté	hard
Nupastel	very hard
PENCILS	
Conté	medium hard
Derwent	hard

This is a rough guide to some popular brands, but I must caution: There are significant differences among colors for any given brand. You'll find information on making your own pastels in Carole Katchen's Creative Painting with Pastel *and Ralph Mayer's* The Artist's Handbook of Materials and Techniques—*see Bibliography.*

MEDIUMS

Most painters do not use any sort of medium with their pastels—which is one of the delights of this form of painting. There are, however, a couple of uses of fluids that might loosely be called mediums.

Water, Turpentine

Some painters brush on water or turpentine (or other thinner) to smear an area of pastel, often so that the smeared area, when dried, can serve as an underpainting for subsequent dry pastel.

Fixative

Many painters spray a light film of fixative over a painting to anchor the powdery pastel in place before applying more. Some spray the finished picture with fixative to keep the pastel from flaking off during framing or shipping. Many artists prefer *never* to use fixative because it can darken a painting's colors.

PASTEL SCORECARD

CATEGORY	PRO	CON
colors available	very wide range	relatively few deep darks
color compatibility	excellent; intermix freely	
film strength		fragile; no true film is formed
drying time	zero	
resistance to damage		flakes off the support; must be handled carefully
yellowing	none; excellent color stability	
adhesion	fair to good on textured grounds	poor on smooth grounds
health risks		pastel dust and fixative must not be inhaled or ingested

You can buy fixative in spray cans in matte and gloss varieties. If used at all, it should be sprayed on sparingly because of its color-darkening tendencies. Too heavy an application can ruin your picture. Spray some practice sheets first so you know what to expect. Prop the picture at an angle against a wall (surrounded by newspapers to keep the stuff from getting on floors or furniture). Hold the can *at least* a foot away from the picture and move it uniformly, depositing a light film evenly over the surface. If you hold the can too close to the picture, the force of the spray can easily blow loose pastel dust off the surface of the picture. Don't hold the can directly *over* the picture—if you do, drops that form around the nozzle may fall onto your painting and leave ugly blotches.

Fixative cans are plastered with warning labels—*pay attention!* This is foul stuff. It's toxic if inhaled, flammable, and some brands are strong-smelling (two nonsmelly brands are Rowney Perfix and Blair No Odor Spray Fix—but just because they don't smell bad does not mean they're not toxic). Try to do your spraying outdoors. Keep away from pets, and don't smoke while spraying.

AL LACHMAN
Busting Loose With Color

RISING TO A NEW DAY
Al Lachman
Pastel with acrylic on mat board
16″ × 18″

For this painting Lachman uses an acid-free mat board he has coated on both sides with a combination of acrylic gesso, pumice and gray acrylic color. The gray allows him to begin work on a middle-value ground. He applies the mixture unevenly with a variety of water-soaked sponges to get a randomly textured surface.

Lachman enjoys building up texture, and likes the energy a picture has when darker layers show through lighter ones. He begins the painting with fairly transparent layers of acrylic to establish colors and values. Some areas, such as the orange field rows, require several overlaying washes to enhance the color intensity. When the underpainting is dry, Lachman begins applying pastel, starting with hard Nupastel and gradually switching to softer pastels, including Sennelier and Schmincke, for more texture and more intense colors. His final touches are made with his own extremely soft handmade sticks, whose colors are especially vibrant. Because of the dulling effect of fixatives, Lachman chooses not to use them.

PAINTING SURFACES

Although pastel can be painted on any surface that will hold the pastel, most are done on paper or board (mounted paper); some are painted on cloth. Aside from permanence (which you want in *any* support, regardless of medium), all that's really required is that the support have sufficient texture to hold the pastel.

PASTEL PAPER

Paper for pastel painting needs "tooth" for holding the pastel. The more tooth, the more layers of pastel the paper can hold. Papers are made in a variety of colors besides white: ivory, buff, gray, blue, green, violet and so on. Your choice of paper color is as important in pastel as is an underpainting in other mediums. There are plenty of pastel papers from which to choose, and you should try as many as possible over time. Those shown in the table below are acid-free.

WATERCOLOR PAPER

Any watercolor paper may be used for pastel, but cold-press and rough surfaces work best. Hot-press surfaces

Some of the colors available in Canson Mi-Teintes and Sennelier La Carte pastel papers.

will not grip much pastel. If you like to underpaint your pastel using watercolor or fluid acrylic paint, watercolor paper is a good choice—not all *pastel* papers are suitable for water-based underpainting, because the water can cause too much wrinkling.

CHARCOAL PAPER

Any paper suitable for charcoal may also be used for pastel. Some charcoal papers (see chapter eight), as well as some less expensive pastel papers, are lightweight, making them more fragile and less able to take the abuse

SOME POPULAR ACID-FREE PASTEL PAPERS

BRAND	TYPE	WEIGHT (gm/m²)	TYPICAL SIZES	HANDMADE?
Canson Mi-Teintes	pad	160	9″×12″ 12″×18″	no
Canson Mi-Teintes	single sheet	160	19½″×25½″	no
Canson Mi-Teintes	single sheet	160	29½″×43¼″	no
Canson Mi-Teintes	roll	160	59″×11 yd	no
Fabriano Roma	single sheet	130	19″×26″	yes
Fabriano Ingres	single sheet	160	19½″×27½″	no
Holbein Sabretooth	single sheet	approx 160	18″×24″ 24″×36″	no
Larroque Bergerac	single sheet	250	20″×26″	yes
Sennelier La Carte	single stiff sheet	200	9¾″×12¾″ 19½″×25½″	no
Strathmore Mil-Tinte	single sheet	160	19½″×25½″	no

Each of these papers comes in colors in addition to white. All except Sabretooth have some rag content.

that heavier papers allow. Charcoal papers are also often less textured and therefore hold less pastel.

SANDED PAPERS

These are papers coated with a fine abrasive (similar to hardware-store sandpaper). They hold a lot of pastel. Although many of those available are not acid-free, they are popular among pastel painters. The Sennelier brand is available in a number of sizes, including 21″ × 29½″ sheets and a large roll, all light beige colored. You can make your own acid-free sanded pastel surface, as described in the sidebar.

Another surface you can prepare yourself is a variation on the recipe shown in the sidebar: Replace the acrylic gel medium with acrylic gesso. Brush the mixture generously over the board's surface in as rough a manner as you wish—use a painting knife (or sponges, as Al Lachman does) to smear and roughen the mixture even more. Instead of a "normal," uniform pastel painting surface, you have a randomly textured surface that reacts with your chalks in new and exciting ways.

PRINTMAKING PAPERS

Don't overlook the possibilities of paper not listed as a "pastel" paper. The catalogs and art stores are full of "printmaking papers," many of which are beautifully suited for pastel. The best way to pick some papers to try is to look at them in a store and feel their textures. Many are acid-free, some are tinted. Weights range from about 120 to 360 gm/m². (An example is Fabriano's Murillo, an acid-free 190 gm/m² paper that comes in over a dozen colored, textured surfaces.) One drawback: If you plan to underpaint with watercolor or acrylic, not all papers will resist buckling adequately.

FABRICS

You can apply pastel to fabrics, such as canvas. Some painters stretch the fabric on regular canvas stretcher strips—if you do this, be careful not to whack the taut fabric and dislodge the pastel. Others mount the fabric to a backing, such as hardboard or stiff cardboard, using acrylic gel medium as an adhesive. You can either paint directly on the fabric or first coat it with acrylic gesso. If you plan to do an oil underpainting, be sure to gesso first, as oil paint may damage the fabric.

Making Your Own Sanded Board

1. Start with stiff acid-free board, such as museum board or illustration or watercolor board (you can even use hardboard, but it's heavy and acidic).

2. Brush water generously onto the back of the board. This is to counteract the warping that will occur when you next wet the front of the board.

3. Brush water over the front of the board, again generously. While very wet, brush on (using a synthetic paint-store brush at least 2″ wide) a smooth coating of grit mixture. The grit mixture should be approximately:

4 parts (by volume) acrylic gel medium

2 parts grit (e.g., 200-mesh flint, marble dust, pumice or carborundum, available through art supply stores and catalogs, and at some hardware stores)

1 part water (adjust this amount for good brushability)

4. Let dry. Repeat steps 2 and 3 until you're satisfied with your surface. If the dried, finished board is not flat, lay it bellied-side down, on a clean surface and paint the concave upper surface with water. Place heavy weights around the edges to flatten the board and let it dry thoroughly. If any bulging remains, repeat, using less water.

TOOLS AND ACCESSORIES

With the exception of a vacuum cleaner, pastel tools and accessories are simple and inexpensive.

DRAWING BOARD, TAPE, TACKS

Your pastel paper must be fastened to some rigid surface—many people use a wooden drawing board to which the paper can be taped or tacked. Some use a softer board, such as Homosote (available at lumber

yards and home centers)—it's soft enough to make tack insertion and removal easy. Hardboard will also work, if you fasten your papers with tape, not tacks. Lighter materials, such as foamboard, may shift annoyingly as you stab at your picture with pastel sticks.

Use either drafting tape (less adhesive than masking tape) or tacks to hold your paper to the board. Fasten all the way around the paper's edges, so it will lie perfectly flat and cannot shift. When you remove tape, pull it slowly, gently *away* from the picture to avoid tearing the picture surface.

BRUSHES

Yes, there is a place for a couple of brushes in pastel work! One of the most effective ways of "erasing" an area is to loosen the pastel with a stiff brush, such as a bristle brush, and then vacuum away the dust. Unless you've used fixative, you can usually get right down to the paper this way. Goat hair watercolor mops are great for blending, and so are makeup brushes. Another use for brushes is to moisten an area with water or some other solvent to "melt" some pastel (see section on underpainting).

WIPING CLOTH, TOWELS

A soft cloth can be used to wipe out a passage of pastel. Many artists use chamois, but T-shirt cotton works well and is more animal-friendly. Paper towels or rags should be on hand for cleaning hands, floors, easels, ears and noses. Pastel dust ends up everywhere!

SANDPAPER, PENCIL SHARPENER

Tape a piece of fine or medium-fine sandpaper alongside your picture so it's handy when you need to sharpen a stick or a pencil. Another handy sharpener is a piece of wire screen or sandpaper jammed into a paper cup—rub pastel sticks against the screen or sandpaper to sharpen them, and let the dust fall into the paper cup. If you use pastel pencils, you'll need a sharpener. You can use a knife or razor blade, but a regular pencil sharpener is faster and easier. Look for a sharpener that will accept the fat bodies that some pastel pencils have, and be sure to get one that works smoothly so that it doesn't continually break the fragile pastel "lead."

STUMPS, TORTILLONS, ERASERS

A stump (also called stomp) is a tightly wound cylinder of paper, pointed at both ends, used for smoothing and blending pastel and charcoal. A tortillon (also called

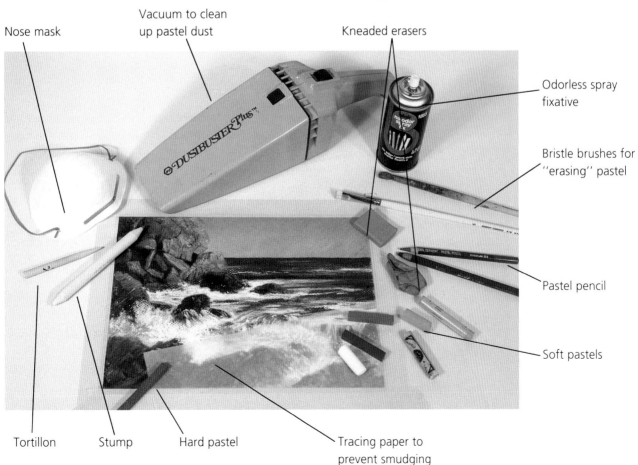

Nose mask

Vacuum to clean up pastel dust

Kneaded erasers

Odorless spray fixative

Bristle brushes for "erasing" pastel

Pastel pencil

Soft pastels

Tortillon Stump Hard pastel

Tracing paper to prevent smudging

tortillion) is similar, but is pointed at only one end and the point is usually sharper than the points of a stump. For "erasing" pastel, dab (don't rub) with a kneaded eraser. Shape the eraser into an edge or point to lift out highlights.

VACUUM CLEANER, MASKS

Do all you can to keep pastel dust from fouling your environment, especially the air you breathe. Like a coal miner, guard against having your lungs coated with health-threatening dust. Some people who work full-time with pastels install elaborate filtering systems in their studios. The least you should do is keep some sort of vacuum cleaner handy. You can install one with a flexible hose and position the hose nozzle at the bottom of your easel where, running continuously, the vacuum will suck up falling particles. This works best if the machine is in a separate room, with only the hose snaking into your work area, so you don't have to endure the constant whine of the motor. I don't work in pastels on a regular basis, so I make do with a portable Dustbuster hand vacuum.

Another way to keep from inhaling pastel dust is to wear a nose-and-mouth mask, available where drugs, house paint or art supplies are sold. They're simple paper filters that fasten around your head with a rubber band. They're effective, but they take some getting used to. As another precaution, some painters wear latex gloves to keep pastel dust off their skin.

Finally, you can wear a respirator, available in art supply stores and catalogs, to thoroughly filter the air you breathe as you work. Contact Center for Safety in the Arts/NYFA in New York City (155 Avenue of the Americas, New York, NY 10013) for information on the proper dust masks and ventilation.

EASEL

Any easel will do, provided there is a means of fastening your board and picture in such a way that the top edge is tilted toward you. The tilt ensures that, rather than sift down onto the picture, falling pastel dust will drop

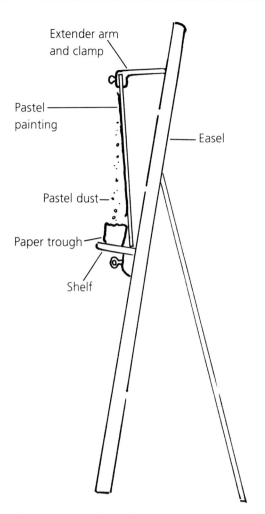

Using an easel that allows the top edge of the painting to tilt toward you is best for pastel work.

to the floor or into the easel's tray. (Make a trough out of newspaper for easy cleanup and disposal.) You can also work on a horizontal or slightly tilted surface, but keep your vacuum handy to suck up loose pastel dust that can't fall away from the picture's surface.

CARRYING CASE

For working on location you need some sort of case with plenty of compartments for storing sticks of pastel. Artbin pastel boxes hold from a couple of dozen to over a hundred pastel sticks, and they're lightweight. They come with latches and a carrying handle. Other boxes, made of wood and intended for studio storage, can be converted for outdoor use by adding carrying straps or handles. If you buy a box with compartments for individual sticks, make sure the brand of stick you use will fit the compartments. Some pastels, such as Schmincke, are fatter than others. Be sure the box you use has a good latch, to avoid the disaster of spilling all your pastels on the ground.

Health Tip

If you're working indoors, don't blow the dust from your pastel. It's an easy habit to fall into, but it's dangerous to your health. Each time you blow, you fill the surrounding air with pastel particles eager to settle in your lungs.

PASTEL SHOPPING LIST

BASICS	✓
SOFT PASTELS boxed set of 25-30 soft pastels	
HARD PASTELS boxed set of 24 color sticks	
PASTEL PENCILS boxed set of 12 pastel pencils	
PAPER 18″ × 24″ sheets sanded paper 12″ × 18″ pad colored pastel paper	
DRAWING BOARD big enough to hold your largest paper	
DRAFTING TAPE	
CLOTH, PAPER TOWELS	
BRUSHES couple of old bristle or stiff synthetic brushes for removing pastel	
STUMPS, TORTILLONS	
KNEADABLE ERASER	
SANDPAPER	
PENCIL SHARPENER	
FACE MASK	
VACUUM	

OPTIONAL	✓
SOFT PASTELS one or two sticks of colors in each of several other brands to compare brands	
CAN OF MATTE SPRAY FIXATIVE	
SOFT BRUSHES for moistening pastel	
CARRYING CASE for work on location	
LATEX GLOVES to keep pastel off your skin	

This list is intended to help a newcomer to pastels get started. Although the huge arrays of pastels in the stores will be tempting, I suggest you start with a small number of basic sticks. After a few pictures, you'll have a better feel for which colors (and which brands) to add.

GETTING STARTED

For most painters, *soft* pastels are their main tool. Soft pastels may be applied to the ground with a feather-light touch or with forceful strokes. If your stroke is *too* light, the particles of color may not adhere well to the ground; if you press too firmly, you may quickly fill up the texture of the paper, making it difficult to add other layers of color. Sometimes you apply broad strokes using the side of the stick; sometimes you use a sharpened edge or point to make a finer mark.

Hard pastels deposit less color than soft pastels. They're often used for underpainting (to be followed by soft pastel). You don't generally use hard pastel *over* soft pastel, because it's impossible to deposit hard pastel without a lot of pressure that will scrape away the soft pastel underneath. However, hard pastels sharpened to fine edges or points *can* be used for final detail work. And they can be used with a light touch to move around some of the soft pastel—to blur edges, for example.

Pastel *pencils*, which are essentially hard pastels sheathed in wood, are used mostly for sketching or for detail work in an otherwise soft-pastel picture. Some artists use pastel pencils alone, rather than in combination with soft pastels.

When using either hard pastels or pastel pencils, be careful not to exert so much pressure that you score or tear the support. Such damage is difficult or impossible to repair.

By the time you use up a stick of pastel and are ready to replace it with a fresh stick, the label may have become torn, smudged, unreadable. You may go looking for a replacement stick, but find that all you know about the used-up stick is that it was some shade of Ultramarine Blue—but *which* shade? There are as many as eight

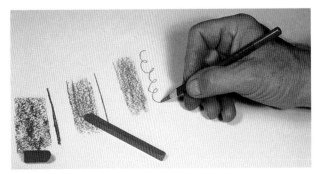

Any pastel can be used on its side to make a broad stroke, or can be sharpened for a finer line. Pastel pencils are effective for making both straight and curved strokes.

"Fat Over Lean"

It's easy to apply soft ("fat") pastel over hard ("lean"), but not vice versa.

shades available, and some of them look pretty close in color and value. Unless you're an experienced pastel artist and can spot and identify colors without difficulty, you need some system for keeping track of things.

If you can keep the labels readable, that may be all you need. Some artists break chunks from either end of the paper sleeve and keep the sleeve (the label) intact until the last chunk is removed from it. Others carefully label compartments that hold the sticks they're using and return a stick to its labeled compartment when not in use. An advantage to having labeled compartments is that you'll always have a place for those small chunks of various colors that have no labels left at all.

Keep your pastel sticks clean, just as you would a brush in another medium. When you rub a stick of red, say, over an area of blue pastel, the next time you use that red pastel it'll have some blue on it if you don't wipe it clean.

DRAWING

Favorite tools for drawing on your support are charcoal, pastel and pencil. Whichever drawing medium you use, be sure it will cover well with pastel. Ordinary graphite pencil has a greasy nature that can be difficult to cover with light pastel; charcoal, if used too heavily, can mix with subsequent pastels and muddy them; any mark that's too dark may be hard to cover without laying on more pastel than you would like. If you draw with a hard pastel or pastel pencil, use a light touch so you don't score the paper. Some artists like to draw loosely using diluted watercolor.

UNDERPAINTING

You can go immediately into pastel, or you can first underpaint. Depending on the surface you're using, you can underpaint with watercolor, acrylic, oil—any medium that's compatible with the support you're using. If you're working on an untreated paper, don't use oil because oil will damage the paper. Watercolor and acrylic are popular underpainting mediums. If you use them, be sure to choose a water-friendly paper that won't buckle or wrinkle excessively. In most cases, if you've fastened the paper securely to a board, wrinkling

will disappear as the paper dries. If you underpaint with acrylic paint, keep the paint thin enough that you don't fill the paper's texture, leaving insufficient tooth for holding the pastel.

Another way to underpaint is to lay in some pastel and then smear it by brushing over it with a solvent—water, turpentine, mineral spirits. The solvent "dissolves" the pastel to make a fluid paint. Some of the softest pastels, such as Sennelier, Rembrandt and Schmincke, dissolve more easily than hard pastels, such as Nupastel.

How detailed an underpainting you do is up to you. Some do a complete, fairly detailed underpainting, while others prefer a loose one. Some paint in colors that approximate the colors they want in the final painting, while others lay in complements of the final colors. Still others simply tone the paper with an overall wash (if you're using colored paper, such a toning is already done and you may need no underpainting).

There are relatively few deep darks in pastel colors, so it's not always a simple matter to get the rich dark you'd like in the final painting. You can help solve this problem by laying in the darkest areas as part of your underpainting—a simple matter if you're using oil, watercolor or acrylic. There is nothing wrong with leaving parts of your painting done in a medium other than pastel.

DARK-TO-LIGHT?

Although you can start in any way you wish, keep in mind that it's difficult in pastel to lay in a dark color over a light one. What results is a pasty-looking smear. One way around this is to establish your darks early; another is to spray a light area with fixative, let it dry thoroughly, and then go over the area with dark pastel.

Health Tips

1. Some colors are toxic—read the labels!
2. Wash hands frequently to avoid transferring colors to your mouth and to avoid absorption through the skin. Consider wearing latex gloves.
3. Don't eat while painting unless you wash your hands thoroughly.
4. Don't breathe in the pastel dust. Use a vacuum to keep dust from accumulating. Arrange for good air filtering or wear a mask over your nose and mouth.

ELIZABETH MOWRY
Pastel Large and Loose

THE MUSTARD FIELD
Elizabeth Mowry
Pastel on sanded paper
20″ × 36″
Collection of The Fern Feldman Anolick Breast Center,
Benedictine Hospital, Kingston, NY

"The Ersta Starcke sanded paper I used is fine grit 400, cut from a roll and dry mounted on museum board. This German-made paper comes only in a light buff tone. I toned what would be the darkest areas in the painting with dark green Nupastel (because such hard pastels leave less pastel on the surface) and then applied Turpenoid odorless turpentine to those same areas with a polyfoam brush and allowed the surface to dry thoroughly. This 'liquid' first step darkened the selected areas without filling the tooth of the paper with pastel.

"Using Sennelier soft pastels, I began with an overall layer of pastel, paying attention to large value masses and giving particular attention to getting middle values in place. Next I established and strength-ened the darkest areas, and finally the lights and highlights. I used quieter and cooler color in the background of *The Mustard Field* and then brighter, warmer and livelier color as I worked toward the foreground.

"The large size of the painting and the loose treatment allowed my hand the freedom to do its own rhythmic dance on the surface—I used mostly variations of a free diagonal stroke throughout. Background strokes are shorter, more controlled, in contrast to the seeming abandon of the foreground strokes. Since there is very little detail in this 'mood' painting, I did not need pastel pencils or the sharper edges of hard pastels to attain the results I wanted. I did not use fixative on the painting."

BASIC STROKES

Pastel can be applied in three basic ways. You can lay down a broad stroke of color with the side or blunt end of a piece of pastel; you can paint many individual strokes side by side or crosshatched, using a sharpened piece of pastel or the sharp edges of rectangular-shaped pastels; and you can use dots of color in pointillist style. A combination of broad and hatched strokes is probably the most common.

The amount of *pressure* you use is important. Firm pressure will tend to fill up the paper's texture and give a uniform value, which may be important if you're doing, for example, a solid area that you want to be as dark as possible. Lighter pressure will skip over the paper's texture and produce a broken-color effect, leaving parts of underlying colors to show through (scumbling). Sometimes you use a feather-light stroke to apply a light, delicate "glaze" over other colors.

Pastel may be left as raw, vibrant strokes or you may do any amount of blending you wish. You can blend using your fingers or a piece of cloth. A common practice is to use a stump or tortillon or a piece of hard pastel or pastel pencil to gently "push around" some of the soft pastel to smooth the appearance of an area or to soften an edge. Using these pointed objects will usually give you a more lively blending than using a finger. The broadness of a finger tends to mix and smear an area of color so thoroughly that the colors become grayed—it's easy to get carried away and overdo blending so that the result looks "too finished."

LAYERING

It's good procedure to establish deep darks early, in the first layer if possible, because it's difficult to place dark

On Sennelier La Carte pastel paper: (left to right) firm pressure, moderate pressure, light and glaze pressure over an existing pink and yellow.

pastel over light. Depending on the surface you're using, you can build up as many as eight or so layers of pastel—fewer if you apply each layer thickly. If you've laid down a lot of pastel and have difficulty adding more, you can spray the picture with fixative, let it dry, and then put on more pastel. You'll notice the fixative changes (darkens) the appearance of the pastel, especially the light colors, so use it carefully. Many artists use fixative between layers, but not over the final layer. As in most painting, establish broad, general areas first and then add detail. You can get sharp detail by using sharpened soft pastels, hard pastels or pastel pencils.

MATTING AND FRAMING

Pastel paintings are usually framed similarly to watercolors—surrounded by a mat and protected by glass or Plexiglas. Take some sensible precautions to keep grains of pastel from loosening and sifting down onto the mat.

First, get rid of all the loose grains you can. Once the picture is mounted on a backing, but not yet matted, hold it tightly and slap it from the rear. Don't be timid

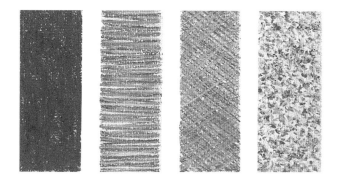

Soft pastel on Canson Mi-Teintes paper: (left to right) broad stroke, hatched (parallel) strokes, crosshatched strokes, pointillist strokes. In this example, one green pastel was used for the broad stroke. A combination of blue and yellow strokes produced the greens in the other examples.

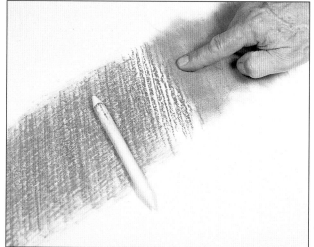

On Canson Mi-Teintes paper, passages stump-blended (at left) and finger-blended (at right).

about this—if any pastel is going to come loose, let it be *before* framing, not *after*.

Next, decide whether or not to spray the finished picture with fixative. There are two armed camps here—some say *yes*, some say *never*! You'll have to decide for yourself, and you can best do this by conducting some tests. Using your throwaway pastels (if you don't have any, I'll send you some), cover one half of each picture with paper and spray the other half. Try this with varying amounts of spray. See for yourself how much difference in appearance the fixative makes.

Either mat your picture or insert spacers between the glass and the picture. Never allow the pastel to touch the glass or Plexiglas, for particles will certainly rub off.

In fact, Plexiglas and similar products tend to have a lot of static electricity that can easily attract nearby pastel particles. An effective way to mat a pastel is to glue a spacer *behind* the mat so there is a trough for particles to fall into.

If you're using a wooden frame, fasten the matted picture into the frame using some method that does not require hammering or the jolting of a stapler or point-driver, all of which may loosen some pastel. Instead, use a tool that squeezes brads in place without hammering, or tabs or spring clips that you screw onto the back of the frame. If you use metal frames, spring clips hold things in place without any jolting.

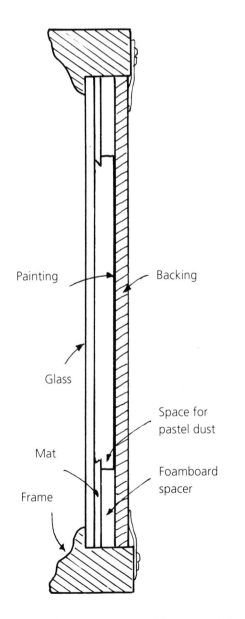

Painting

Backing

Glass

Space for pastel dust

Mat

Foamboard spacer

Frame

Here is one way of matting that provides a trough for loosened pastel particles.

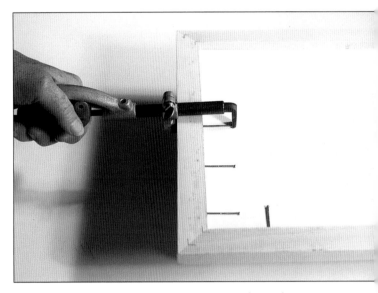

To avoid hammering and loosening grains of pastel, use (above) brads that are squeezed into place or (below) clips that are screwed on.

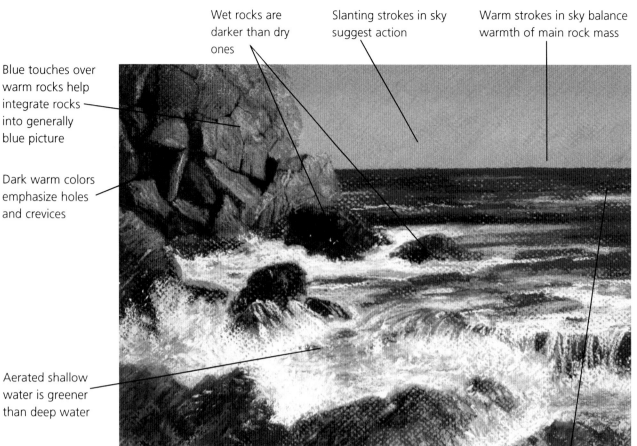

Wet rocks are darker than dry ones

Slanting strokes in sky suggest action

Warm strokes in sky balance warmth of main rock mass

Blue touches over warm rocks help integrate rocks into generally blue picture

Dark warm colors emphasize holes and crevices

Aerated shallow water is greener than deep water

Horizontal strokes in distant water suggest calm

MAINE SHORE
Phil Metzger
Pastel on buff-colored Canson Mi-Teintes pastel paper
8¼" × 11¼"

WHAT IS OIL PASTEL?

Like regular pastels, oil pastels come in stick form, but in place of a gum binder they contain oil and wax.

Oil pastels are different from *oil sticks* (discussed in chapter three). Oil sticks are oil paint in stick form and they act like oil paint. They dry to a tough film, just as oil paint does. Oil *pastels*, on the other hand, do *not* dry. They remain soft to the touch pretty much as children's crayons do. Unlike oil paint and regular pastel, oil pastel adheres well to smooth surfaces such as glass and metal.

Both oil pastels and oil sticks can safely be used on any surface suitable for oil paint, including primed canvas or hardboard, and treated paper, such as Multimedia Artboard and Sennelier Multimedia paper. If you paint on paper (such as pastel or watercolor paper) that

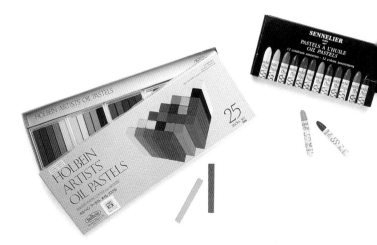

Unlike regular pastels, oil pastels create no "dust."

has not been coated to prevent oil absorption, you run the risk that the oil in the sticks will eventually damage the paper.

While oil pastels are not yet in wide use, some artists have switched to them from regular pastels because they get some of the characteristics of regular pastels without the health problem—there is no dust involved at all.

Oil pastels don't have quite the waxy feel of crayons—they go on more smoothly. As in regular pastel, any broad, solid layers of color should be put down in the first layer, because exerting pressure during later layers will disturb and pick up underlying color. You can work up layers of color by using fine strokes, one over the other, either side-by-side or crosshatched. If you keep the stick of oil pastel very sharp, using a knife or sandpaper, you can get a beautiful buildup of many layers. Blunter edges tend to push aside the underlying color instead of lying on top of it. You need to clean a stick of oil pastel continually because with each stroke you're bound to pick up some of the color you're painting over.

Oil pastel can be manipulated with brushes in some of the same ways as regular pastel. You can pick up the paint by gently scrubbing with a bristle brush, and you can liquefy the paint with solvents such as turpentine or mineral spirits. With some solvent on a soft brush you can brush out a solid stroke of pastel into a thin wash. When the solvent dries, you can continue painting over it. Since oil pastel does not dry to a hard film, as

Looking Back

The first oil pastels, called Cray-Pas, were made in the 1920s with children in mind. In 1949 artists Henri Goetz and Pablo Picasso convinced French manufacturer Sennelier to come up with an artist-quality oil pastel. Later, other companies, notably Holbein, refined oil pastels still further and made them available in a variety of open-stock colors.

Society Notes

The Pastel Society of America (PSA) was formed in 1972, under the leadership of Flora Giffuni, when the American Watercolor Society decided no longer to include pastels in its exhibits. The current address for information about PSA is:

Pastel Society of America
15 Gramercy Park South
New York, NY 10003

There is a new, information-sharing umbrella organization called The International Association of Pastel Societies. It's made up of Pastel Societies, not individuals, in the U.S. and other parts of the world. Write to:

Urania Christy Tarbet, President
P.O. Box 1032
Diamond Springs, CA 95619

oil paint does, you can go back into a painting at any time and rework it.

With recent refinements in oil pastels, they've grown in popularity and are being used by some as a primary medium. While you can, of course, build up a picture completely with oil pastel, some painters use it in other ways. They use it on top of a dried oil or acrylic painting—or any other painting—as a final layer or simply for some accents. (It would be unwise to paint acrylic or other water-based paints over oil pastel.) Others use oil pastels as a drawing or sketching medium. Still others mix regular and oil pastel in any order.

Oil pastel paintings may be framed under glass for protection against damage, or you may choose no glass and use instead a varnish made for oil pastel, such as Sennelier Oil Pastel Fixative. If you've ever left a wax crayon in a hot place, such as atop a radiator, you know the colors can melt. Use the same precautions with oil pastels as you would with crayons—don't subject them to abnormal heat.

DEMONSTRATION

Painting a Lively Pastel
by Sally Strand

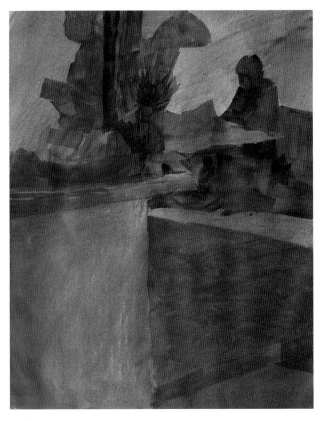

1 *Strand uses 140-lb. Arches cold press watercolor paper from a roll. She soaks and stretches it and staples it to a plywood board, placing several layers of newsprint or newspaper between the watercolor paper and the wood board as a cushion. She marks off the image area with drafting tape and uses soft vine charcoal to draw the big, general shapes of her composition (which she has worked out ahead of time in a sketch book). She sprays the charcoal lightly with Krylon workable fixative.*

2 *She uses watercolor to underpaint, establishing her lights and darks and big, abstract shapes.*

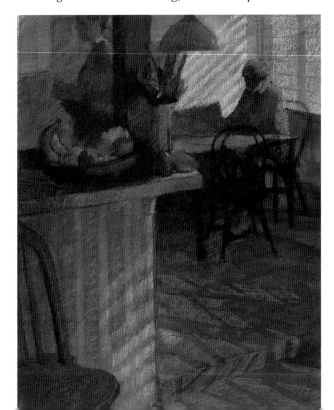

3 *When the underpainting has dried, she begins laying in pastel, using Rembrandt soft pastels. She looks for areas of lightest light and darkest dark and establishes those early to set her value limits. Now she works out the basic light and dark patterns, defining basic shapes rather than any detail. She adds the chair at the left to help balance the composition.*

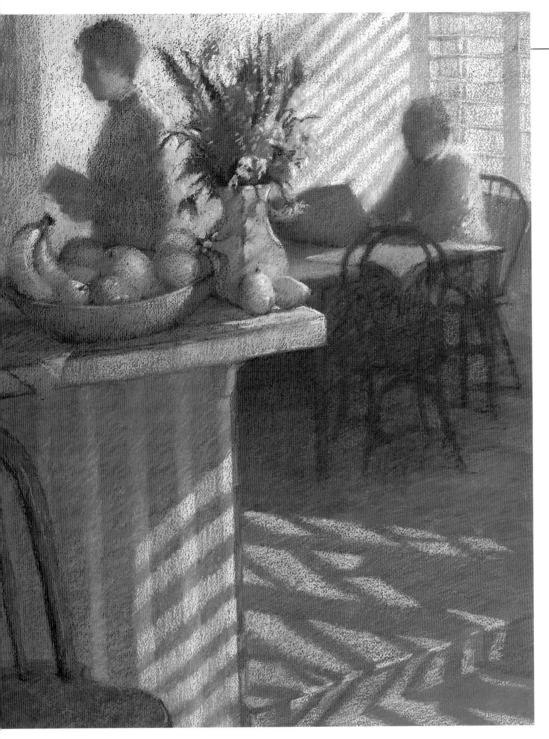

PASSING QUIETLY
Sally Strand
Pastel
26″ × 20″
Courtesy of
J. Cacciola
Galleries

4 *Working from dark to light, Strand resolves details and makes changes in her composition—for example, she removes the post and places the woman's figure lower. She adds increasingly vibrant color to all areas, especially the light areas, using her trademark linear strokes for a lively look, rather than using the side of the pastel stick. She brings the vase into focus and shifts the background figures slightly out of focus. At the end, she puts in highlights, taking care not to have highlights "all over the place!"*

Although she sprays lightly with fixative at intermediate stages, she does not spray the last stage, for the fixative would alter colors and values. Throughout the painting sessions, Strand uses Winsor & Newton Artguard cream worked well into her hands and, for extra protection, wears thin latex gloves—all to keep from absorbing pastel into her skin and causing irritation or other possible health problems. She also uses good ventilation, a vacuum and an easel tilted forward with a trough to catch falling pastel dust.

Colored Pencil

ASPEN LEAVES
Don Pearson
Colored pencil on Strathmore kid finish paper
14" × 19"

WHAT IS A COLORED PENCIL?

For our purposes, a colored pencil is one made specifically for artists, as opposed to those available in dime stores for children. Like graphite pencils, colored pencils have a "lead" sheathed in wood. Colored pencil lead (containing no lead at all) consists of *pigment*, a gum *binder*, a chalk or clay *filler* that gives the pencil lead its body, and *wax*. The wax helps the pencil mark adhere to the drawing surface and gives the lead its smooth texture. The more wax, the more smoothly the pencil lead "flows" across a ground.

Depending on how thickly or thinly you apply the color, there is practically no limit to the number of layers you can use. The waxy color adheres well to the color underneath it, with no danger of flaking off, as in pastels.

Experiment with different brands to find ones that suit you. Some cheaper grades are self-defeating because no matter how diligent you are, you won't get the richness of color that better grades offer.

Like watercolor, colored pencil art was once thought of as nonserious—something you fooled around with or used to make sketches for *seeerious* work. No longer. Like graphite pencils, colored pencils are simple tools that in the hands of skilled artists can be used to make glorious pictures. Do you *paint* with colored pencils, or do you *draw* with them? It's an academic question. I choose to call any picture that's more or less filled-in with color, a painting.

TYPES OF COLORED PENCILS

Colored pencils are made with either a thick, relatively soft lead (for example, Berol Prismacolor and Design Spectracolor) or a thin, harder lead (such as Berol Verithin). Either can be used for both thick and thin lines, but as you might expect, the fat leads are used more for thick lines and broad color areas and the thin leads are used for fine detail. Popular brands of colored pencils are Berol, Faber-Castell and Derwent.

Colored pencils are essentially waterproof (and are usually advertised as "smudgeproof"), but there is a class of pencils (such as Conté Aquarelle and Derwent Watercolor pencils) that are water soluble. With these, you can brush water over areas you've laid down and either completely dissolve an area (resulting in a water-color-like wash) or partly dissolve the color, depending on how much you scrub with the brush. You can also get soft, feathery lines by either dipping the pencil points into water before drawing, or by drawing through a wet surface.

In addition to the various types of pencils, there are *color sticks*, such as Berol Prismacolor Art Stix that are about ¼" square and 3¼" long, resembling sticks of hard pastel. Art Stix are made of the same material as the lead in Berol's Prismacolor pencils, but with a higher proportion of pigment. They can be used alone or along with pencils. Their sharp corners (or sharpened points) can give you fine lines, while their flat sides yield broad color strokes.

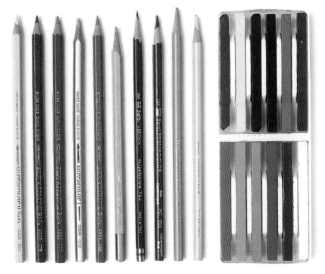

Although colored pencils and color sticks may both be used for any kind of stroke, sticks are handier for filling in large, densely colored areas.

COLOR RANGE, PERMANENCE, TOXICITY

The range of colors available is excellent, with some brands offering over 120 colors in soft-lead pencils, over 40 colors in hard leads and over 20 color sticks.

Each brand has its own *permanence* rating system—sooner or later a standardized system will probably be adopted. Ratings are not usually imprinted on each pencil. You have to get a color brochure to find out about permanence. If you're lucky, your store will have a copy, but more likely, you'll have to call or write for one. (Many manufacturers' addresses are at the rear of this book.)

In Rexel Derwent's current brochure, 72 Derwent Artists Pencils are listed. Each is assigned a lightfastness of from five stars to one star. ★★★★★=excellent; ★★★★=very good; ★★★=good; ★★=moderate; ★= poor. I would use any rated three stars or better. Berol Prismacolor uses a similar rating system for its 120 colors: A=excellent; B=very good; C=good; D=fair; and E= fugitive. Again, use any except D and E. In both cases, as you might expect, only a small number of colors are rated less than "good."

Most artist's colored pencils, including Berol Prismacolor, Design Spectracolor and Derwent carry either a PMA (Pencil Makers Association) seal of approval, meaning that they are certified as nontoxic, or some other seal or statement about toxicity. Derwent's brochure says this: "All Derwent pencils comply with all current legislation concerning pencil and writing instrument toxicity. They are considered non-toxic."

If you can't find a PMA seal or other statement of nontoxicity, don't buy the pencil.

This PMA seal signifies that the core ("lead") in a pencil is nontoxic, and that the pencil's other parts are nontoxic as well: its wood casing, the lacquer coating on the wood, the eraser, and the ferrule (the metal sleeve that fastens the eraser to the body of the pencil).

Courtesy of Writing Instrument Manufacturers Association/PMA, 236 Rt. 38 West, Suite 100, Moorestown, NJ 08057.

COLORED PENCIL SCORECARD

CATEGORY	PRO	CON
colors	over 120	
color compatibility	excellent; intermix freely	
film strength	strong; no flaking	
color change	nonyellowing	wax bloom
adhesion	excellent, even on smooth grounds	
health risks	minimal	fixative: avoid inhaling, keep away from flame

MEDIUMS

The only fluids generally used with colored pencils are water (if you're using water-soluble colors) and fixative. Some artists spray lightly over intermediate coats of color to protect against smudging; some spray only the final picture for protection against "wax bloom" (discussed later) and some never use fixative at all. If you use fixative before the picture is completed, use very thin coats—too much fixative can make it difficult or impossible to add color to the picture.

PAINTING AND DRAWING SURFACES

You can draw or paint with colored pencils on a huge variety of surfaces, including drawing paper, pastel paper, watercolor paper, mat board, printing paper, illustration board, watercolor board, plastic, Mylar, vinyl, hardboard and wood. You should try as many surfaces as possible to find those that are best for your subjects, your way of drawing or painting and your temperament.

As I have stressed throughout this book, no matter what surfaces you choose, make sure they are materials

that won't disintegrate before your next birthday. There are so many surfaces available that are acid-free, that using iffy surfaces is hard to justify. Not only will your work last a thousand times longer on rag paper than on newsprint, for example, but you'll *feel* better about the work and do a better job. Working with throwaway materials can easily result in throwaway pictures.

The usual surfaces used are *papers* of various kinds, and there are plenty of them that are acid-free and have rag content. Chapter five lists a number of pastel papers that are also excellent for colored pencil, and in chapter two are listed watercolor papers, many of which also are suitable for colored pencil.

Become a paper junkie. Look through the art stores, especially the larger ones, and sample the papers available. First find the ones that are acid-free and then choose those whose colors and textures appeal to you. Make sure the paper you choose isn't so thin and flimsy it's easily damaged by erasing or handling or easily buckles if you're using water with your pencils. My own preference is to use mounted papers, such as Strathmore 500-Series illustration board, which comes in a "regular" (slightly textured) and a "high" (smooth) surface. For colored surfaces, acid-free mat board or pastel papers are excellent.

Another surface popular among colored pencil artists is Mylar film. For advice about working on this surface, see the work of Robert Guthrie on page 125.

TOOLS AND ACCESSORIES

One of the attractions of this medium is its portability. You can travel light and not bring along anything that smells bad or anything that might spill (except your coffee). You can carry all your supplies except paper and easel in your pockets. The tools you'll need are simple and inexpensive.

DRAWING BOARD, TAPE, TACKS

If you're working on unmounted paper, you'll need to fasten it to a rigid support, such as a wooden drawing board, a piece of hardboard, thick foamboard or Homosote. If you're drawing or painting on illustration board or watercolor board, it may be rigid enough that no other board is needed.

Use either drafting tape (less adhesive than masking tape) or tacks to hold your paper to a board. Fasten

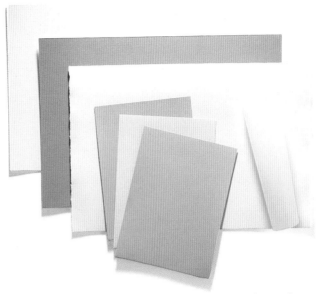

Some of the many surfaces suitable for colored pencil: pastel papers, watercolor paper, illustration board, mat board, and drafting film.

your paper all the way around its edges, so it will lie perfectly flat and cannot shift. When you use tape, remove it by pulling it slowly, gently *away* from the picture to avoid accidental tearing of the picture surface.

BRUSHES

You'll need a couple of brushes if you are using water-soluble color. The sizes depend entirely on what sort of passages you're painting. You can start by borrowing a couple of brushes from your other mediums. If you have no brushes at all, then I suggest two for a start: a ½" flat and a no. 6 round, both synthetic. Another helpful brush is a soft, wide one to whisk crumbs of color from the picture surface as you work.

ERASERS AND SHIELD

You can use several kinds of erasers, including kneadable rubber, pencil erasers, art gum erasers and vinyl erasers. Each has its own abrasiveness. Some, like pink pencil erasers, can leave behind a colored smudge. The best approach is to get one of each kind and try them— but try them first on scraps, not on a picture you've labored over.

In many cases, you'll need to sharpen an edge of an eraser with a knife to get an edge that will lift out a highlight or some thin passage of color. A kneadable eraser, so useful with many mediums, can be formed into just the shape you need for a specific use. One thing a colored pencil artist learns quickly is that, no matter what kind of eraser is used, lots of patience is required. Many a picture has been ruined by scrubbing away with

DON PEARSON
Colored Pencil Techniques

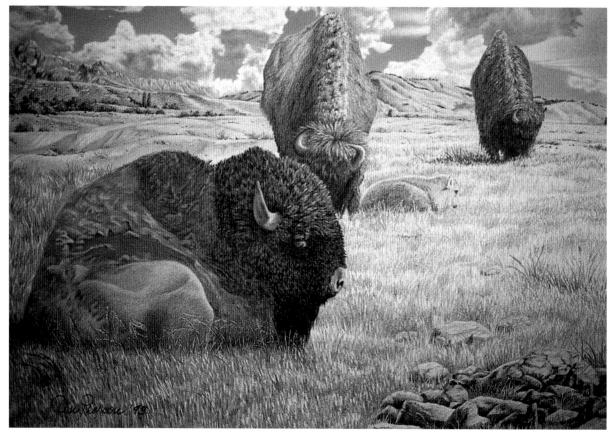

BISON
Don Pearson
Colored pencil on acid-free Crescent mat board
14" × 18"

"I combined elements from several photographs to make up this composition. I prefer Prismacolor pencils because of their texture—not too hard, not too soft, and I like working on mat board because its hard surface allows for considerable pressure from a sharply pointed pencil.

"The pencil strokes come down to linear strokes for grass and fur, circular strokes for clouds, and shading and burnishing for smooth areas, such as the sky, horns and nose. Burnishing means applying pressure over a colored area to smooth the color. To burnish an area, I use a harder pencil from the same color group as the color I'm burnishing—the idea is not to add color, but to smooth out what you already have.

"I almost always start with the light colors because you can always go back and darken if necessary. Next I do the dark areas, then the midtones. You can darken by adding more color or lighten by blotting off excess color with a kneaded eraser without damaging your working surface.

"I never use fixative until my picture is finished and I've had time for several visual 'final' reviews—then I apply spray fixative. That coating prevents the wax in the color from rising to the surface ('blooming') and causing a hazy look. Spraying *before* a picture is finished makes it nearly impossible to blend, burnish or erase."

SAM
Bernard Poulin
Colored pencil on 4-ply
acid-free mat board
24″ × 20″
Collection of Mr. and Mrs.
L. Outerbridge, Bermuda

an eraser, smearing color, shredding paper and making a general mess. As in watercolor, once you've damaged your paper by erasing, there's not much you can do to salvage things.

An erasing shield is a plastic or metal card with holes and slots of various shapes and sizes. When you want to erase a restricted area and protect the surrounding area, place one of the shield's openings over the area to be erased.

SANDPAPER, PENCIL SHARPENERS

Tape a piece of sandpaper alongside your picture to have it handy for point-sharpening. When the pencil point becomes *too* worn, you'll need either a knife or a mechanical pencil sharpener to expose new lead. A knife is simple, but I prefer a small, battery-powered pencil sharpener. Mine is a Panasonic that requires four AA batteries. It's lightweight (fits in a pocket) and reliable. There are other brands, such as Boston, and of course there are many kinds of nonelectric sharpeners. Among those are the little hand-held sharpeners that love to

break off points and then dare you to dig the broken point out so that you can stick the pencil back in and try again.

Put a little time into selecting a sharpener, because in any kind of pencil work you'll spend a *lot* of time sharpening pencils—time I'm sure you'd rather spend drawing or painting. Here are some considerations:

- The *shape* of the sharpened pencil—some sharpeners leave a longish point, some a more blunt shape. The choice is yours.
- The *size* pencil the sharpener will accept—not all sharpeners will accept the fattest pencils. Some manually operated sharpeners have an adjustable faceplate to accommodate different pencil thicknesses.
- The *smoothness* of the mechanism, if it's a rotary sharpener. Don't get a clunker that insists on breaking off the tips of your leads.

PENCIL HOLDER

There are several kinds receptacles for holding and keeping track of your pencils while you work. If you just leave them in a heap you'll spend precious time finding the one you want. You might simply use cups or mugs, or you can buy a variety of holders with rows of holes for holding your pencils upright. Bernard Poulin, in *The Complete Colored Pencil Book*, shows the simplest holder of all—a piece of 2″ × 4″ lumber drilled with rows of holes for his pencils. He's painted it white, and numbered the holes; there's a piece of felt on the bottom to keep the board from sliding off a tilted table.

VEST

Another Poulin piece of gear that makes a lot of sense for drawing outdoors is a vest, such as sportsmen wear. These vests have lots of pockets of different sizes, and you can stuff anything you want in there except your paper, drawing board and easel. The alternative is some sort of carrying case or tackle box—art supply stores and sporting goods stores are full of them.

HAND REST OR MAHLSTICK

To keep your hand from smearing your picture, use a bridge or a mahlstick, such as those shown in chapter eight. Another method is to lay a piece of waxed paper or clear vinyl over the part of the picture you want to protect, but this is iffy—if you allow the paper or vinyl to shift, it may smear your picture.

TABLE OR EASEL

A tilting drafting table is ideal, but a flat table works fine and so does an upright easel if you prefer to keep the picture more or less vertical. For outdoor work, a folding French easel is good—you can also get by with the picture across your knees as you sit on a bench or campstool (or rock) as long as there are no armrests to get in your way.

MISCELLANEOUS

You'll need rags or paper towels for cleaning hands so you don't rest a smudged hand on your paper. A pencil lengthener is useful for holding stubby, almost-used-up pencils. And stumps or tortillons, used often for blending strokes of charcoal or pastel, are useful in colored pencil work, too. They are simply tightly wound cylinders of paper with a point at one or both ends (one end for a tortillon, both ends for a stump).

COLORED PENCIL SHOPPING LIST

BASICS	✓
SOFT PENCILS set of at least 48 pencils	
HARD PENCILS set of at least 24 pencils	
COLOR STICKS set of at least 24 sticks	
PAPER 9″ × 12″ pad of assorted colors pastel paper 9″ × 12″ pad of white drawing paper	
DRAWING BOARD big enough to hold your largest paper	
DRAFTING TAPE	
CLOTH, PAPER TOWELS	
ASSORTED ERASERS kneadable rubber Art Gum pencil eraser ink eraser plastic eraser	
FINE SANDPAPER	
PENCIL SHARPENER, KNIFE or RAZOR BLADE	
HAND REST or MAHLSTICK	
PENCIL HOLDERS	
OPTIONAL	✓
WATER-SOLUBLE PENCILS set of at least 24 watercolor pencils	
BRUSHES one flat ½″ synthetic brush, soft one round no. 6 synthetic brush, soft soft 2″ brush for whisking granules from surface	
VEST OR CARRYING CASE	
FIXATIVE Low-odor spray fixative	
PENCIL LENGTHENER	
STUMPS or TORTILLONS	

GETTING STARTED

Changes halfway through a colored pencil picture are not easy, especially if the area you want to change contains dark colors. Develop your drawing first on newsprint or other paper and then carefully transfer it to your working surface by using a sheet of transfer paper. While tracing over your drawing to transfer it, press only as hard as necessary to get a faint image—you don't want hard-to-cover graphite lines, and you don't want to press grooves into your paper that will later interfere with your colored pencil strokes.

Unless you apply fairly heavy layers of pencil color, a *graphite* drawing may show through. Instead of using graphite transfer papers, then, you might want to make your own transfer paper by coating one side of a sheet of tracing paper with *pencil color* that is compatible with the painting you're about to do.

Basic strokes include blue dots over solid yellow, blue hatching over solid yellow, blue hatching and red crosshatching, blue hatching and red and green crosshatching.

BASIC STROKES

There are really only two basic strokes (and their variations) in pencil work: You can lay in a broad swath of color using the side of a lead or the side of a color stick; or you can make individual narrow strokes with a pencil point or an edge of a color stick. Strokes can be either pointillist dots or straight or curved lines. Lines laid side-by-side are called *hatching*; overlaying one area of hatching with another at an angle is called *crosshatching*.

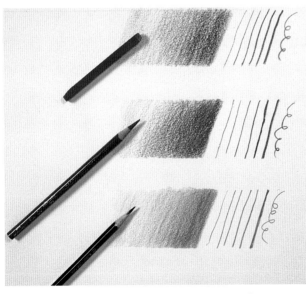

Individual strokes made on hot press watercolor paper using (top to bottom): the side of a color stick, a soft pencil, a hard pencil.

Using combinations of these simple strokes you can build up an endless variety of textures and colors. It's best to plan your picture well and lay in your darks thoughtfully because it's *difficult to cover dark colors with light ones*. Working from light to dark is the safest route, or you can start with middle tones and work in both directions (toward darks and lights).

Where you want to lay in solid color (as opposed to hatching or pointillism) color sticks are effective. These sticks, such as Prismacolor Art Stix, contain dense color and are much stronger than the lead in color pencils. You can bear down hard with a color stick without breaking it. Solid color stick passages were used for the darks in the demonstration at the end of the chapter.

When you need to drastically change a dark area to light, you may need to *remove* color first. You can manage this using erasers, sharp blades (razor or X-Acto) or fine sandpaper. Whichever combination of color-removers you use, the most important ingredient will be *patience*! Remove a little at a time, brush away the crumbs, feel the surface with your clean, dry finger to make sure you're not gouging it, then repeat. When you use a blade, hold the blade nearly perpendicular to the paper and scrape gently. Don't gouge with the point of the blade. Scraping or sanding away a color works best on a hard surface, such as hot press illustration board. Softer boards or papers tend to shred as you scrape or sand them.

BERNARD POULIN
A Limited Colored Pencil Palette

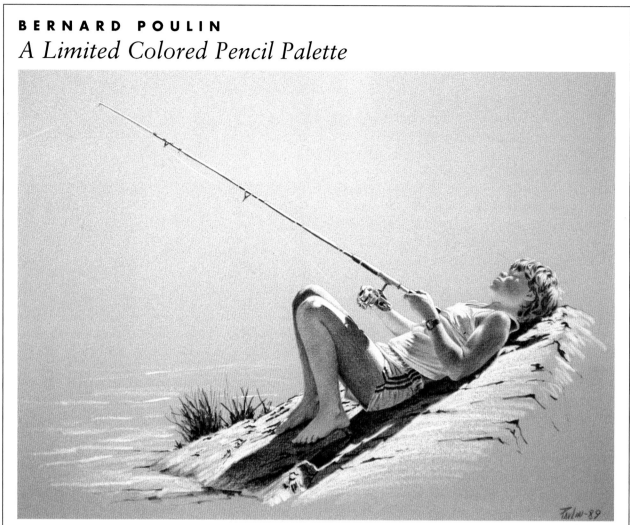

A LAZY MONDAY
Bernard Poulin
Colored pencil on 4-ply acid-free mat board
15″ × 20″
Collection of Dr. W. James, Ottawa, Canada

"In this picture I wanted to show the glow of a hazy day, with its silvery light. I wanted to contrast a warmer skin tone with this silvery light, but I didn't want the warmer tone to dominate. I therefore chose to limit my palette to Prismacolor's #947 Dark Umber and #938 White. My drawing surface was a soft dawn-gray, untextured mat board, Crescent #1574, acid-free and 100% rag.

"When rendering figures in only one or two colors, I enjoy using this umber as a shadowed skin tone. Over a cool-tinted surface, light to medium layers of this color allow the tinted surface to 'glow through.' In skin midtone areas (between deeper shadows and highlights) I mix the dark umber with white.

"The theme of this drawing is a sunny Monday afternoon in June, when it's just too hot to spend the day in school! Rather than a comical approach, I wanted to show the nonchalant calm of a boy who has rationalized his decision to skip school. For help, I phoned Gregg, one of my models, and we met to discuss the 'storyline.' This particular rendering called for a 13-year-old's expertise. He knew the best fishing spots on the river."

See a variety of colored pencil techniques by Poulin and others in his excellent book, *The Complete Colored Pencil Book* (North Light Books).

Some artists begin by laying in light color all over the paper, using either broad strokes with a color stick or light hatching. Others begin in a small area, *finish* it and move on to the next area, finishing as they go—this way of working requires a good mental picture of what the final picture is to look like. Whatever the approach, it's helpful to start at the top of the picture and work your way down to keep from smudging your picture with your hand.

Another way to begin is to *underpaint* with watercolor or diluted acrylic. If you choose that approach, make sure the surface you're working on will accept the underpainting medium you've chosen.

WAX BLOOM

The wax in colored pencils often rises to the surface and leaves a pale, whitish haze. If you paint with light pressure, you may notice little or no haze—it's particularly noticeable when dark colors are applied heavily. This "wax bloom" may not occur right away, sometimes not until the next day. To get rid of it, gently polish the affected area with a *soft* cotton cloth or tissue. Get rid of the bloom before applying more color. When finished with your painting, a light spray coat of fixative will prevent the bloom from returning.

COLORED PENCIL TECHNIQUES

Aside from basic strokes, there are a number of useful techniques for getting specific results.

Burnishing

After laying in color, especially dark color, you can rub over it hard with a light color, such as white or yellow, to get a veiled, pearly effect. You might use this to get a satiny sheen on a shiny object in your picture. Sometimes artists burnish an entire picture to give it an overall satin finish.

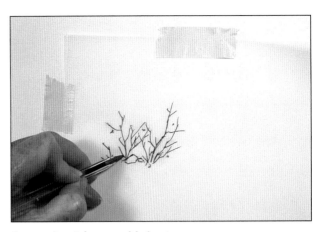

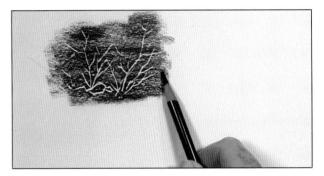

Impressing (above and below).

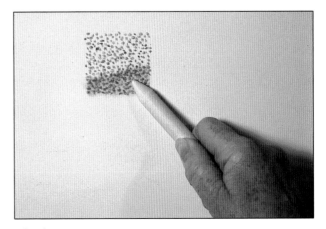

Impressing

If you lay a piece of tracing paper or clear acetate over your picture and press firmly (but not so hard as to puncture your paper) with a pencil or a ballpoint pen, you'll make shallow *impressions* in your painting surface. Now when you place color strokes over those areas, the lines (valleys) will be skipped and will show up lighter than surrounding areas.

Blending

Use a tortillon to rub across adjacent color strokes to blend them. Use this sparingly—too much blending can rob your picture of its spark.

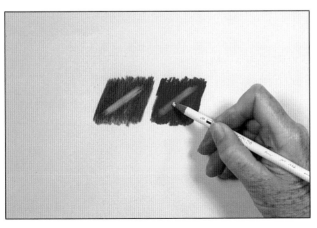

Burnishing.

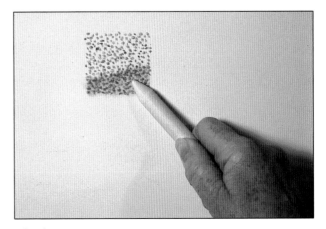

Blending.

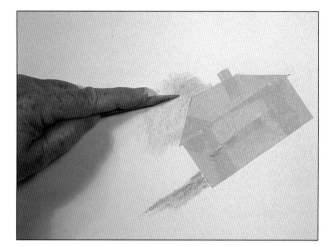

Masking.

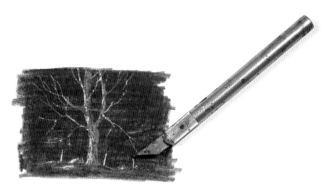

Sgraffito.

Masking

Cover an area with a piece of stiff paper cut to the shape you want, so you can rapidly lay down adjacent color without intruding into the masked area. Again, use this judiciously to avoid too stiff a look.

Sgraffito

This means any effect you get by cutting through one or more layers of color to expose what's underneath. After building up color, especially dark color, you can gently gouge it with any instrument—a blade tip, a fingernail, a toothpick—and produce sharp, light lines. You can also scrape with broader edges and expose layers, even down to the texture of the paper.

Frottage

A "rubbing" made by placing some textured object under your paper and rubbing the paper with your pencil.

Erasing

Sometimes you erase *mistakes*, and sometimes you erase as a painting technique—to lighten an area, for example, or to make a highlight. When the area to be erased is dark, or if it is built up of a number of layers, try first dabbing color away with kneadable rubber; then remove more with a stiffer rubber or plastic eraser; finally, if more color must be removed, gently scrape with a sharp blade.

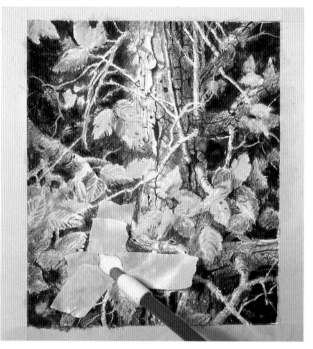

Here I used a Pink Pearl eraser pencil. I first outlined with drafting tape the area I wanted to erase. I could also have used an erasing template.

Society Notes

Colored Pencil Society of America
1620 Melrose Avenue, #301
Seattle, WA 98122

ROBERT GUTHRIE
Colored Pencil on Mylar

201 ARIZONA
Robert Guthrie
Colored pencil on Mylar drafting film
8″ × 24½″
Courtesy of Capricorn Gallery, Bethesda, MD

Guthrie has perfected the use of drafting films, such as Mylar brand, as a support for colored pencil. Here he uses 6-mil-thick film and Berol Prismacolor pencils and Art Stix. Guthrie loves to work on Mylar, but warns that it won't take much erasing and will hold fewer layers of color than many paper supports. On the plus side, Mylar does not smudge and allows the drawing of very crisp lines.

He begins by drawing carefully on the *back* side of the transparent film (drawing the design in reverse), and goes on to lay in values, also on the back side. When he flips the film over, the color on the back serves as his first layer, a sort of underpainting.

At the same time, of course, he now sees his design in reverse, and that's helpful for spotting design and value problems.

Guthrie works mostly with sharp pencils, doing fine hatching and crosshatching with light finger pressure. He works from light to dark. He rarely uses white pencils, even though his works usually have some very bright passages. Instead of white pencil, he relies on the white mounting board behind the film to show through. Whatever you place behind the film, of course, will show through and affect the final look of the picture.

Strong Value Contrasts With Colored Pencil
by Phil Metzger

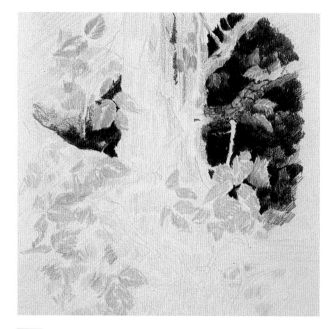

1 *I drew directly on the drawing surface with a light gray pencil and then did a very rough lay-in, using a light pink on the trunks and main branches and Canary Yellow for the leaves.*

2 *I began establishing darks early with Art Stix—Crimson Red followed by Ultramarine Blue and Dark Brown. I pressed hard and filled dark areas fairly solidly. Later I scraped away portions of the dark color with a blade. Using mostly crosshatched strokes I began work on the trunk, then the branches and some leaves with an assortment of Prismacolor, Spectracolor, Verithin and Caran d'Ache pencils—whatever was handy. They're all good pencils.*

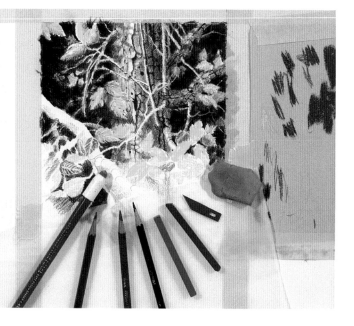

3 *After a while I decided on the top and side boundaries of the picture and marked them off with drafting tape. Then, working from the top down to minimize smearing color with my hand, I began detailing, using many crosshatched layers of reds, blues, yellows, browns, oranges and so on. At times, as shown here, I used a piece of tracing paper to keep from smearing the picture. Often I scraped color from the dark areas using an X-Acto knife blade, and once or twice a small piece of fine sandpaper. In lighter areas, I occasionally erased, using either a kneadable eraser or a Pink Pearl eraser.*

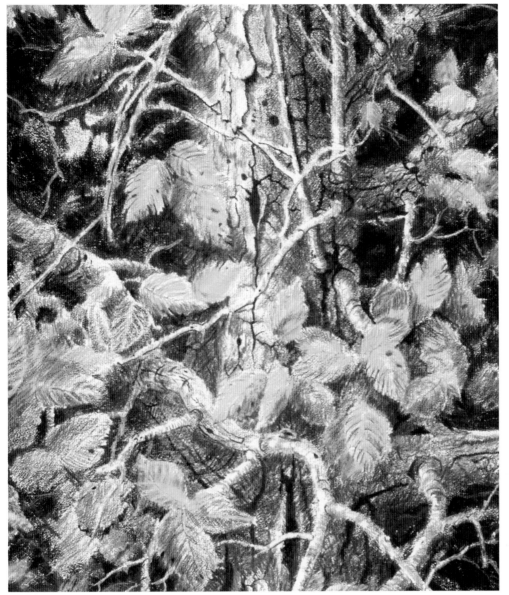

TREE STUDY
Phil Metzger
Colored pencil on
Strathmore illustration
board
8" × 7"

4 The surface I worked on was Strathmore 500-Series illustration board, "regular" surface, which has a fine texture. Its hard surface is well suited to scraping out and erasing color without damaging the paper.

Egg Tempera, Gouache and Casein

Working on a traditional gesso ground, Vickrey paints a favorite subject: his son Sean. Here, as in many of his paintings, Vickrey uses a well-designed shadow pattern to help set a mood. He sees shadows as delicate passages, and the translucence of egg tempera helps him capture that delicacy. Color is played down, in keeping with the contemplative mood. Notice the patch of blue at the left that nicely repeats the blue in Sean's shirt. As for the mysterious bird-shape at the right, it may be real or it may be fantasy.

IN THE BOATHOUSE II
Robert Vickrey
Egg tempera on
Masonite panel
16½" × 24"
Private collection

WHAT IS EGG TEMPERA?

The word "tempera" has a fuzzy artistic history. Its strict meaning is a paint whose binder is an emulsion—an oily substance suspended in water. There are several forms of tempera paints, as described by Mayer, but the most-used tempera paint today is *egg tempera*. Cheap jars of "tempera" paint found in stores, mainly for children's use, are not tempera paints at all, but are usually glue- or starch-based.

Egg tempera paint is a mixture of powdered *pigment*, *water* and ordinary hen's *egg*. A variation on this formula, especially as used by the old masters, is one that adds oil to the mix. Egg is an excellent binder—anyone who has left a film of uncooked egg on a pan or dish knows how tough a film it forms, and the film gets tougher and more water-resistant with time. Usually the part of the egg that is used is the yolk, which gives a more durable, slightly more elastic film than does the white or the whole egg.

BASIC PROPERTIES

An egg tempera painting is built up of thin, translucent layers. Thick, impasto layers may not be used because such layers will crack and flake off. Because the thin layers are translucent, all the underlying layers affect the final look of the painting. This buildup of layers results in a glow that gives the medium its unique charm.

Egg tempera paint dries very fast (usually within seconds), so that layer after layer may be applied without disturbing what's underneath. The paint continues to dry, or cure, for a long while—a year or more—but it's dry enough to handle almost immediately. Because

EGG TEMPERA SCORECARD

CATEGORY	PRO	CON
colors available	broad range	
film strength	very tough	not flexible, requires rigid support
resistance to damage	not subject to cracking if used thinly	can be damaged by water and by scratching
drying time	rapid	too fast to manipulate the paint
finish	satin-matte	
yellowing	none	
adhesion	excellent on nongreasy, porous surfaces	

the surface of the painting can be easily damaged by gouging or scratching or even by water, egg tempera paintings are often framed under glass.

Flexing of materials such as canvas would cause the paint to crack and flake off, so you need a rigid support, such as wood or hardboard. The traditional ground used to coat the support is *gesso*—not acrylic "gesso," but true gesso, a combination of chalky white pigment, glue and water. When properly applied and finished, gesso provides a beautiful, fine-toothed painting surface to which egg tempera adheres well (gesso is also suitable for other mediums, such as oil). Some painters use *acrylic* gesso as a ground, and others paint directly on untreated surfaces such as acid-free illustration boards. Such surfaces are suitable, but their "feel" is different from that of gesso.

PREPARING PAINTS

Egg yolk spoils after a relatively short time, so you mix your own paints as you go along. Buy powdered pigments (such as Winsor & Newton, Holbein, Blockx, Gamblin or Sennelier) and mix them with water to form pastes that you keep in small airtight jars or in empty aluminum tubes available in several sizes. At painting time you mix some of the color paste with medium (a mixture of egg yolk and water) and the result is egg tempera paint. Mix a small enough puddle of paint that it won't dry out on your palette before you can use it.

When you prepare your pastes, try for a consistency

Looking Back

Egg tempera was widely used by medieval and early Renaissance painters. The invention of the much more versatile oil paints practically killed egg tempera except as an underpainting for some oils; oils were used over the egg tempera underpainting. Egg tempera had a revival in the early 1900s and has been given a big boost in public awareness by the work of Andrew Wyeth and Robert Vickrey.

Powdered pigments, baby food jars for storage, empty tubes, distilled water.

similar to oil paint. As you gain experience with individual pigments, you may vary the consistencies a lot. What you should strive for is the proper feel and workability of the paint. The exact amount of water is not critical, except in the case of titanium white—too much water mixed with the white will rob it of its opacity. Robert Vickrey suggests mixing the white directly with medium at painting time rather than premixing it as a paste.

You'll quickly notice that some pigments, such as umbers and siennas, mix easily to a smooth paste. Others are devilishly hard to mix. Cadmium powders, for instance, almost refuse to mix with the water. It's like trying to mix fine flour with water when you're baking—until you get the first bit of flour to break through the surface tension of the water, it seems they'll never combine. What I find works best is to cap the jar and shake vigorously to get the mixing started. I don't recommend adding anything to break the surface tension, because I don't know if such an added ingredient might have unwanted consequences. I know of one painter who uses a drop or two of laundry detergent to break the surface tension, and he claims this gives him no problems.

Although baby food jars are easy to find and use, it would be smarter to locate much smaller jars—many craft stores have them. Smaller jars expose the pigment mixtures to less air, so you'll have less drying out. Just as important, smaller jars waste less pigment—the larger the jar, the more pigment becomes "lost" as a coating around the jar's inside surface. When you're dealing with expensive pigments, such as Cobalt Blue, you can easily waste several dollars' worth of paint in this way. If you stuff your pastes into empty tubes instead of jars, use the smallest tubes you can find—again to minimize waste. Art catalogs offer them in sizes as small as 12 ml.

Options

Instead of mixing paints as described, you may try other methods:

✓ Rowney offers *Egg Tempera Colours* in tubes. However, this product contains linseed oil as well as egg yolk and preservative. The oil alters the look of the dried paint and poses the possibility of some amount of yellowing. This paint dries more slowly than straight egg tempera.

✓ You may use traditional tube watercolors in place of powdered pigment pastes. I learned this method from Robert Vickrey's book—he often uses watercolor with egg medium while working rapidly and away from his studio on cover assignments for Time Magazine.

Watercolor-and-egg handles very nicely. I know of no studies that indicate problems between egg medium and the gum arabic in watercolor. Use watercolor tube paint just as you would powdered pigment pastes, adding as much water as you need for workability.

✓ Some painters use gouache rather than watercolor with egg medium. Because of the opaque nature of gouache, expect to get a somewhat less translucent paint.

Most painters use tap water for their paint mixes. If your tap water contains lots of minerals or acids or whatever, use distilled water, which is safe and inexpensive.

PREPARING MEDIUM

As mentioned earlier, the yolk of the egg is a better binder than the whole egg. Egg-yolk-and-water medium is made by separating the yolk from the white and mixing the yolk with water. Prepare enough medium to last one or two days—the egg yolk will spoil if you keep it too long, even though you store it in a refrigerator. Take care not to break the yolk when you separate it from the rest of the egg. Dry the white from the yolk sac by rolling the sac gently on a paper towel or patting it with a tissue. Then, pick up the yolk carefully in your fingers and squeeze it or prick it to break the sac and let the contents run into a clean jar or glass. Add enough water (room temperature) to get a consistency about like that of light cream. If you get bits of the egg sac in your mixture, you can strain the egg-and-water mixture

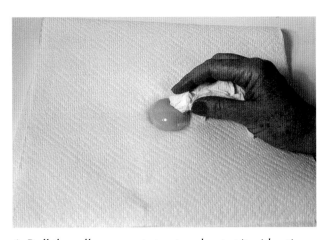

1. Roll the yolk sac on a paper towel or pat it with a tissue.

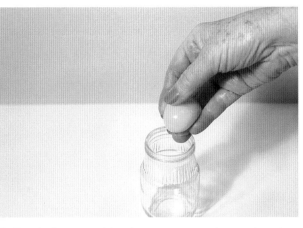

2. Break the sac and let the contents run into a clean jar.

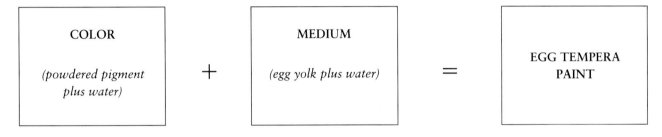

COLOR *(powdered pigment plus water)*	**+**	MEDIUM *(egg yolk plus water)*	**=**	EGG TEMPERA PAINT

through cheesecloth. The container for the medium should be a narrow one (not a saucer, for example) so that as little surface of the mixture as possible is exposed to air. A baby food jar works well.

MIXING PAINT AND MEDIUM

Place dabs of pigment paste on your palette using a clean palette knife or spoon or similar tool—or squeeze some from a tube. Then add medium to each paste color, making small puddles of paint—as much as you need for the next half-hour or so. Don't mix paint for the whole day—it will dry out and be ruined. You may adjust the proportions of medium and pigment (a fifty-fifty mix is about right) to get more or less transparency, and you may freely add water to the paint to get the consistency you want. Don't dip into your clean supply of medium with a brush or knife that has paint on it—keep the medium clean. You may pour small amounts of medium onto your palette, or use an eyedropper.

Test your paint to make sure there is sufficient medium in it by painting a few strokes on a piece of glass or plastic. If the dried paint can be separated from the glass with a knife in a cohesive strip that's not dry and crumbly, it should be okay. Otherwise, add more medium. If the paint dries too slowly (minutes rather than seconds), you may be using too much medium.

TOOLS AND ACCESSORIES

Depending on your approach to this medium (see Getting Started), you'll need some or all of these items:

BRUSHES

If you choose to paint in the traditional style, doing hatching and crosshatching, you'll need a few small, pointed brushes. You can use either synthetic or natural, provided you choose brushes with sharp tips and care for them well.

Many modern painters in egg tempera combine delicate hatching with much more vigorous brushwork. They use larger brushes in addition to the small pointed ones. A variety of flat brushes can be used for laying down broad areas of paint, and their ends can be used in a stabbing motion to stipple or create textures.

KNIVES AND RAZOR BLADES

Regular palette knives and painting knives are used to mix pigments with medium and often to apply paint to your panel (but in very thin layers—not impasto). Razor blades and X-Acto blades are used to scrape out areas for repainting. You can snap the edges of several razor blades with a pair of pliers to make scrapers of different sizes.

ROBERT VICKREY
Capturing a Mood in Egg Tempera

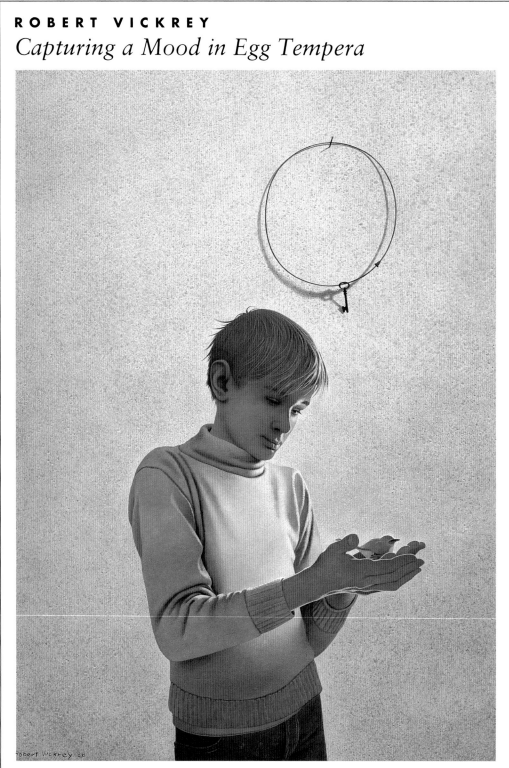

Robert Vickrey has long been one of the very few masters of the egg tempera medium in this country. In this painting, as in all his work, he uses the subtle glow so often associated with egg tempera, along with a spareness of design, to establish a mood of solitude and contemplation around his son, Sean.

MOCKINGBIRD
Robert Vickrey
Egg tempera on Masonite
31″ × 23″
Private collection

EGG TEMPERA SHOPPING LIST

BASICS	✓		✓
POWDERED PIGMENTS (1-ounce jars) *OR* TUBE WATERCOLORS Ultramarine Blue Phthalocyanine Blue Phthalocyanine Green Cadmium Red Cadmium Yellow Yellow Ochre Burnt Sienna Raw Sienna Burnt Umber Raw Umber Titanium White Ivory Black		SUPPORT untempered hardboard 16″×20″ *or* Strathmore Series-500 illustration board	
		GROUND (not necessary on illustration board) Unflavored gelatin and gesso mix	
		FRESH EGG YOLKS	
PALETTE, such as enameled tray or paper palette		PIGMENT STORAGE CONTAINERS small jars or small paint tubes	
		WATER CONTAINERS	
BRUSHES 2″ flat 1″ flat ½″ flat no. 10 round no. 6 round no. 1 round no. 0 round no. 000 round some worn bristle or other stiff brushes		PAPER TOWELS	
		WATER SPRAYER	
		OPTIONAL	✓
		PAINTING KNIFE AND PALETTE KNIFE	
		SPONGES: KITCHEN AND NATURAL	
		DRAFTING TAPE	
		SANDPAPER	
		EYEDROPPER	

PALETTE

If you use too slick a palette, your paints may tend to bead up. A white plastic or enameled palette *slightly* roughened with very fine sandpaper works nicely, or you may use paper (disposable) palettes, the less slick, the better.

PAPER TOWELS

Keep a small stack of paper towels cut into quarter-sheets for wiping out a wet section of paint, cleaning a painting knife, draining excess paint from a brush and general mop-up.

MISCELLANEOUS

Use a medium grit sandpaper for making corrections, and very fine sandpaper for smoothing the corrected area before repainting. Keep plenty of small pieces of sandpaper handy, and discard a piece as soon as its grit becomes clogged.

Use a large container of water for keeping brushes clean and a smaller container for clean water to add to paint mixtures. Also keep a spray bottle filled with water for misting your palette to keep paints from drying.

For texturing, use a variety of sponges, both natural and commercial.

GETTING STARTED

There are a number of surfaces you could use for egg tempera. Stiff illustration or watercolor board is good, provided you choose a board with a hard surface, such as Strathmore 500-Series illustration board (softer surfaces make it difficult to scrape off paint cleanly when making corrections). A product made by Ampersand

called Claybord (hardboard with a white clay coating) provides a nice, receptive surface and it allows corrections to be made easily. It comes in many sizes, starting at 5" × 7". Acrylic gesso on a hardboard or wood panel is a safe surface to use, but it's not quite as receptive to egg tempera paint as is Claybord or illustration board. The traditional, preferred painting surface for egg tempera is a hardboard (or wood) panel coated with a true gesso ground. It has a lovely, receptive surface for this medium, and it allows easy scraping-out for corrections or texturing.

HOW TO PREPARE A PANEL

1. Choose a piece of untempered hardboard, such as Masonite, in the size you need. Sand front, back and edges to remove any films or dirt and to provide a bit of tooth. Wipe clean with a damp cloth. Rub dry with paper towels.

2. Coat both sides of the panel with *size* to close the panel's pores and prevent deep absorption of the gesso. Two common sizes are gelatin (or gelatine) and rabbitskin glue. Rabbitskin glue is available at many art supply stores—prepare it as instructed on the package.

If you use gelatin, you have two choices: the cooking variety is readily available at grocery stores and the less expensive leaf, or sheet, variety can be bought from chemical, laboratory and drug supply houses. If you use cooking gelatin, dissolve the powder in water as directed on the label, typically one packet of powder to ¼ cup of cold water. If you use commercial gelatin, dissolve about one part (by volume) of gelatin in about sixteen parts cold water. After all the water is absorbed you'll have a thickish mass. Heat this in the top of a double boiler (stirring frequently) until the mass becomes a clear liquid. Don't overheat (boil) the gelatin.

Scrub a thin layer of *warm* sizing (glue or gelatin) onto both sides of your panel with a stiff brush to penetrate and seal pores. Allow to dry thoroughly.

Note: If you wish to avoid using animal products, use illustration boards without gesso, or hardboard panels prepared with acrylic gesso.

3. Coat one side of the panel with gesso, using a large (two- or three-inch), fairly stiff brush. When dry to the touch (normally a few minutes) turn the panel over and coat the other side. Coating both sides helps prevent warping. As each coat dries, repeat the process until each side has at least three coats of gesso. Each time you brush on another coat of gesso, brush in a direction perpendicular to that of the last coat to get an even coating.

To prepare a panel with a true gesso ground, you'll need gelatin, gesso mix, a double boiler, a sanding block and a wide brush.

Although you may make your own gesso mix, you can buy a prepared mix, such as Rowney Gesso Powder, Grumbacher Dry Gesso Mixture or Fredrix Gesso Ground Dry Mix. They typically contain three ingredients: crushed marble, titanium white pigment and animal glue. Prepare them according to the directions on the labels.

4. When the gesso is *bone dry* (give it at least a couple of hours), sandpaper the working surface until it's as smooth as you wish. Many artists like to produce a surface that's ivory-smooth (it will still have plenty of tooth for paint adhesion), while others prefer a rougher surface. That's up to you. If you want a smooth surface, be sure to finish up with a very fine sandpaper. If you sand so much that you expose some of the brownish panel, you either overdid the sanding or you need to use additional coats of gesso.

You may sand *between* coats of gesso if you wish, but I usually sand only once. You can do a good job with an electric flat-sander and finish up by hand with fine sandpaper wrapped around a block of styrofoam big enough to fit your hand. If you use an electric sander, be careful to keep it perfectly flat so as not to gouge the gesso surface. Change the sandpaper as soon as it becomes clogged with gesso dust.

Pre-Gessoed Boards

If you find pre-gessoed panels available at your art store, by all means try them. But if you're after true gesso rather than acrylic, ask questions. The Dick Blick catalog, for example, offers a "gessoed panel," but it's coated with *acrylic* gesso.

DRAWING

Since egg tempera is translucent, dark drawing lines may show through the paint. It's best to develop your drawing on paper and then use graphite transfer paper to copy the drawing onto your panel. Use just enough pressure with a blunt pencil or ballpoint pen to get a faint image without dark lines and without scoring the panel's surface.

TRADITIONAL TECHNIQUES

The traditional way of painting with egg tempera is to build up layers of paint using many thousands of tiny strokes, working generally from light to dark. Using only small, pointed brushes, make relatively short strokes and lift the brush briskly from the panel at the end of each stroke to avoid the formation of tiny blobs of paint at the ends of strokes.

You may apply pure colors to the painting, one over another, and build up the final color you want, essentially mixing on the panel. Or you may mix colors on your palette, as you might with any other paint.

Each stroke dries in seconds and you may overlay strokes practically without limit until you've built up the effect you want. You may use any type of stroke, straight or curved, long or short, hatched or cross-hatched. Some strokes (in a finely blended sky, for example) may be essentially points (stippling), not lines.

MODERN TECHNIQUES

Many painters use traditional strokes along with much looser, gutsier treatments, thanks in great measure to the example set by Robert Vickrey. They use flat

Use blunt brushes for stippling, or stabbing paint onto the panel. This is one way of getting a blended effect, as in this section of sky. If you stipple repeatedly over existing paint layers, stab lightly enough that you don't disturb, loosen and pick up the existing layers.

brushes, sometimes quite large, to lay in broad areas or to glaze over an area. They scumble. They flick, or spatter, paint by riffling the hairs of a paintbrush or toothbrush. They stipple either with the point of a brush or the broad, blunt end of a large brush. They lay down thin layers of paint with a painting knife or a sponge. In short, there's not much you can do in other mediums that you can't do in egg tempera—*except* lay on thick paint.

Shown here at actual size are some of the techniques you can use in egg tempera. The blue-gray base color was painted with a ½" flat brush. Some rough, broken color was applied in thin layers with a small painting knife. Whitish spots were attained by squirting small water droplets onto the painted surface and then blotting with a paper towel—wherever there was water, paint was lifted by the blotting. The highlights along the sunlit edges of the boards were scraped out with an X-Acto blade. Everything else was done using a no. 00 rigger.

These strokes were made using a one-inch flat brush. One stroke ends in a blob because the brush was not lifted quickly enough at the end of the stroke. It's virtually impossible to go back and mop up to even out such a blob. In egg tempera, you can't "fix" a stroke while it's still wet, but you can wait for it to dry, scrape it out and do it again.

Use a sponge to create texture, working fast before the paint dries in the sponge. Clean the sponge immediately.

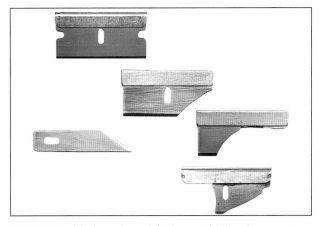

An X-Acto blade and modified razor blades for scraping out sections of paint.

MAKING CORRECTIONS

You can "erase" a fresh passage if you quickly scrub it with a bit of coarse cloth, such as cheesecloth. Once the paint has dried, you may scrape out a passage with a razor blade or sandpaper, all the way down to the gesso, if you wish. In any scrape-out operation, be exceedingly careful not to gouge your panel.

If you use razor blades, file off the corners of the blades to help prevent accidental gouging. You can snap off pieces of a blade with pliers to get whatever size you want (protect your eyes when snapping off blades!). Usually it's best to hold a razor blade nearly perpendicular to the painting and scrape with a light scuffing motion, not a digging motion. You'll need patience in order not to ruin your panel.

If you use sandpaper, shape a small, clean piece around an appropriately sized object (such as your finger or a small block of wood) and sand until the paper clogs. Continue with a new piece of paper. Use a medium-to-coarse paper if you're taking out a large area, and finish up with a fine grit. Blow or brush the dust away as you work so you don't grind loosened paint back into the panel.

In a first try at the demonstration painting, I took the lazy route and worked on Whatman watercolor board instead of a gessoed surface—big mistake. The Whatman surface is fragile, and the first time I tried scraping out a passage I began shredding the paper. If you choose to paint on watercolor or illustration board, choose one that has a hard surface, such as Strathmore 500-Series illustration board. But better yet, use a gessoed hardboard that makes corrections a snap.

VARNISHING

An egg tempera painting is always subject to physical damage from scraping, gouging and staining by water or other fluids. You may protect it from such damage by framing it under glass as you would a watercolor. Or provide partial protection by framing it without glass, using a deep frame that projects far enough beyond the painting's surface to act as a sort of bumper.

If you choose to use varnish instead of framing under glass, understand that varnish may change the values and colors in the painting, depending on how heavy a coat you apply and the type of varnish you use (probably an acrylic matte varnish will produce the least change in the appearance of the painting). Varnish may also change the look of the surface, and that special look is part of the allure of egg tempera. Once you varnish, you can no longer add egg tempera paint unless you remove the varnish, a tricky business.

Painting Loosely With Egg Tempera
by Phil Metzger

1 *I transferred the drawing lightly to the panel using graphite transfer paper and laid in a rough underpainting using a 1" flat Grumbacher Aquarelle brush. I could afford to be loose because my subject was a rough old barn. Had I chosen a smooth, delicate subject, such as a child's face, my approach would have been more careful.*

2 *I built up texture and color, mostly using a ½" flat brush, but often painting lightly with a fine natural sponge, and sometimes laying on thin glazes of paint with a painting knife. For most paint mixtures I used a 50-50 combination of color paste and egg yolk medium. Sometimes I added a little more water.*

3 *Now I worked up the details using a Robert Simmons no. 0 round Aquatip, a brush with a fat handle that's more comfortable to hold than typical small brushes with skinny handles. I laid in shadows using the Aquatip and the ½" flat, taking care to allow the areas under the shadows to remain visible. Finally, I scraped out the tree with an X-Acto blade and painted the exposed white gesso using the Aquatip.*

BARN OVERHANG
Phil Metzger
Egg tempera on gessoed ¼" hardboard
9"×11"
Collection of Mr. and Mrs. Morris Waxler

Recipe:

Paint:
four egg yolks; distilled water; Cobalt Blue, Yellow Ochre, Raw Sienna, Burnt Sienna, and a pinch of Ultramarine Blue and Cadmium Yellow Light

Panel:
¼" untempered hardboard; two packets Knox Gelatine; one cup Fredrix Ground Dry Mix

Sandpaper ½" Aquarelle brush Aquatip brush Sponge Eggshells Water container Drafting tape

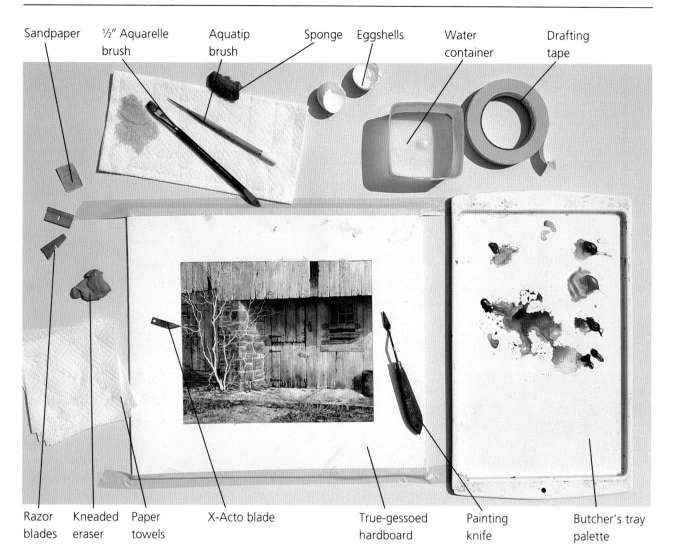

Razor blades Kneaded eraser Paper towels X-Acto blade True-gessoed hardboard Painting knife Butcher's tray palette

MAKING CORRECTIONS TO EGG TEMPERA

Scraping away egg tempera paint is easy, provided the ground is hard (like gesso) and unlikely to shred (like some watercolor boards). The tree shape has been scraped out, down to the white gesso, using only an X-Acto blade.

This is the painting called Barn Overhang *shown in the step-by-step demonstration on page 137.*

Society Notes

National Academy of Design
1083 Fifth Avenue
New York, NY 10128

American Watercolor Society
47 Fifth Avenue
New York, NY 10003

WHAT IS GOUACHE?

Gouache (pronounced gwash) is opaque watercolor. Like watercolor, gouache contains a gum binder, as well as sugars and glycerin to improve the paint's handling characteristics. But in addition, gouache is made to be *opaque* by the addition of an inert chalky material such as precipitated chalk or blanc fixe. Watercolor is generally little more than a stain, while gouache is a paint film with measurable (albeit small) thickness.

Gouache is not poster paint. Poster paint, intended mainly for children's use, usually has a starch base. Poster paint is not at all permanent, and it easily cracks with age.

BASIC PROPERTIES

Various forms of what we now call gouache have been used for centuries. Gouache is a favored medium for illustrators because it allows changes to be made easily, it lends itself to fine lines or broad, graded passages, it's well suited to airbrushing, and its opacity allows for deliberate buildup in thin layers, working either from dark to light or light to dark. It also dries to a uniform matte finish, so there is no gloss to interfere with photographic reproduction. All those qualities make it suitable for fine art, as well.

Gouache paint should not be applied in impasto fashion, because dried gouache is brittle and thick layers could crack and flake off the support. Instead, build up a painting using thin layers—the opacity of the paint is such that you don't need thick layers to get hiding power.

A stroke of gouache dries fast, so you'll often notice brush streaks, especially if you're covering a large area. To slightly slow down the drying and minimize streaking, professional illustrator Rob Howard adds a dozen drops of ox gall to each cup of water he uses for mixing his paints. Streakiness can also be fixed by gently going over an area of dried paint with a damp brush. In fact, such blending is one of gouache's attractive features.

The finished surface of a gouache painting is uniformly matte, but you must take care not to mar the finish. Chance scraping or rubbing with any hard object may produce a shiny streak on the otherwise matte surface, and oil from your hands can cause a blemish. Howard advises wearing thin cotton gloves (with all the fingers except the pinky cut off) to keep the heel of the hand or the little finger from resting on and marring the

painting surface; Daniel Tennant suggests using a mahlstick. Some painters varnish the finished painting, but many simply frame the picture under glass.

Like watercolors, gouache paints from different manufacturers are compatible, so you can intermix brands freely.

HOW GOUACHE IS SOLD

Gouache is available in tubes of several sizes, including 5, 14 and 15 ml (and for whites and blacks, 37 ml). Cakes are also available but not so commonly used. As with all paints, I suggest you avoid student grades and stick with artist-quality paints, such as Winsor & Newton Designers Gouache and Holbein Gouache.

Each manufacturer uses a rating system to indicate the permanence of its paints. Winsor & Newton, for example, uses the same designations for both their gouache and watercolors: AA (extremely permanent), A (permanent, durable for most uses), B (moderately durable) and C (fugitive). Unless you're an illustrator and permanence is not a concern, avoid C and be leery of B.

> ## Looking Back
>
> Winsor & Newton's popular gouache, called *Designers Gouache*, is so named because decades ago the company made colors for English carpet designers.

Mid-size tubes of gouache (14-15 ml) are popular. The smallest tubes (5 ml) are not practical except for those colors you use infrequently. You'll use a lot of white, so buy it in larger tubes.

NED MUELLER
The Unique Properties of Gouache

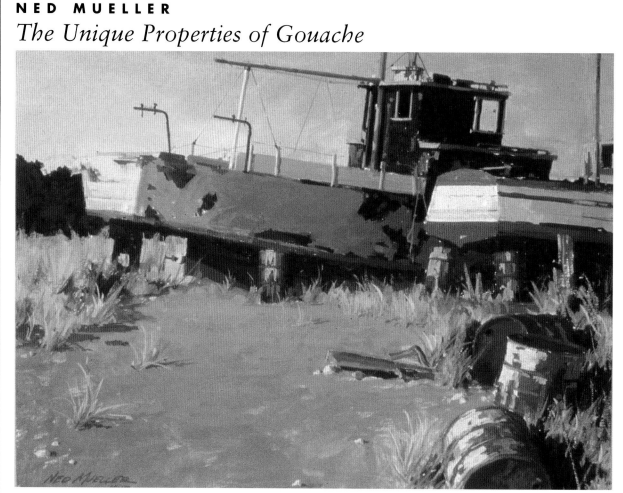

THE BONEYARD
Ned Mueller
Gouache on Crescent cold press illustration board
10" × 13"
Collection of Mrs. Mary Bass

"I prefer Winsor & Newton Designers Gouache and also use some Grumbacher colors. I like Winsor & Newton series 7 round sables, but because of the expense I often use some of the fine synthetic brushes. I use a butcher tray for my palette, but most watercolor palettes will work just as well.

"After working out my design on scrap paper, I draw directly on the board with a soft graphite pencil. Sometimes I use a light spray of fixative to keep the graphite from smearing. For this painting, I underpainted with a watery mixture of Cadmium Red Pale and Cobalt Blue to set the mood I wanted.

"Then I began with bold, wet, opaque mixtures for the sky—the opaque paint gives more richness than I'd get from a watery treatment. I work rapidly to block in the entire picture surface, and then go

back and make color and value corrections. By its nature, gouache has a hard-edged quality. I modify hard edges by softening and blending paint with a clean, damp brush. I also do a lot of dry-brush painting with small brushes to modify edges and transition areas.

"Used opaquely, gouache may be painted light over dark, or vice versa. Gouache usually dries a value or two lighter than it appears when wet, but lighter tones may dry *darker* than they first appear if they're laid *over* a dark tone. By painting directly and opaquely, you can achieve brilliant lights and rich darks. For major corrections, I sponge out an area, softly rubbing and dabbing away the loosened paint. For smaller areas, I use a clean wet brush to lift out paint."

SUPPORTS AND GROUNDS

Illustrators often paint on flexible surfaces that can be rolled around the drum of a laser color separator in preparation for reproduction. If they use gouache paint, they must paint quite thinly and special care must be taken not to crack the brittle paint film. If laser reproduction is not a concern, it's best to use a rigid support. Illustration board, watercolor board, hardboard, canvas mounted to hardboard and wood are all good supports for gouache. It's best to select a surface with some tooth, but gouache will adhere well even to a slick surface, such as hot press paper or acetate, if you add a little wetting agent to your mixing water. Experiment to find out how much wetting agent is needed for the surface you're using.

You may paint directly on the support (probably the most common choice) or first coat the support with a ground of acrylic gesso or true gesso. Many painters feel acrylic gesso is unreceptive to traditional gouache and prefer to paint directly on an uncoated support, most often illustration or watercolor board.

ACRYLIC-BASED GOUACHE

In addition to traditional gum-based gouache, there are now acrylic-based gouaches. Two examples are Holbein's Acryla Gouache and Turner Acryl Gouache. The

Acrylic-based gouache handles much like traditional gouache, but it cannot be reworked once it has dried.

two use different types of acrylic binder, so their working characteristics differ, but in both cases, the paint dries more water-resistant than regular gouache. This means you can paint over acrylic-based gouache without disturbing it. You can freely intermix layers of regular and acrylic-based gouache.

For a minute or so these gouaches may be reworked and manipulated pretty much the same as regular gouache—after that the paint becomes almost insoluble. It dries to a beautiful, flat finish. Acrylic gouache is difficult to clean from a plastic palette, so it would be better to choose an enameled or paper palette instead.

The painting by Rob Howard on page 148 and the demonstration later in this chapter by Shirley Porter were done with Holbein Acryla Gouache (sold in 20 ml and 50 ml tubes).

GOUACHE SCORECARD

FEATURE	PRO	CON
colors available	over 120	many are not rated permanent
brand compatibility	no problems	
film strength		brittle
opacity	very high	
resistance to damage		must be protected against physical and water damage
making changes	easy	
drying time	fast (minutes)	
yellowing	none	
adhesion	excellent on all porous surfaces	doubtful on oily or extremely slick surfaces

Health Tips

1. Some gouache colors, such as the cadmiums and cobalts, carry warning labels. Follow sensible precautions to avoid ingesting these paints. Keep your hands clean and don't hold brushes in your mouth.

2. If you use an airbrush, don't inhale the spray. Work in a well-ventilated area and use a face mask.

JESSICA ZEMSKY
A Painter-Friendly Medium

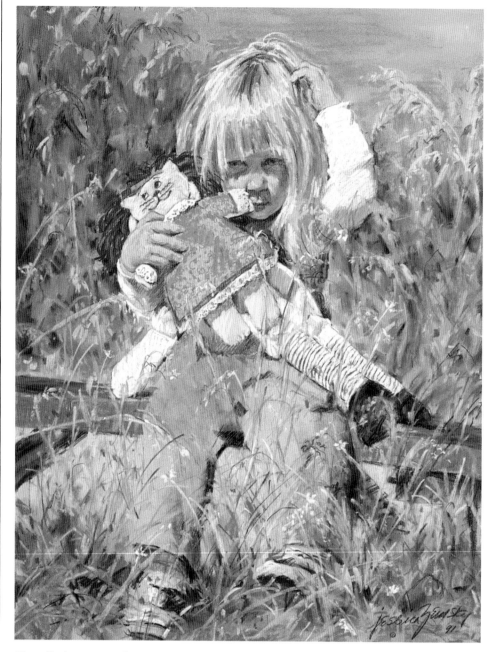

WHERE'S ANNIE?
Jessica Zemsky
Gouache on paper
20″ × 16″

"I really love gouache. It's 'painter-friendly'—you can mix so many colors together and not get gray or muddy. I find it a magic medium for doing paintings of children. It keeps their young flesh tones fresh and full of life. I want my paintings to be full of color and gouache is the absolute ideal answer.

"I painted *Where's Annie?* on toned paper. I drew on it first with brown Prismacolor pencils and then stretched the paper as you would a watercolor. I use round Pro Arte brushes that hold lots of paint

and keep a great point longer than any others I've found. My paint is Winsor & Newton Designers Gouache. I work with thin washes to begin with and go opaque as I build up the color. At the end I often add a touch of pastel."

Note: Jessica and her husband, painter Jack Hines, are the exclusive dealers in the U.S. for Pro Arte products; see Art Materials Sources in the back of the book.

TOOLS AND ACCESSORIES

The Watercolor chapter includes a discussion of brushes, palettes and other tools, all of which may be used for painting in gouache. As in watercolor, you'll need two water containers, a large one for keeping brushes clean and a smaller one with clean mixing water. A difference between watercolor and gouache is this: Your container of brush-cleaning water will quickly become clouded as you wash gouache-filled brushes in it, so you'll need to replace the water more frequently or use a larger container, or both.

Another possible difference from watercolor involves the use of tape as a mask. If you mask over gouache, even ordinary drafting tape *may* pull up some paint when you remove it. Test your tape to be sure. The brand of tape I use, Scotch 230 Drafting Tape, works fine. With any tape, you can make it less tacky by first pressing it out on some smooth surface (thus removing a little of its adhesive) before putting it on your painting.

Among your watercolor tools may be a hair dryer. Unless your layer of gouache is very thin, don't use the hair dryer to accelerate drying because there is some danger of cracking the paint layer.

GETTING STARTED

You may draw with a medium-soft pencil directly on the painting surface or develop the drawing first on paper and then transfer it to the drawing surface. For looser treatments, draw with diluted gouache paint. Although gouache has excellent opacity and can easily cover any lines in your drawing, it makes sense to make your drawing only dark enough that you can easily follow it.

A nifty technique developed by Rob Howard is this: After completing your drawing on the support, coat it with several thin layers of acrylic gesso, completely covering the drawing. Then sand the gesso until the drawing reappears. You'll have a smooth working surface and a drawing still trapped under a thin film of gesso, so that it can't bleed through into your gouache.

GOUACHE SHOPPING LIST

BASICS	✓
PAINTS (14 ml tubes) Ultramarine Deep Phthalocyanine Blue Cobalt Blue Permanent Green Light Viridian Cadmium Red Deep Cadmium Red Light Cadmium Orange Cadmium Yellow Deep Yellow Ochre Raw Umber Burnt Sienna Burnt Umber Zinc White Permanent White Ivory Black	
OX GALL OR OTHER WETTING AGENT	
PLASTIC PALETTE *OR* ENAMELED OR PAPER PALETTE (if using acrylic-based gouache)	
ILLUSTRATION BOARD	
BRUSHES 2″ flat 1″ flat ½″ flat no. 10 round no. 6 round no. 4 round no. 1 round no. 0 round rigger	
TWO WATER CONTAINERS (one large)	
SPRAYER (Windex bottle)	
PENCIL, MEDIUM-SOFT	
KNEADABLE ERASER	
TRANSFER PAPER	
PAINTING BOARD	

OPTIONAL	✓
PAINTING AND PALETTE KNIVES	
SPONGES: KITCHEN AND NATURAL	
LOW-TACK DRAFTING TAPE	

PAINT APPLICATION

You may dilute gouache to paint thin veils of color, especially for underpainting, but in subsequent layers, you should generally thin the tube paint with water to the consistency of cream. You may vary the mixture a lot without problems, but remember that gouache is not suitable for thick, impasto painting. Thick passages may crack as they dry. (You may, however, use it as impasto if you mix it with Winsor & Newton Aquapasto painting medium.)

Gouache dries quickly, so you don't have the luxury of fussing with it once you've put it on. You'll often end up with brush marks you don't want, but they will have dried before you can smooth them. However, once the paint is dry, gently go back over an area with a slightly damp, clean brush and do all the smoothing you wish. Regular gouache rewets easily. Be careful not to use too much water or bear down too hard with the brush, or you may end up with a pasty mess. A way to minimize visible brush strokes is to mix a dozen or so drops of ox gall to each cup of your paint-mixing water.

You may use most of the painting techniques you use for other mediums, such as watercolor or acrylic. You may spatter, or flick paint by riffling the bristles of a brush (taking care first to mask the areas where you don't want spatter); use a painting knife to develop texture (but with *thin* layers of gouache); use sponges, tissues, cloth and other materials to create texture; and produce graded tones and special effects by using gouache in an airbrush. You may also scrape out or sandpaper areas you wish to repaint, or scrub them out with a bristle brush—these are effective actions if you're using conventional gouache, but much more difficult if you're using acrylic gouache.

One of gouache's endearing qualities is its opacity, which allows you to cover dark with light or light with dark. You may work in any direction you wish, therefore, as far as values are concerned.

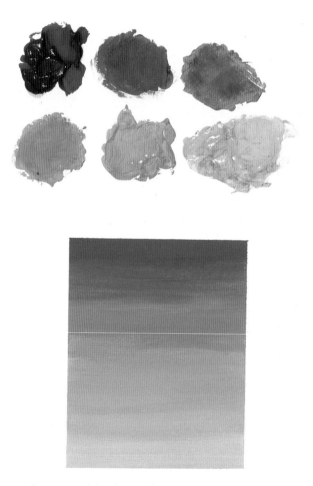

Gouache dries quickly, so getting graded, blended color is not as easy as in watercolor. One technique is to lay down adjacent stripes of gradually lighter color. As soon as the paint is dry, go back over the "joints" between the stripes with a soft, damp (not wet) brush. Brush gently and patiently and you'll get a smooth transition from one stripe to the next. Here I've blended the stripes once and allowed the paint to dry (only a minute or so), and then blended them a second time. To get a completely smooth transition, I could go back any number of times. If you scrub too hard or use too wet a brush, you'll pick up paint instead of smoothing it. This technique works much better on rough or cold press paper than on hot press, because paint lifts too easily from a smooth (hot press) surface.

Another way to blend gouache is to paint wet-in-wet—that is, lay down adjacent stripes of paint quickly before the previous stripe is dry. First mix the puddles of paint you need to make the transition you want, then brush them on in succession, overlapping stripes slightly and quickly blending edges. This works better if you first dampen the paper (not too wet or your gouache will be thinned to watercolor as you brush it on).

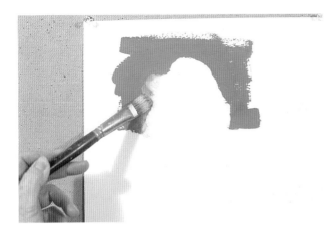

Here is a rough cloud formation against a blue sky. The paint is dry. I've begun to soften some edges with a damp brush. If you're using traditional (not acrylic) gouache, you can dampen and push around the paint to blend and soften edges as much as you wish. You can also use a stiff brush, such as a synthetic or bristle, to add paint to an area and at the same time loosen paint that's already there. To do this, you gently "poke" at an area until you've loosened and blended the paint to your satisfaction.

WHITES

There are two whites available: Zinc ("Chinese") White and Titanium ("permanent") White. Experienced gouache painters use *only* Zinc White for mixing with other colors because it's more tranparent than Titanium White and it mixes to form beautiful tints without a chalky look; Titanium White is useful for painting solid white passages against a dark background.

A bit of white that gets into your other paints inadvertently can produce some chalky messes. Keep your white paint well separated from your other colors and be sure to keep your brushes clean. Don't dip into a color with white still on your brush, and don't dip into white paint with some other color on your brush.

To paint an area of solid color, brush in one direction and then, while still wet, brush in a perpendicular direction to smooth the paint.

COLOR MIXING

When you mix a white with another color you decrease the color's brilliance. Sometimes you get a tint that may not be what you expected—rather than a lighter version of the color, you get a seeming shift in color. Sometimes the tinted color is much cooler than the original color. You may find similar problems if you add black to lower a value. For that reason, you must sometimes alter a gouache color's value by adding *other colors*, rather than adding white or black. For example, to raise the value of Yellow Ochre, you might add Cadmium Yellow Pale; to lower the value of Cadmium Yellow Pale, you might add Yellow Ochre. Rob Howard's *Gouache for Illustration* offers a lot of help in color mixing.

WET VERSUS DRY

In watercolor, there are significant differences between the value of a wet passage and that same passage when dry. Although value-shift is not as drastic in gouache, there is some, especially among the darkest colors. Some colors lighten as they dry, while others darken. It's something to get used to and learn to compensate for.

You may work from dark to light or from light to dark. A thin stroke of paint covers fairly well, and a second stroke (after the first is dry) covers nearly completely. Had I used thicker paint, one stroke would have been enough.

Airbrushing With Gouache

Here's some advice from a master painter in gouache, Daniel K. Tennant. For a lot more on the use of gouache with and without an airbrush, see his 1996 book, *Photorealistic Painting* from Walter Foster Publishing. It includes demonstrations and over 170 color illustrations.

"If someone had to design the perfect medium for airbrushing, it would be gouache. These versatile opaque watercolors can be thinned for the airbrush without losing their opacity and they dry so rapidly that they are perfect for airbrushing. Gouache won't clog the airbrush, either. I had used gouache paints in the traditional way with brushes for years. Then I tried them in an airbrush and immediately expanded my painting possibilities. I found there were effects that simply could not be achieved with brushwork alone. Blowing snow, smoke, mist, shimmering highlights on metal, or beautiful graded blendings—the airbrush was the tool that could do it all.

"Usually painters drybrush or crosshatch over gouache so as not to disturb the existing paint layers. The airbrush allows you to paint over previously applied gouache without disturbing it.

"I use an Olympos MP-200B for fine work. Sometimes I load it with gouache, sometimes with watercolor, depending on the degree of opacity or transparency I'm after. I never took airbrush lessons, so this should not stop you. Buy a good book, such as Judy Martin's *The Complete Guide to Airbrushing Techniques and Materials* (Chartwell). I found it terrific.

"There are over 125 different airbrushes. I recommend an 'interior mix' airbrush, which mixes air and paint within the body of the airbrush and produces a uniform spray. I use a 'double action brush,' which gives the greatest control in paint application—pressing the trigger down gives you a stream of air, and pulling it back gives you a gradually increasing mix of paint with air. A good airbrush can cost between $80 and $400. I started with a cheap one, fell in love with airbrushing, and bought more expensive ones. If you have the drive and interest, you can learn airbrushing quickly."

DANIEL K. TENNANT

WHAT IS CASEIN?

Casein paint is an opaque, water-based medium similar in many ways to gouache—but rather than a gum binder, it uses *casein*, a derivative of milk curd. While used as a powerful adhesive for centuries, casein was adopted as a binder in artists' tube paints in the 1930s. Although other water-based paints, such as acrylic and gouache, have become more popular, casein paint is still used by many illustrators and fine artists.

Casein paint is thinned and cleaned up with water. It may be painted in thin washes or in heavier, more impasto fashion—but not too thick, as a thick film may crack. You can cover dark paint with light and vice versa. The paint dries fast, but may be rewet and reworked during the hours and days (sometimes weeks) after it's applied. In time the paint becomes resistant to moisture. It dries to an even, matte finish.

Casein paintings may be done on any surface used for gouache, such as watercolor paper or illustration board, or on most nonoily surfaces. To avoid cracking, a rigid support is best. You may use the same brushes, palette and other tools as for gouache. Like gouache, but unlike acrylic, casein paint may be easily sanded or scraped to make corrections.

Casein paint is made by Shiva and is available in over thirty colors.

Society Notes

American Watercolor Society
47 Fifth Avenue
New York, NY 10003

DANIEL K. TENNANT
Brush and Airbrush Magic

FANCIER'S FANTASY
Daniel K. Tennant
Gouache and watercolor on museum board
40" × 60"
Private collection
Photo courtesy of Gallery Henoch, New York, NY

"This was one of the most challenging paintings I have ever undertaken. The challenge was to capture ivory, ceramic, cloth, glass, wood, tapestry, velvet, bone, silver, paper, plastic, feathers, marble and silk. After first painting the background and then the foreground cloth, I worked on the objects one at a time, starting with the most distant one (the silver trophy cup) and working my way forward. In addition to gouache brushwork, I sprayed on watercolor glazes with an airbrush. I also used Prismacolor pencils to render texture in the background cloth.

"While airbrushing, it's often necessary to mask some areas to make sure the spray lands only where you want it to. I protect areas using pieces of newsprint and drafting tape.

"For quickness of drying, terrific color selection, ability to achieve fine lines and tremendous opacity, nothing compares to gouache. It's easy to clean up, nontoxic, and superb for photographing because of its matte finish. I use Winsor & Newton Designers Gouache because I like its high quality and opacity. Winsor & Newton's Sceptre series 101 brushes are fine performers. While I use sizes 00 to 8, a no. 2 brush is the workhorse for most of my paintings.

"It's important to use a sturdy support for gouache as flimsy supports will cause the paint to crack. Gouache should be applied in a creamy, brushable consistency. Too thick a layer can crack. Some artists find the quick drying a problem—but it's this characteristic that makes it so practical because you can cover a lot of territory in an hour. Despite the size and complexity of this painting, I finished it in just 120 hours."

DANIEL K. TENNANT
Capturing a Mood in Gouache

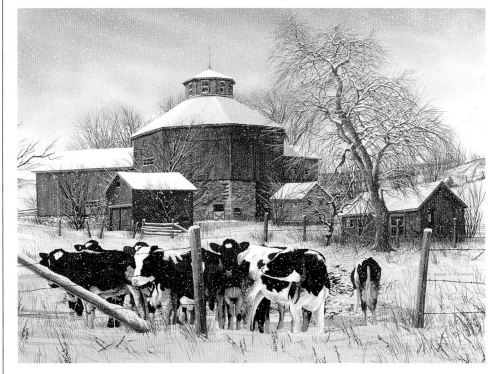

COUNTRY WINTER
Daniel K. Tennant
Gouache on
illustration board
30″ × 40″
Collection of Dr.
Gary D. Tennant,
Homewood, IL

ROB HOWARD
A Crabby Illustrator

CRABS
Rob Howard
Holbein Acryla Gouache on
pebble-textured mat board
11″ × 11″

This painting by a master illustrator will appear in Holbein Acryla advertisements. It was done directly, *alla prima*, with very little blending.

DEMONSTRATION

Abstract Landscape in Acrylic Gouache
by Shirley Porter

1 *Working with Holbein Acryla Gouache and synthetic brushes, Porter laid in an abstract design as the base for the painting.*

Acryla is gouache that uses acrylic polymer emulsion as its binder. The acrylic binder allows overpainting without disturbing the paint underneath. It's a very smooth-handling paint and its opacity allows you to paint easily light over dark or vice versa.

2 *Next Porter added a second group of abstract shapes. These define smaller, more detailed areas of the design and introduce additional colors.*

Her palette for this painting included Ultramarine Blue, Carmine, Light Green, Sap Green, Burnt Sienna, Yellow Ochre, Deep Yellow and Chinese White.

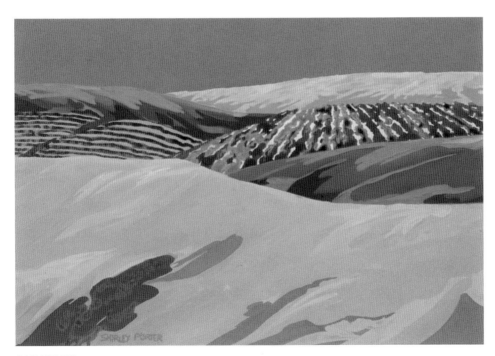

3 *Finally, Porter added some detail and adjusted values. The sky and foreground were both brighter than she had wanted, so she painted over them (easy to do) with a toned-down mixture of the original color. Where she wanted softened edges, such as where the yellow and purple passages meet, she blended quickly. Acryla does not allow the blending time of regular gouache. Once dry, it cannot be reworked.*

FAR FIELDS
Shirley Porter
Holbein Acryla Gouache on Crescent illustration board
12″ × 18″

Pencil, Pen & Ink, Charcoal

IN THE BEGINNING . . . FRIENDS
Paul Calle
Graphite pencil on paper
30″ × 38″

WHAT IS A GRAPHITE PENCIL?

There are dozens of kinds of pencils. The kind we're concerned with here is called by some a *graphite* pencil, by others a *drawing* pencil. It has a "lead" (a compressed mixture of graphite and clay) encased in a wooden sheath (or sometimes in a metal or plastic holder).

The proportions of graphite and clay in the lead determine the hardness of the pencil—the more clay, the harder the lead. Depending on the brand you use, drawing pencils are made in as many as twenty degrees of hardness. Common designations range from 9H (very hard, light) to 6B (very soft, dark). In the middle of the range are HB and, sometimes, F, which is similar to HB but has a slightly different tone. An HB is roughly the same as a no. 2 office pencil. Some brands go beyond 6B for even softer, blacker leads. Staedtler, for instance has two grades called EB and EE that are blacker, but grainier, than their 6B.

There are slight differences among brands—one brand's B may be another brand's 2B—so after experimenting a while it's a good idea to select a brand and stick with it.

You may keep on hand many grades of lead but find that you use only a few in a given drawing. Paul Calle, whose superb work is shown here, does most of his work with an HB (he prefers Design 3800 HB), with an occasional use of others, such as 2H or 4H.

As you would expect, you need to use more pressure to make a dark line with a hard pencil than with a soft one, but no matter how much pressure you use, you can't get the rich black from a 4H that you can with a 4B. Rather than use excessive pressure with a hard lead

Looking Back*

Long before the 1500s, people had learned that lead, a grayish metal, could be used to make a gray, uniform mark on a light surface, such as papyrus. Before the Renaissance arrived, people were using writing instruments containing a thin rod made of lead.

Modern pencils make their marks by depositing carbon, not lead, on a surface—but the name "lead" has stuck. The first known use of carbon was in England in the mid-1500s. A mine at Borrowdale yielded a rich, black carbon that was formed into sticks and wrapped in various materials, including wood. Not all carbon deposits were so pure, however, and in the 1760s a German named Faber developed an effective mixture of less-pure carbon with other materials.

Later, the carbon used to make pencils was named *graphite*, from the Greek word meaning "to write."

* From an article in the September-October 1994 issue of The Daniel Smith Catalog of Artists' Materials.

to make a dark mark, try a softer lead—that way, you avoid making grooves in your drawing surface that may interfere with your work.

OTHER PENCILS

There are many other types of pencils, each differing in some way from the ones we've been discussing.

Carpenter's Pencil

Also called a flat sketching pencil, the lead is rectangular in cross section and the wood sheath is like a slightly

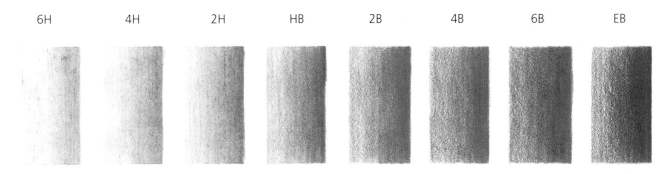

| 6H | 4H | 2H | HB | 2B | 4B | 6B | EB |

Marks made by a range of graphite leads.

rounded rectangle. It can be sharpened with a razor blade or knife to a flat, chisel point. You can notch the flat point so it will draw two or more lines at one stroke.

Conté Drawing Pencil

Conté chalk is made of pigment, clay and water mixed and baked at high temperatures. The resulting sticks of color are sold either in rectangular stick form as Conté crayons or, clad in wood, as Conté drawing pencils. They come in black (hard, medium and soft), sanguine, sepia and white. You can get a wide range of tones with these versatile pencils. It's wise to start lightly because Conté is hard to erase. Other manufacturers make pencils similar to these.

Carbon Pencils and Charcoal Pencils

Their "feel" is somewhere between graphite pencils and charcoal. They produce dark, grainy marks and there is a noticeable "drag" as you move them over the paper compared to the more slippery feel of graphite. Used flat, they can produce a variety of textures, depending on the paper you're using. For more information on charcoal pencils, see page 167.

MECHANICAL PENCILS

You may choose refillable mechanical pencils instead of wooden ones. They offer about the same range of leads

A range of pencils: graphite drawing pencil, mechanical pencil, leads, carpenter's pencil, charcoal pencils, carbon pencil, regular office pencil.

and they eliminate the need for a regular pencil sharpener. You can shape the lead by using sandpaper or you can buy an inexpensive rotary sharpener (such as the Mars 502 Lead Pointer) made for such pencils.

DRAWING SURFACES

Many papers are suitable for pencil drawing, including those called "drawing papers" (see the table at right) and those listed as watercolor, pastel or charcoal papers. Try at least a dozen or so before you settle on a couple of favorites. As you experiment, keep in mind these questions: Is the paper tough enough to take erasing without damaging the paper's surface? Is it acid-free so that it will last a long time without yellowing or disintegrating? Does it have a texture appropriate for the drawing you plan to do? Is it the right color?

To meet the first requirement (strength), choose *100 percent rag* papers (see chapter one). They will accept the most abuse. Next in line are papers with *some* rag content. Lowest in the pecking order are papers made entirely of wood pulp. Within that category, some are much tougher than others.

For long life, select only *acid-free* papers. If you're doing throwaway work, such as preliminary sketching, you can certainly choose cheaper papers, but keep this in mind: Often a drawing you intend only as a sketch goes so well you decide to keep it as a finished product. If only you had begun on acid-free paper!

As for textures, there are three commonly found: (1) *Smooth* surfaces (often called "plate" or "high" or "hot press"); (2) *moderately textured* surfaces ("regular" or "cold press"); and (3) *rough* surfaces. As a rule, the smoother surfaces allow for the finest detail, while rougher ones result in softer-edged drawings.

Most drawing papers are some form of white, but

Choosing Papers

I have a couple of large drawings that took many days of work. Unfortunately, the 100% rag paper I used was not acid-free, and after only ten years or so the papers are yellowing badly. Ten years ago I thought 100% rag automatically meant "also acid-free." Not so, of course.

SOME POPULAR ACID-FREE DRAWING PAPERS

NAME OF PAPER	TYPICAL SIZES	SURFACE TEXTURES	RAG CONTENT	COLORS
Strathmore 500-Series Drawing	23″×29″ sheet 30″×40″ sheet 11″×14″ pad	regular (slight tooth) and plate (smooth)	100%	white
Strathmore 500-Series Bristol*	23″×29″ sheet 30″×40″ sheet 11″×14″ pad 14″×17″ pad	regular and plate	100%	white
Morilla Bristol*	11″×14″ pad	plate	100%	white
Fabriano *5*	19½″×27½″ sheet 22″×30″ sheet	smooth, cold press and rough	50%	white
Fabriano *Artistico*	22″×30″ sheet	smooth, cold press and rough	100%	white
Canson *Mi-Teintes*	see listing in Pastel chapter	smooth one side, textured other	66%	many
Canson *Ingres*	19½″×25½″ sheet	textured	"high"	many

** "Bristol" means the paper is formed by laminating under pressure two or more sheets, or plies. Bristol papers come in various thicknesses—2-ply, 3-ply, 4-ply, 5-ply, depending on the manufacturer.*

often a tinted paper can help you attain just the right effect. There is a good variety of colored papers, including the Mi-Teintes papers used by pastel painters. You might also like to try clay-coated papers—they have a surface color, such as yellow, but when you scratch through the coating you reveal white underneath.

AA batteries. In addition, there are manual sharpeners that have a face plate that adjusts to pencils of differing diameters. Try out a sharpener for smoothness of operation to be sure it doesn't break the tips of your soft-lead pencils. There are some very soft pencils and some odd-shaped ones that won't work in a pencil sharpener—for those, you'll have to use a blade.

TOOLS AND ACCESSORIES

Aside from pencils and drawing paper, there are only a few simple extras you need:

PENCIL SHARPENER

You can use a penknife (the word originally meant a knife for sharpening quills for use as pens) or a razor blade or any sharp instrument that suits you. My choice is an electric pencil sharpener. Why spend half your drawing time whittling away at pencils (and fingers!)?

There are several good electric sharpeners available, such as slim Panasonic and Boston models powered by

Pencil sharpeners range from the simple razor blade to electric models.

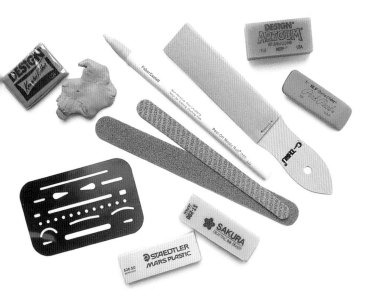

Experiment with the variety of erasers available to find out which ones give the cleanest results for the type of drawing medium you're using and the type of surface you're drawing on. An erasing template helps to zero in on exactly the area you want to erase. Sandpaper blocks and emery boards are handy for fine-tuning points.

SANDPAPER

Often you'll want to wear down the tip of a lead to a chisel shape for making broad lines. You can use a piece of fine sandpaper, a nail file or emery board, or, if you're working outdoors, even a piece of stone. What I find handiest is a piece of sandpaper glued to a small block of wood.

ERASERS AND ERASING TEMPLATE

Many of the erasers available—rubber, plastic, gum and so on—can be used, but you can get by most of the time with only a kneaded eraser. It's soft and pliable and unlikely to damage your paper's surface. With any eraser, it's sometimes handy to use an erasing template (shield) to help erase only the area you want to without disturbing surrounding areas. A template is a small piece of plastic or metal with a variety of holes and slots—you place an appropriate slot over the area you want to erase.

DRAWING BOARD

Unless you're working on a stiff support, such as illustration board, you'll need to attach your paper to some smooth, solid surface. You can buy a board with a built-in clamp for holding your paper or you can use wood, hardboard, foamboard, thick cardboard or Homosote and fasten your paper with tape, tacks or staples. Wood drawing boards and foamboard are available in art sup-

ply stores. Hardboard and Homosote are available at lumber yards. If you choose taping, you can use any of the boards, but if you choose tacks or staples, avoid hardboards because it's difficult to press tacks or staples into them.

If you use hardboard, either tempered or untempered, sand it lightly and then wash it with soap and water before its first use to remove any surface oils. Wash both sides to prevent warping. If you use Homosote, you'll need to smooth and harden its soft, dimpled surface by coating it with acrylic gesso—or you can place a sheet of stiff paper between your drawing paper and the board. Whatever type of board you use, it's convenient to have a couple of sizes to avoid having to use an unnecessarily large, heavy board for a small drawing.

If you use thin drawing paper over a hard drawing board, you may find the drawing surface feels too hard and unresponsive. Slip a sheet or two of paper between your drawing and the board to make the drawing surface a bit spongier.

DRAFTING TAPE

My favorite way to fasten drawing paper to a board is with drafting tape. Using tape, everything lies flat and there are no tacks or clamps to get in your way. Use *drafting* tape because it's less adhesive than masking tape and is less likely to tear your paper when you remove it. Using tape is an easy way to preserve a nice, clean border around the edge of your picture.

TRACING PAPER AND SCRAP PAPER

An 11″ × 14″ pad of tracing paper is a handy size. You can use this when you goof and decide to start a drawing over. Tape a piece of tracing paper over the drawing, trace the parts you want to keep, and then transfer the

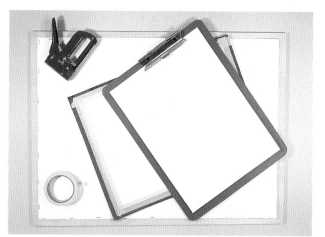

Drawing boards using tape, staples and clamp.

drawing to a fresh sheet of drawing paper.

To transfer your drawing, smear the reverse of the tracing paper with an HB pencil (or use a piece of prepared transfer paper). Then trace over your drawing with a ballpoint pen—the pen is unlikely to tear the paper and the inkline it leaves will tell you where you've traced. Don't press so hard in tracing that you dig into the new drawing paper—all you need is a faint outline.

For working out your design, you can use any paper at all, such as a pad of newsprint. Use it also for fine-tuning a pencil point, or trying out a stroke before committing it to your drawing paper.

VIEWFINDER

When you're scouting subjects, there's often so much before you that it's difficult to zero in on what to draw. A small piece of cardboard with a rectangular hole is a big help—the cardboard holder for a 35mm slide works well. Hold it up and look through it at various views until you settle on an area you like. A larger piece of cardboard with a small hole is even better, since the larger cardboard blocks out the surroundings and lets you concentrate on what you see through the hole.

MIRROR

As discussed in chapter one, a mirror is important for viewing designs in reverse. Make a small mirror part of your drawing kit.

An alternative way to view in reverse is to hold your paper up to a strong light (assuming your paper is reasonably thin) with the drawing *toward* the light so that you see it in reverse.

DRAWING BRIDGE

There are several ways to avoid smudging your drawing with your hand as you work. Many artists simply lay a piece of newsprint or other paper over the part of the drawing to be protected; some use clear acetate film so the drawing underneath remains visible. Those methods pose some danger of smudging.

I use a bridge instead, a piece of Plexiglas that slides over the drawing surface without touching it. You can

Using a clear bridge to support your hand helps you avoid smudging your work, and you can see your drawing through it.

Fit one end of a mahlstick with a piece of felt or a rubber cap to keep it from slipping against your drawing board.

make a bridge to fit each of your drawing boards. Using Plexiglas instead of an opaque material lets you see what's underneath. A bridge works nicely if you tape your paper to a board, but if you use pushpins or clamps, they will interfere with the movement of the bridge.

An alternative to the bridge is the traditional *mahlstick* (or maulstick), which is any stick or rod you hold in one hand as a rest for your working hand. You can make one out of a piece of wood or plastic, such as a dowel.

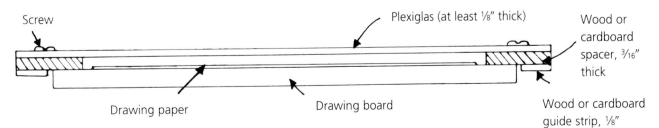

Screw

Plexiglas (at least ⅛" thick)

Wood or cardboard spacer, ³⁄₁₆" thick

Drawing paper

Drawing board

Wood or cardboard guide strip, ⅛" thick

Here's how to construct your own drawing bridge.

PENCIL SHOPPING LIST

BASICS	✓
PENCILS Four each: 6B, 4B, 2B, B, HB, H, 2H, 4H, 6H	
PAPER Pad of 11″×14″ Bristol paper, high (smooth) surface; Illustration board, any size, regular surface (slight tooth); Pad of 11″×14″ charcoal paper	
DRAWING BOARD Large enough to accept 11″×14″ paper	
DRAFTING TAPE	
PENCIL SHARPENER Portable, battery-powered *or* razor blade *or* knife	
SANDPAPER BLOCK	
PAD OF NEWSPRINT	
KNEADABLE ERASERS	
ERASING TEMPLATE	

OPTIONAL	✓
MIRROR	
BRIDGE or MAHLSTICK	
TRACING PAPER	
TORTILLON (BLENDING STICK)	

GETTING STARTED

Since *values* are so important in most black-and-white pictures, work them out ahead of time on scrap paper or in your sketch book. Decide where the middle tones, the lightest tones and the darkest darks are going to go, because once you lay down a strong dark stroke, it's difficult to do a clean erasure. Trace your design—the important shapes—onto your drawing paper, using only enough pressure to get a light image.

You may begin the drawing anywhere you please, but I suggest starting with light-to-middle values. (Only if you're sure where you're headed should you sock in those luscious darks right away.) It's also helpful to start at the top of the paper and work your way down to minimize the danger of smudging parts of the picture with your hand.

Sharp and chisel points.

In pencil drawing you have a choice of leads to use (hard, medium, soft) and you have a choice of points, sharp or chisel. You get a chisel point by rubbing the lead at an angle against an abrasive surface (such as your sandpaper block). With just those options, you can produce a great variety of effects and textures, just a few of which are shown below.

Overlapped hatching, sharp HB

Hatching, sharp 2H

Hatching, sharp 2H; crosshatching, sharp HB

2H hatching, HB strokes, 2B strokes

Hatching with 4B and 2H chisel points

Stabbing marks, 2B

HB held flat against paper

2B smeared with a stump

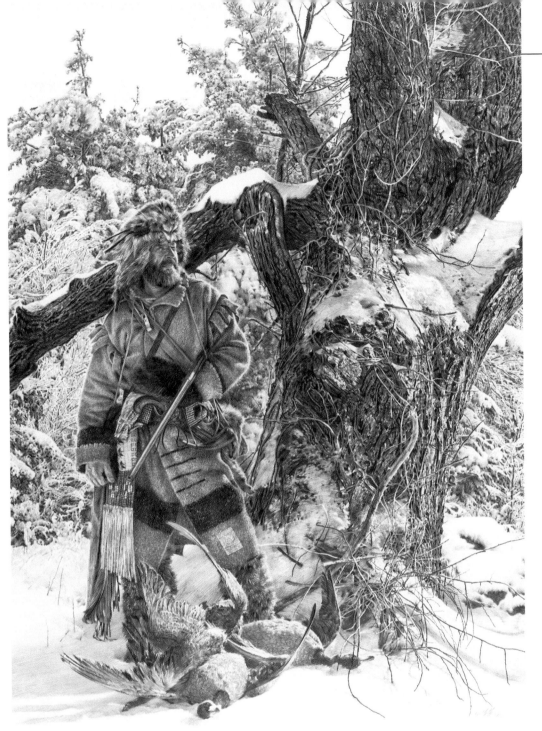

THE WINTER
HUNTER
Paul Calle
Pencil
40″ × 30″

A LESSON FROM PAUL CALLE

Calle is a master of many art mediums, but probably the one he is best known for is the pencil. You can study his working methods and many fine drawings in his book, The Pencil, *available from North Light Books.*

While he stresses the need to try out different materials for yourself, he has over the years narrowed his own choices. He uses Faber Castell Design 3800 HB pencils for most of his work, sometimes using a 2H or 4H for lighter areas. His favorite paper is Strathmore 4-ply plate finish Bristol board. His eraser of choice is the kneadable eraser. When a drawing is completed, Calle places it upright and from a distance of about sixteen inches, using a smooth side-to-side motion, applies a thin coat of spray fixative.

He cautions not to flood or overspray an area because overspraying tends to bleed or slightly blur the pencil stroke. He uses Blair No-Odor Matte Spray Fixative.

Calle uses a single-edge razor blade to sharpen his pencils, tapering the wood and leaving about ⅜″ of graphite exposed. He then gives the lead a conical shape using a sandpaper block. He removes the graphite dust from the point with a soft cloth or paper towel.

"While working," he says, "I always have several dozen pencils sharpened, enabling me to continue uninterrupted for a period of time. This is important because it is frustrating to stop to sharpen a pencil just when the drawing is moving along."

Just two of many contrasting styles: individual strokes (far left), and strokes made with the side of the lead, blended somewhat with a stump.

DRAWING STYLES

You can use the pencil in as many different ways as a painter uses a brush. Use a lively, linear approach that lets each pencil stroke show, or blend your strokes to get a smoother, more photographic effect. Use lots of short strokes (or even dots), or longer strokes, straight or curved. My own leaning is toward fairly bold, un-blended strokes, with plenty of tiny whites showing between strokes to liven things. But you may prefer smooth blending or some entirely different approach.

WHAT IS PEN AND INK?

Black drawing ink, also called India ink, is a suspension of very fine carbon particles in a solution of water and a binder, such as shellac. Inks come in a range of blacks, depending on the ratio of pigment to other materials. They are usually sold in glass bottles with eyedropper-type caps or in plastic squeeze bottles with narrow necks—both styles allow you to fill a pen easily without spillage.

When you buy a bottle of ink, some of the pigment may have settled. Shake the bottle and test the ink on a piece of paper—it should be jet black and not grainy-looking. (Most inks should stay in suspension unless they are past their shelf life. I've bought ink that had apparently been on the shelf a long while and no amount of shaking could remix the pigment.) Some inks have a date of manufacture stamped on the label.

A safe rule of thumb is to buy inks not more than two years old.

For use in technical pens (see next section), you'll usually need an ink that's permanent, opaque and non-clogging, such as Koh-I-Noor Ultradraw and Universal, Higgins Black Magic or Staedtler Marsmatic. Many of the inks used in writing pens (including the popular ball-points) are not at all permanent. They may lighten and sometimes turn brownish in relatively short times. Even some drawing inks (especially those that are dye-based, not pigmented) will fade, so choose inks that are rated as permanent. In addition to being permanent, nonclogging and opaque, your ink should be waterproof unless, of course, you intend to get special effects by intentionally wetting and loosening the ink.

TECHNICAL PENS

Time has seen lots of different kinds of pens, including quills (the hollow shafts of bird feathers) and dip pens, which have metal tips that mimic the action of quills. The most popular artist's pen these days is the *technical pen*, which is the type we'll concentrate on in this chapter. A technical pen holds a reservoir of ink, it comes in

Looking Back

Nobody knows *exactly* when black drawing inks were invented, but there is general agreement that they've been around for at least four thousand years and may have been invented in both China and Egypt at about the same time.

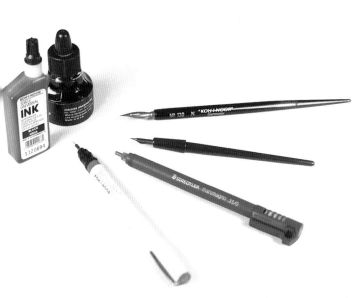

Inks come in bottles that can be used for dip pens and in bottles with small snouts for refilling cartridges. Pens are of two general kinds, dip pens and technical pens. Here is a regular dip pen and a smaller crow quill dip pen, along with a refillable Rapidograph technical pen and a disposable Marsmagno technical pen.

a variety of sizes (that is, line widths), it puts down a uniform line, and it's less likely than a dip pen to leave a blob of ink where you don't want one. Unlike a dip pen, the technical pen allows you to stroke in any direction. There are three basic types of technical pens:

Refillable

These have a plastic ink cartridge you fill with your choice of ink. Two popular examples of these pens are the Koh-I-Noor Rapidograph and the Staedtler Mars-

matic 700. Both may be bought in over a dozen nib (point) sizes.

Disposable Ink Cartridge

Instead of filling plastic cartridges, you buy them already filled and simply insert them into the pen. Koh-I-Noor's version of these pens is called Rotring Rapidograph and Staedtler's version is called Marsmagno 2. The disadvantages with these pens are that because they were designed for drafting and not art applications, there are fewer point sizes (about half the number available with refillable pens) and little choice of inks.

Disposable Pen

When the built-in ink supply runs out, you throw away the pen. I use Staedtler Marsmagno disposables (which are not the same as the Marsmagno 2, above) and the newer Grumbacher Artist Pen—they work smoothly and they appeal to my lazy streak, but so far they're available in only a few nib sizes. As they gain in popularity, that may change.

OTHER PENS

Technical pens are certainly not the only way to go. In North Light's book, *Basic Drawing Techniques*, you'll find excellent examples of ink drawings done using dip pens, ballpoint pens, felt-tip pens and markers.

Dip pens have metal nibs that are removable from their wooden or plastic holders for cleaning and replacing with other sizes. You dip the tip into a bottle of ink, remove excess ink by pulling the tip against the bottle rim, and draw until the ink is used up. Until you get used to a dip pen, blobs and splatters are a common

The parts of a Rapidograph pen.
Courtesy Koh-I-Noor.

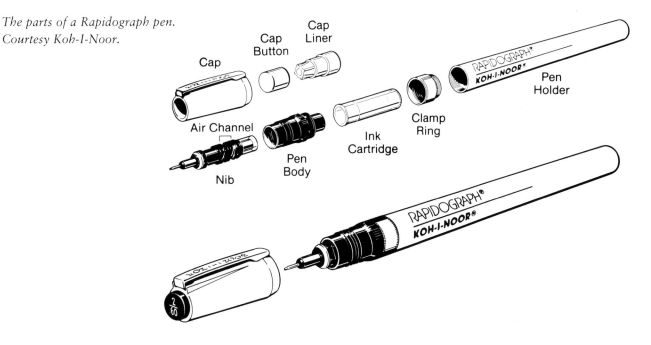

This is the variety of point sizes available for the refillable Rapidograph. Other brands offer a similar point selection. Points are available in steel (the usual choice) or sapphire or tungsten (for more abrasive drawing surfaces). The top numbers, such as 6x0 (read as "six-aught" or "six-oh"),

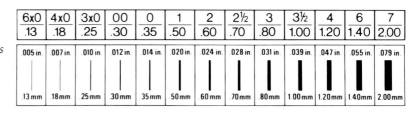

6x0	4x0	3x0	00	0	1	2	2½	3	3½	4	6	7
.13	.18	.25	.30	.35	.50	.60	.70	.80	1.00	1.20	1.40	2.00
.005 in.	.007 in.	.010 in.	.012 in.	.014 in.	.020 in.	.024 in.	.028 in.	.031 in.	.039 in.	.047 in.	.055 in.	.079 in.
.13 mm	.18 mm	.25 mm	.30 mm	.35 mm	.50 mm	.60 mm	.70 mm	.80 mm	1.00 mm	1.20 mm	1.40 mm	2.00 mm

are an older form of identification. The next row gives the width of the line in millimeters—.13 mm, .18 mm and so on. Both markings appear on each pen in two places: the end of the cap and the nib assembly. Each pen is color-coded in three places so you don't mix up the parts if you have more than one pen disassembled at a time. The line widths are also listed in this chart in inches (.005 in., .007 in., etc.). A chart like this is supplied with each pen you buy. Diagram courtesy of Koh-I-Noor.

problem. You can avoid a lot of the blob problem by *depositing* a drop of ink onto the upturned barrel of the nib instead of actually *dipping* it into the ink bottle. Some do this by using a small brush to carry a drop of ink to the nib. Others (like Fred Bartlett, later in the chapter) use a dropper, such as the one that comes with some bottles of ink.

Points, or nibs, for dip pens come in a variety of sizes and shapes designed to give fine, medium, and broad lines. Some are shaped especially for lettering and calligraphy, including versions for left-handed and right-handed users. There are flexible nibs that give varying line widths. Others, called "crow quill" nibs, are smaller (requiring their own holders) and are used for finer lines. Sharper than larger nibs, they can clog with paper fibers if used on paper that has too soft a surface.

There are other pens, such as ballpoint and felt-tip, for use in your sketchbook or even on a final drawing. But be sure to look for pens that use permanent inks. There are a number of them listed in catalogs, such as Pilot BP ballpoint. If an ad or label doesn't say the ink is permanent, assume it's not.

Dropping a bead of ink onto a dip pen nib.

USING THE TECHNICAL PEN
Refilling the Pen

The instructions that come with your pen tell you how to refill the cartridge. Make sure you fill it only to the line on the side of the cartridge, leaving a small air space. Slowly press the pen assembly down over the filled cartridge. With a paper towel, wipe everything clean, including the area around the nib assembly. To avoid catastrophe, don't do your refilling anywhere near your drawing.

Starting the Ink Flow

Experts like Gary Simmons and Claudia Nice recommend starting the ink flow in this manner: First, hold the pen with the point down and tap the top end of the barrel a few times with your finger. Try drawing a line. If there's no flow, hold the pen horizontally and give it one or two shakes. Try drawing a line. Finally, if there's still no flow, turn the point upward and gently tap the end of the barrel on a hard surface. If the nib is clogged slightly, this should release it. *Don't* shake the pen; that will only make things worse. You may also stab yourself or whack the pen against a tabletop and ruin the point.

If these actions don't get the ink flowing, then probably you're out of ink or the pen needs a cleaning.

Holding the Pen

Work with the pen either vertically or at a slight angle, whichever is more comfortable. The angle at which you can hold a pen and still get ink flow varies with the size of the nib. Unlike dip pens, you can move the technical pen in any direction across the paper.

Routine Maintenance

Any ink, including "nonclogging" types, will eventually cause clogging if you don't treat your pens right. There are some simple rules to observe:

- Put the cap on the pen when not in use for longer than a minute or so. Inside the cap is a cushion that seals the end of the nib to keep the ink in the nib from drying out.
- Realize that if you draw on soft or fibrous material, you increase the chances of clogging the fine nib.
- A pen is fairly rugged, but the nib can be damaged by careless use (such as dropping on the floor).
- When you reassemble the pen after cleaning, tighten the plastic parts finger-tight to avoid cracking them. Don't use the wrench that comes with the pen except to loosen a part that's stuck.
- The more frequently you use the pen, the less often you must clean it. As a rough example, if you use the pen only once a week, then clean it once a week. If you lay it aside for some indeterminate time, clean it first. Clean it each time you refill it.

Cleaning the Pen

The cleaning instructions that come with your pen are easy to follow: Unscrew the pen body (see the pen diagram earlier in the chapter) and gently tap excess ink from its rear onto a paper towel. Unscrew the nib from the body and clean both parts under warm running water or by soaking in a pen cleaning solution (Koh-I-Noor's version is called Rapido-Eze). If you're using waterproof ink, pen cleaning solution will work better than plain water. Rinse in clean water, shake out any remaining liquid, and dry the nib and body with a paper towel. Reassemble.

An inexpensive and effective cleaner that forces water or cleaning solution through the nib is a syringe (Koh-I-Noor's is called Syringe Pressure Pen Cleaner). Screw the pen body and nib into the syringe and dip the nib into clean water. Repeatedly force water through the nib. When reasonably clean, repeat, using pen cleaner instead of water. Finally, use water again to remove the cleaning solution from the pen. Shake out excess fluid and dry the parts with a paper towel.

An effective cleaner, especially for a pen that has missed its routine maintenance and is tightly clogged, is an ultrasonic cleaner. There are several listed in the catalogs, ranging in price from about $35 to $160. If you plan a lot of ink drawing, this is a good investment.

COLORED INKS

Art catalogs list a dozen or so colored inks, but many are made from impermanent dyes. These are suitable only when permanence is not required (work that is to be reproduced, for example). Read labels and literature carefully to know what you're getting. Among permanent inks are Speedball Drawing Inks (both waterproof and non), Higgins Waterproof Drawing Ink and Luma Waterproof Pearlescent Inks.

In addition, you may use other fluid media as inks—for example, Dr. Ph. Martin's Spectralite Acrylic Airbrush Colors, Dr. Ph. Martin's Hydrus Watercolors or Rotring Artist Colors (the transparent colors especially are made to use in Rapidograph pens).

DRAWING SURFACES

The usual surface for ink is paper. For permanent work, choose only acid-free papers, such as those listed earlier in this chapter for pencil drawing. For ink drawing, there is another consideration: Soft-surfaced papers may quickly clog the nib of your pen. In fact, if *too* soft, the paper may actually be gouged by your pen.

TOOLS AND ACCESSORIES

You need most of the same items mentioned under *Pencil*: a drawing board, (ink) erasers, drafting tape and so on. In addition, many people use electric erasers, but be careful you don't erase a hole in your paper. Keep erasure crumbs and paper fibers away from your pen nib to avoid clogs.

Keep a piece of ink blotter or tissue handy so when the inevitable blob of ink drops onto your masterpiece, you can wick it up quickly by carefully touching an edge of the blotter or tissue to the blob.

Cleaning Dip Pens

If you use dip pens, remove them from their holders, clean them thoroughly under the water faucet, and dry them. Keep the holders clean and dry—some have a metal sleeve that can corrode in time if not kept dry. Pen cleaning solutions and ultrasonic cleaners used for technical pens may be used for dip pens, as well.

CLAUDIA NICE
Using a Variety of Strokes

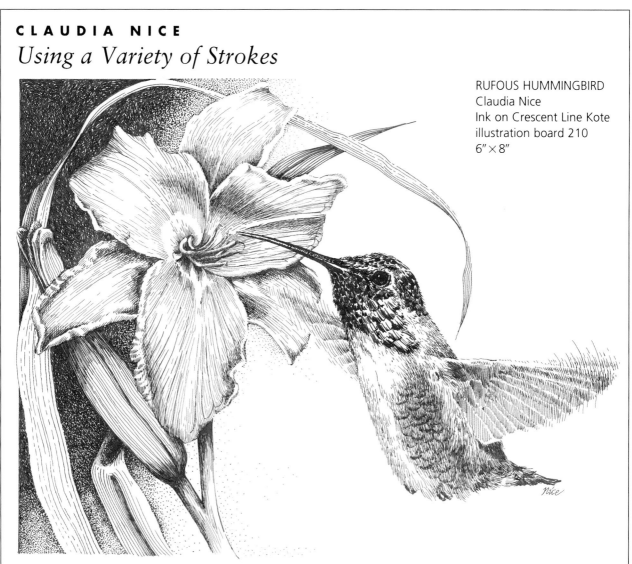

RUFOUS HUMMINGBIRD
Claudia Nice
Ink on Crescent Line Kote
illustration board 210
6″×8″

"The heart and soul of a striking pen and ink drawing is contrast. Design and definition depend on it. Contrast of *value* is the most important, but running a close second is contrast of *texture*—the stroking patterns you choose to shade and define your drawing.

"I choose from a 'palette' of seven basic pen strokes to depict any texture I can imagine. All of them are represented in this hummingbird sketch. The *contour line* (daylily petals) is used for smooth, rounded objects or to suggest motion. The *parallel line* (hummingbird wings) works well to suggest distant, blurred objects. *Crosshatching* (petal shadows) varies from a slightly textured look to very rough, depending on the angle of the pen, the nib size, and the precision of the stroke. *Scribble lines* (heavy background area) provide a thick, tangled appearance. For a gritty, dusty or velvety texture, try *stippling* (dotted background area). Repetitive grainlike

patterns can be suggested by using *wavy lines* (daylily bud and leaves). *Crisscross lines* (hummingbird body) work well for animal fur, grass or soft, overlapping feathers.

"My favorite inking tool is the Koh-I-Noor Rapidograph. It provides a steady, reliable, leak-free flow and has a nib that is precise and can be stroked in any direction. I fill it with Koh-I-Noor Universal Black India Ink, which is opaque and quick-drying. When I wish to work in color, I fill the pen with Rotring transparent liquid acrylic. The Grumbacher Artist Pen also performs well and is a convenient, reliable instrument. It's prefilled with a quality black India ink.

"For drawing surfaces, I find hot press illustration boards ideal."

For an excellent treatment of many pen and ink styles, see Nice's book *Sketching Your Favorite Subjects in Pen and Ink*, in the Bibliography.

MICHAEL DAVID BROWN
Fast and Loose and Colorful

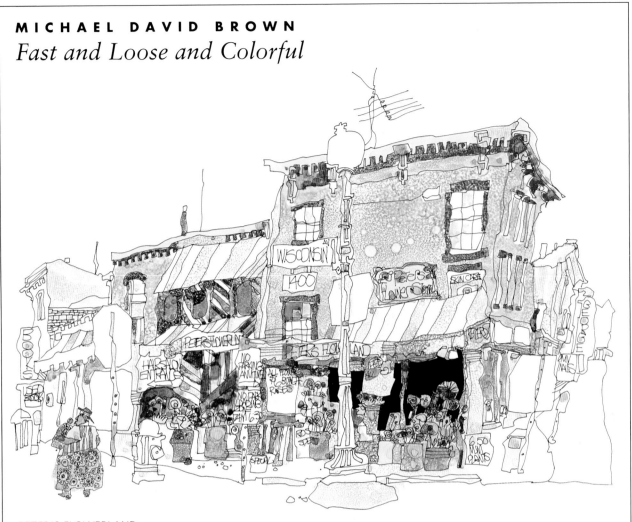

PETER'S FLOWERLAND
Michael David Brown
Ink on vellum paper
10″ × 14″

Michael Brown is both illustrator and fine artist. His work has appeared in magazines, ads, newspapers and galleries all over the country. He works in several mediums, including watercolor and collage, but he seems to work most freely, with purposeful distortion, in ink. He does drawings like this one in Washington, D.C., on the spot. With no preliminary pencil drawing, but with a good idea what image he is after,

he uses a Rapidograph in almost continuous-line fashion. He works rapidly, rarely stopping for a correction. For color, he uses either ink or watercolor, or both, and brushes it on loosely, in keeping with the loose ink lines. When his work is intended for reproduction, as in this case (it's part of a booklet called *Washington D.C.*), he sometimes uses favorite colors even though they're fugitive.

GETTING STARTED

Given a relatively modest tool kit—a pen, some ink and a piece of paper—artists have developed an extraordinary array of styles. During the eighteenth and early nineteenth centuries, books (especially children's books), magazines and newspapers were full of exquisitely rendered ink drawings by some *very* talented people (many are represented in Arthur Guptill's book, *Rendering in Pen and Ink*—see Bibliography). In this chapter, four artists show you a variety of effective styles.

Individual styles are a result of mixing many ingredients, of course, including your personality. An important ingredient is your choice of *strokes*. In the most basic sense, there are only three kinds of strokes: lines, dots and washes. *Lines* may be any length, any width, straight, curved and so on. Dots (use of which is called *stippling*) may have any diameter. Washes may be opaque or transparent, uniform or graded. Below left is a tiny sampling of the strokes possible. The books by Gary Simmons and Claudia Nice listed in the Bibliography will open your eyes to a huge number of possibilities.

Crosshatching

Dots (pointillism)

Hatching

Continuous line

Curved strokes

Wash (ink dropped into wet surface)

Here are a few of the strokes that can be made with either a technical pen or a dip pen (or, for washes, a brush).

PEN AND INK SHOPPING LIST (TECHNICAL PEN)

BASICS	✓
PENS Two technical pens: .25 mm and .50 mm points (or your choice)	
INK Koh-I-Noor 3085-F Ultradraw Black India Ink or Staedtler Marsmatic 745 R Drawing Ink	
PAPER Pad of 11″×14″ Bristol paper, high (smooth) surface	
DRAWING BOARD Large enough for 11″×14″ paper	
DRAFTING TAPE	
ERASERS white vinyl	
BLOTTING PAPER or TISSUE	
BRIDGE or MAHLSTICK	
RAPIDO-EZE PEN CLEANER	
SYRINGE PEN CLEANER	
OPTIONAL	✓
ELECTRIC ERASER	
ULTRASONIC PEN CLEANER	
MIRROR	
TRACING PAPER	

GARY SIMMONS
Careful Hatching and Crosshatching

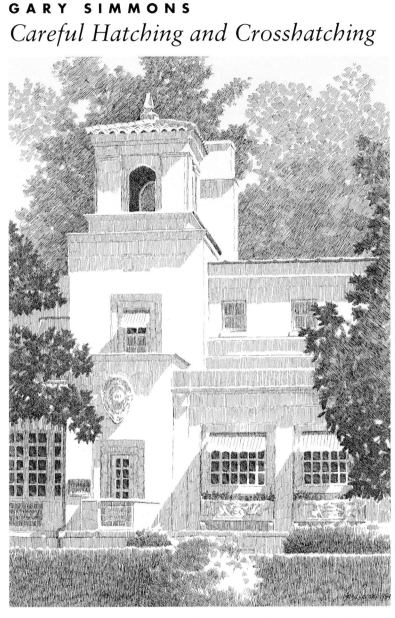

OZARK TOWERS
Gary Simmons
Pen and ink on illustration board
15½" × 11"

"In this piece I worked exclusively with a Koh-I-Noor Rapidograph pen, size 3x0, and used Koh-I-Noor 3080-F Universal India ink. I drew on a Crescent illustration board that has a cold press 100% rag surface.

"I begin with a tight pencil drawing, using 3H or 4H lead. The drawing sets up shapes and indicates low-value areas, such as shadows. Sometimes I actually do some careful hatching with the pencil to help me identify where the darkest values are to go.

"I methodically begin building up values with ink lines, starting with the darkest shapes. My first ink lines are a single set of hatch marks with consistent direction and spacing. I work all over the drawing, filling in the areas that are eventually going to be the darkest, but I take care not to finish any dark area too soon.

"When the first shapes are established with this single layer of hatch marks, I go back over that layer with a second layer of marks at an angle to the first (crosshatching) wherever the next darkest areas are to be. Then I add another layer of crosshatching to the areas that are to be still darker. Each time I add a layer I try to be consistent with the direction of the lines while hatching.

"After the third set of hatch marks, I have four values: white, light gray, middle gray and dark gray. I next work on smaller shapes and textures, and then finally go back over the whole drawing, fine-tuning, adding dark accents and so on."

FREDERICK W. BARTLETT
A Little Dotty?

1903 BURNHAM WILLIAMS CAMELBACK 0-4-0
Frederick W. Bartlett II
Ink on illustration board
9⅜″ × 14⅜″

For his stippled drawings, Bartlett's tools are Gillotte holders and #659 crow-quill pen points, Higgins #4415 waterproof India ink, Laserline 700 Series hot press illustration board, a sharp eye and endless patience. He also uses white vinyl erasers, scratch pads and white paper napkins for pads under his drawing hand. Fred buys dozens of pen points at a time, and tests ("auditions," he says) each one, because no two are alike.

He does not dip the pen into the ink bottle because that would give him an uncontrolled amount of ink on the point. Instead he turns the pen over and uses the bottle's dropper to place a bead of ink into the underside of the pen point. Then he turns the pen back to its normal position and goes ahead with his stippling. He keeps the pen aimed downward at all times to keep ink from running back into the pen holder.

The crow-quill point is pressure-sensitive—the line or dot size you get varies with the amount of pressure you apply to the point. Bartlett makes a lot of use of his scratch pads to test points and strokes.

Bartlett achieves shading by varying both the size and the density of the dots (". . . lotsa dots, darker—notso lotsa dots, lighter"). It's important, he says, "to begin with a lighter concentration of dots and gradually work darker . . . it's a messy dickens of a job to try to lighten an area you've unintentionally darkened."

In preparation for the hours of dot-work (over 400 hours for this drawing) Bartlett first makes a careful pencil underdrawing, detailed enough to steer him through the stippling. When the stippling is finished and completely dry, he erases the pencil lines.

He suggests a few more pieces of equipment if you get serious about ink drawing: a Bruning electric eraser, an erasing shield and an ultrasonic cleaner for your pen points. He uses an ultrasonic *denture* cleaner—effective and less expensive than a pen cleaner.

FIRST STROKES

Plan your drawing on newsprint or other inexpensive paper. When satisfied with your design, transfer it to your drawing paper by inserting a sheet of transfer paper between the newsprint and the drawing paper and tracing over the design. Use only moderate tracing pressure so all you transfer is a light outline you can erase later with a kneaded eraser (after inks are dry).

If you're doing either hatching or stippling, explore first some light or medium-value areas and work toward the darker passages only when you're sure where they should go. Erasing is difficult in ink-work—it's easy to damage the surface of the paper so that subsequent ink lines or dots will spread unacceptably.

Keep scrap paper handy (preferably the same kind of paper you're drawing on) and do plenty of trial strokes before you commit to your drawing paper. As you'll see, at the end of a stroke there is a tendency for little blobs or "hooks" to form until you learn to lift the pen briskly from the paper at the end of a stroke.

It's important to make early strokes correctly. It's hard to cover a poor beginning with later strokes. Work with the finest points first to avoid overwhelming an area with individual strokes that are too prominent.

WHAT IS CHARCOAL ?

As in pencil and ink, the pigment in charcoal is *carbon*. Artist's charcoal is made by heating such materials as willow twigs, beech twigs and vines to high temperatures (without air, so they don't burn). Depending on the type of wood used, the temperature, and how long the heat is applied, the resulting charcoal has varying degrees of softness/hardness.

Some charcoal is used in its "natural" form, just as it comes from the oven—a coarse, brittle material. Another form is compressed charcoal—the charcoal, sometimes with other materials added, is formed into sticks under pressure. Compressed charcoal is usually darker, more dense and less subject to breakage than natural charcoal.

Charcoal can be bought in three basic forms: chunks, sticks and wood- or paper-clad pencils. Chunks are usually uncompressed, while sticks may be either compressed or uncompressed. Pencils contain compressed charcoal. Wood-clad pencils, such as Grumbacher, Wolff and General, may be sharpened (carefully) in a regular pencil sharpener, while other forms are usually sharpened with a knife or sandpaper.

DRAWING SURFACES

Aside from cave walls and backyard grills, paper is the most common support for charcoal. Charcoal papers have "tooth" so that the dusty pigment has something to hold onto. All of the papers listed in the pastel chapter are suitable for charcoal. Some of those listed earlier in this chapter for pencil and ink may also be used, but the smoother papers may not have enough tooth—they will accept thin layers of charcoal, but may not hold heavier buildups.

You can also draw in charcoal on surfaces such as

Strokes made by (top to bottom) hard and soft charcoal pencils, a compressed charcoal stick, and hard and soft vine charcoal.

canvas, hardboard and wood—but paper remains the most popular. In selecting a paper, as I've stressed throughout this book, think in terms of permanence. Use cheap newsprint for throwaway sketches, but select acid-free, permanent papers for your serious work. In addition to those labeled as "charcoal papers," try watercolor and pastel papers. Also, printing papers, such as Arches cover and Rives BFK, are excellent supports for charcoal.

TOOLS AND ACCESSORIES

Your needs are few, similar to what's needed for pencil drawing. A drawing board, drafting tape, and so on—and don't forget erasers! Charcoal is one medium that responds well to erasing, and the most useful eraser of all is the kneaded eraser. It will pick up charcoal quite easily, without much pressure. This is useful not only to correct mistakes, but to pick out highlights, much as you "lift" watercolor to expose the white paper underneath. You can blot up charcoal with the broad surface of a kneaded eraser or form the eraser into a point or edge and lift only a small area. As a kneaded eraser becomes "dirty," you simply pull and stretch and re-form it (that is, knead it) until a clean, new surface appears. Eventually the eraser becomes too full of charcoal and must be discarded. Other erasers are useful, including Pink Pearl and typewriter erasers, chamois cloth and soft paper towels.

If you use charcoal sticks, such as vine charcoal, you may want to use a holder, especially when the sticks become very short. Holders are metal sleeves that grip the charcoal. Some holders may be attached to a longer handle, such as a piece of wooden dowel. This arrangement allows you to stand back from a drawing a few feet as you draw. Obviously, your control over the tip is far shakier than if you were to hold the charcoal in your fingers, but standing back enables you to "see" the emerging design better. You can move up close when you get to the details.

As in pastel work, a tortillon or a stump may be useful to blend charcoal strokes. Beware of overdoing it—too much blending can result in a tired-looking picture.

To keep your hands from smearing your drawing, use a bridge or a mahlstick, described earlier in this chapter. One additional item you'll need, especially if you work outdoors away from the sink, is something to keep your hands clean, such as Handi-Wipes.

PROTECTION

A charcoal drawing may be easily harmed by rubbing against another surface. A workable fixative, such as Blair No-Odor Spray Fix, will give good protection. Always apply fixative in *light* coats, allowing previous coats to dry thoroughly.

Another way to protect your drawing is to cover it with a sheet of thin, smooth paper, such as glassine or tracing paper. If you use this method, make sure the paper cover can't *move* against the drawing surface—any rubbing at all is liable to smudge your work. When you store unframed drawings (or paintings), store them flat with sheets of glassine between them to minimize the chances that the picture surface will stick to the back of the next picture in the stack. Taping the protective sheets in place will minimize the danger of inadvertent shifting and smudging.

GETTING STARTED

Charcoal sticks and charcoal pencils can be intermixed with each other and with other mediums. Many times, charcoal is used as the preliminary drawing for an oil or other painting. In those cases, the charcoal is usually applied lightly so that there is not too much charcoal dust to mix with the paint. A light spray of workable fixative can be used before painting over charcoal to prevent mixing.

BASIC STROKES

You can rapidly cover an area with a light or medium or dark tone by using a piece of charcoal held flat against the paper. You can do an entire drawing using only broad strokes. In other drawings you might use sharpened pieces of charcoal to make outlines or to do hatching and crosshatching. In still others, combine fine line work with broad tones. You may use a colored chalk, such as white pastel, to highlight the charcoal.

Uncompressed charcoal lends itself to relatively loose drawings without fine detail. Compressed charcoal, however, either in stick or pencil form, allows for much greater detail and precision because it's far less crumbly.

CHARCOAL SHOPPING LIST

BASICS	✓
CHARCOAL Box of uncompressed vine charcoal, soft Box of uncompressed vine charcoal, hard Charcoal pencils, two soft, two medium, two hard Box of assorted compressed charcoal sticks	
CHALK Stick of white pastel for highlighting	
PAPER Pad of 12″×18″ drawing paper, assorted colors Pad of white charcoal papers, 18″×24″	
KNEADED ERASER and PINK PEARL ERASER	
SOFT CLOTH	
DRAWING BOARD Large enough for 18″×24″ paper	
DRAFTING TAPE	
SANDPAPER BLOCK	
NEWSPRINT PAD	

OPTIONAL	✓
MIRROR	
BRIDGE or MAHLSTICK	
GLASSINE or TRACING PAPER	
WORKABLE FIXATIVE	
TORTILLON (BLENDING STICK)	
HANDI-WIPES	

Health Tip

Spray on fixative outdoors, if possible. Keep it away from flames and don't inhale the fumes.

URUAPAN MAN
Ned Mueller
Vine charcoal on toned Canson paper
17″×13″
Collection of Mr. and Mrs. Kent Davies

Mueller chose the smoother side of a sheet of Canson toned pastel paper for this portrait. He used Grumbacher vine charcoal and picked out lighter areas from the charcoal with a kneaded eraser. For details and dark accents, he used extra soft vine charcoal, and for a few carefully chosen highlights, he used white chalk.

He does a lot of rubbing and smearing of the charcoal with his fingers. Throughout the drawing process, he tries to use good value contrasts to give the man's features the craggy look he is after. Mueller advises being careful not to include unnecessary details. Of course, in this medium, an unwanted detail is gone with the swipe of a finger or a dab of an eraser.

When finished, Mueller sprays the entire picture with several light coats of Blair matte fixative.

STANLEY MALTZMAN
Working with Vine Charcoal

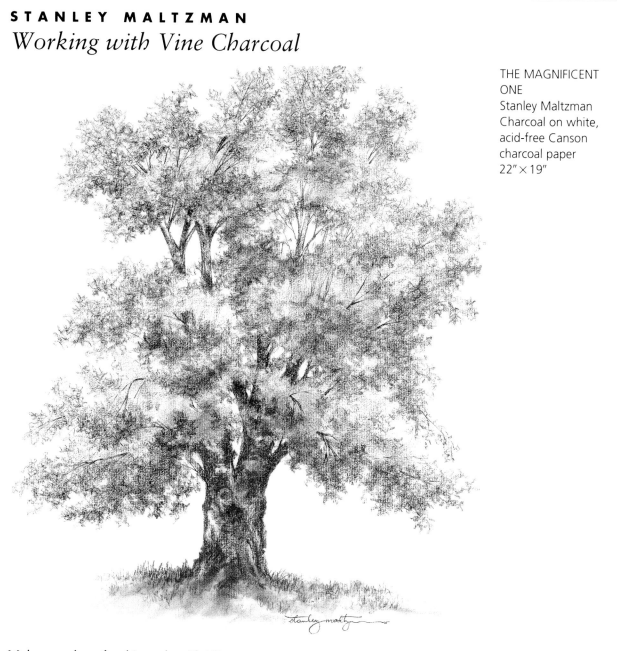

THE MAGNIFICENT
ONE
Stanley Maltzman
Charcoal on white,
acid-free Canson
charcoal paper
22″ × 19″

Maltzman chose for this study a "laid" paper, a textured paper with fine lines running parallel to the paper's edge. Such a surface is suitable for holding the relatively soft vine charcoal.

Starting as he always does with small sketches on scrap paper to work out a design, Maltzman then lightly sketches the outlines of the tree on his drawing paper. Along the way he uses a chamois, tissue or cloth as an eraser. When satisfied with his contour drawing, he begins describing light and dark masses of foliage using soft and medium vine charcoal sticks. Then he indicates the trunk and main branches, taking care to taper the branches as they grow outward.

Once all main values are blocked in, he uses 4B and 6B charcoal pencils to emphasize the details, such as shadows, knotholes and smaller branches, that give the tree its individuality. At the end, he uses a kneaded eraser to pick up charcoal dust from any areas that need cleaning.

He finishes by spraying the picture with workable matte fixative. Because vine charcoal is loosely held by the paper, Maltzman cautions that you must hold the spray can at least a forearm's length away in order not to blow loose the charcoal. Spray very lightly. When dry, spray again.

Mixed Media

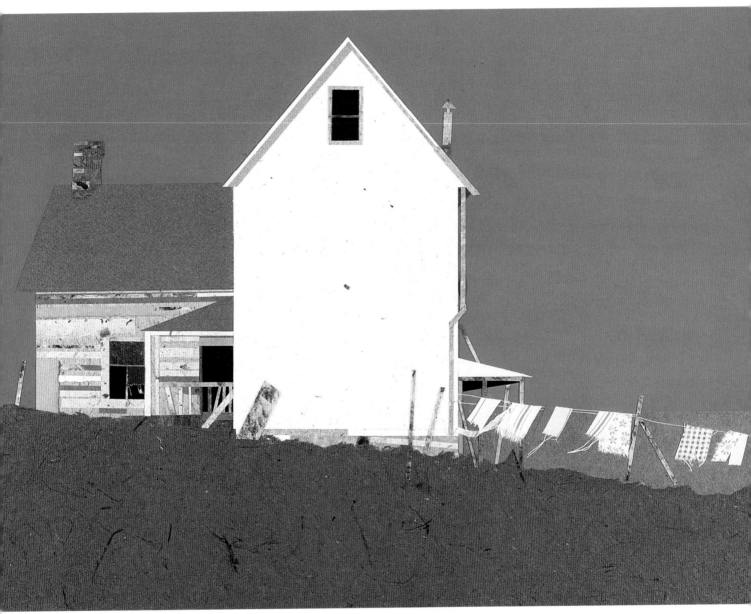

Brown starts with no drawing, but with a good image in his head. He paints the background watercolor board with acrylic paint, then uses the heat and pressure of a dry-mount press to adhere large pieces of paper to the support. For small pieces, such as a post or a bit of chimney, he uses a small, spade-shaped heating element from a wood-burning tool. The pieces of string for the clothesline are glued in place with a touch of 3M adhesive. For his papers, Brown uses some that are already colored and he paints others.

WASH DAY
Michael David Brown
Collage on Bainbridge
acid-free watercolor board
15" × 20"

WHAT IS MIXED MEDIA?

O r, if you prefer, what *are* mixed media? *Mixed media* means the use of more than one basic material in a given work of art. There is no limit to the number of combinations of mediums and objects that may work together effectively—paint, paper, cloth, sand, wire, foil, shells—the list is endless. This is no-holds-barred art. It's environment-friendly art, too, because people who get hooked on mixed media never throw anything away! No telling when you'll need that old photograph or dried noodle or dead bug for your next masterpiece.

Probably the major form of mixed media is the one called *collage*. Collage—taken from the French *coller*, "to glue"—means an artistic composition made by gluing various materials to a background, or support. The materials may be simple pieces of paper or they may include paper and paint or other materials. Most of this chapter is devoted to collage.

COLLAGE MATERIALS

Collage is generally accepted to mean gluing *relatively* flat materials to a flat background—if you fasten more

French Lesson*

assemblage (ah sem blah′ j): combination of three-dimensional objects glued to a surface.
decoupage (day koop ah′ j): decorating a surface with (usually flat) pieces of cut paper.
frottage (frot ah′ j): Rubbing a design onto collage materials from a textured surface.
photomontage (fo to mahn tah′ j): Collage of glued photographs or cutout photos.

* from *Creative Collage Techniques* by Nita Leland and Virginia Lee Williams.

three-dimensional objects, such as nuts and bolts or slabs of bark, that's called an *assemblage*. But in the "*-age*" business, definitions are not so sacrosanct. If you stick a slab of bark onto an otherwise flat collage, most would still call the result a collage.

Among the common materials used in collage are papers of all sorts, fabrics, foils, metallic chips, sand, organic material (leaves, twigs, bark, flowers, bugs, feathers), dyes and paints. Any material may be used, provided it fits your intentions and is reasonably permanent—and you can get it fastened to your support.

Many collages have short lives because materials in them crumble or their colors fade, or both. If you want your collage to live longer than you, select its materials with care.

One of the materials most used is paper. There is an enormous variety of papers, white and colored, now on the market, and many of them are acid-free. A quick trip through the Daniel Smith Catalog of Artist's Materials shows many dozens of acid-free papers in these categories: watercolor, pastel, drawing, printing, oriental, lace, handmade and marbled.

You may find an acid-free paper you like, but it may not be colorfast. If a catalog does not say anything about the lightfastness of a paper's colors, it's usually safe to assume the colors are not permanent. A perfect way around this problem is to color your own papers using dilute watercolor or acrylic paints (rated permanent, of course).

You may find a paper you simply *must* use, permanent or not. Newspaper and magazine color pages are often irresistible. Newspapers and magazines are not printed with "forever" in mind, but there are steps you can take to improve the odds of survival of these materials in your collage. The first is to select the fancier publications (such as *National Geographic*) because chances are they use the better inks and papers. Second, use liberal coatings of acrylic mediums to seal off materials from the air. You may also frame collages (or any artwork) under special glass that screens out ultraviolet light, which is responsible for most fading.

Looking Back

Although around 1912 Picasso and Braque are generally credited with introducing collage as fine art, collage had already been around for at least eight hundred years as a way of decorating many items, such as book covers and religious images.

ADHESIVES AND COATINGS

You may stick the pieces of your collage together with any strong, permanent adhesive. Stay away from rubber cement because it is not permanent. Here are some popular adhesives:

Acrylic Mediums

Probably the most-used collage adhesive, acrylic mediums are permanent, nonyellowing and tough. Any of the acrylic mediums and gels discussed in the acrylic chapter may be used. Use acrylic medium (either matte or gloss) to adhere papers and light materials; for heavier papers, acrylic *gel* medium is stronger; and for *really* heavy objects, use a half-and-half mixture of acrylic modeling paste and gel medium.

In addition to acting as a glue, you may use acrylic mediums to coat individual objects, especially those you suspect of having a high acid content, to protect adjoining parts of the collage from acid invasion. Finally, you may coat the finished collage for protection from the elements and from spills.

If some of your collage objects are delicate (fragile flowers, insects, thin leaves) you can often enable them to withstand handling by coating them with acrylic medium before placing them in your collage. A way to do this is to hang them from a "clothesline," a string or wire stretched across a cardboard box and then *spray* them very gently with one or more coats, front and back, of acrylic varnish. Either do this outdoors on a still day (don't let the breeze break your delicate pieces) or indoors in a well-ventilated area while wearing a face mask.

Experiment with all the acrylic mediums— they have astonishing versatility. Try them on some scraps to see whether you want to use the matte or gloss varieties.

Dry Mount

Some artists use photographers' dry-mount film as their adhesive. This involves cutting and placing film on the rear of each piece you intend to stick down. Then you lay the pieces to be joined in a dry-mount press, which heats the materials under pressure and causes the film to melt and fuse with both the back side of the piece you're fastening and the face of the surface behind it. This is the method used by Michael Brown in his collage work in this chapter. This method works for truly *flat* pieces, but obviously won't do for thick or curly or rolled pieces. An advantage to this method is that there are never pesky bubbles to contend with—the heat and pressure flatten everything.

Health Tips

1. Use acrylic spray varnishes outdoors or in a well-ventilated area; wear a face mask.

2. Collage artists tend to get involved with a mess of adhesives, paints and materials—wear latex gloves to keep materials off your skin.

3. You're sure to have sharp objects around your work table. Use them carefully and keep them away from children.

Pastes

Long before acrylics came into prominence, artists used, and still use, pastes such as wheat or rice starch pastes. Unlike acrylic adhesives, these pastes may be moistened and removed. They are, however, less permanent than acrylic mediums and they may be attacked by insects.

VARNISH

You may frame a collage under glass for protection or you may varnish it. Often, artists use acrylic varnish, either matte or gloss, sprayed or brushed on. These products are porous and dirt can accumulate in the pores. Nonporous final varnishes, such as Liquitex Soluvar and Winsor & Newton Acrylic Gloss or Matte Varnish may be used instead (see acrylic chapter). Golden Artist Colors has an excellent final varnish (acrylic) with a UV inhibitor.

TOOLS

If you work in any of the painting mediums, you're likely to have at hand most of what you need for collage: An assortment of brushes, including inexpensive ones for brushing on acrylic mediums, and, of course, paint brushes if painting is to be part of your collage; palette; a brayer or other roller for pressing a piece of collage against the support; thin latex gloves to keep your hands out of the goo of paints and adhesives; scissors and other cutting tools, such as a mat knife or an X-Acto knife or razor blades; and water containers, pencils and so on.

WORKSPACE

Here's where you may have a big departure from working in other mediums. When assembling a collage, unless you're working very small, you need lots of working space. Not only do you need a place (horizontal or vertical) for your collage-in-progress but for all the pieces of

VIRGINIA LEE WILLIAMS
Marbling

I HEAR THE SOUND
Virginia Lee Williams
Oil Marbling
23″ × 10½″
Collection of H. R. Dickenson

Collage artists often use marbled papers like this one as part of their collages. Here are the basic steps Williams uses for oil marbling. You'll find a detailed description of materials and procedures in Williams' and Nita Leland's book, *Creative Collage Techniques*, including how to prepare the paper used in the following:

(1) Prepare a bath (also called a size) in a tub such as a dishpan or litter tray. The bath is a thickish mixture of wallpaper paste (cellulose, not vinyl) and water. Its purpose is to provide a surface that colors may now be added to. (2) Put a layer of fluid oil paints on the surface of the bath, using eyedroppers or similar tools. (3) Form a pattern you like by placing drops of paint with the droppers, or by pulling a comb or other object gently through the paint, or by any means you wish, without *stirring* the paint so much that it mixes with the bath. (4) Pick up a piece of prepared paper by its two opposite corners and lower it onto the surface of the bath, starting at one corner and ending up at the other. (5) After ten seconds or so, pull the paper up, starting at one corner, let excess paint drain from it, and lay it face-up on some sheets of newspaper for ten minutes. (6) Over the sink, squeeze clean water from a sponge over the paper's surface to rinse away excess paint and size. Put the paper aside to dry.

stuff you're thinking of trying out—pieces of paper and other objects. You may manage this with one long table or with two or more smaller surfaces. Card tables are handy. Be sure you have room to spread out the materials you're working with so that in the heat of creativity you're not constantly flustered because you can't *find* something.

Since you'll usually be working with wet or sticky materials, prepare your work surface in such a way as to make it easy to clean. You wouldn't want to build a collage on your wooden dining table. Williams and Leland suggest covering your work surface with taped-together strips of freezer paper (available at the grocery store). I have a 4′ × 10′ surface of smooth tile board (like Formica, but less expensive) from the building supply store—it doubles as a matting area.

In addition to a working surface, you need to become a smart file clerk. As you become more involved

in collage, you'll collect more and more materials and you'll need not only to store them safely but to *find* them when you need them. There are a couple of ways collage artists try to solve the filing problem:

File Drawers

The flat kind, with drawers an inch or two deep, work well if you have the space and can afford enough of them. You can often find such cabinets (often called map cabinets) in used furniture stores. I have two stacks of these cabinets, side by side. On top, spanning both cabinets, is a $4' \times 10'$ sheet of $3/4''$ plywood, and glued to it is the tileboard working surface I mentioned earlier.

Hanging Racks

A good way to keep sheets of paper is to hang them from a series of bars, or even ropes or wires, set up parallel to each other. Each piece of paper (or fabric or other material) can be hung from the bars or ropes using clamps or clothespins. This arrangement has two advantages over drawers: (1) Air can circulate freely around the papers, helping to prevent mildew, and (2) it's easy to spot the paper you're looking for.

GETTING STARTED

Once you start making collages, you'll decide on methods that work best for you. There are probably more differences in approaches among collage-makers than among any other group of artists, but if you're beginning, here are some guidelines.

DO . . .

1. Choose an acid-free support and coat it front and back with acrylic medium, gel, gesso or paint. The idea is to seal the board and stiffen it so subsequent layers of materials won't warp it too much. Two coats may be necessary.

2. Cut out or select your main collage pieces and arrange them on the board. When you're satisfied, make a sketch of the arrangement of the pieces—if necessary you can number the pieces on the back and write corresponding numbers on the board. Remove the pieces from the board. (See the comments under Bob Kilvert's collages for other ways to proceed.)

3. Working from back to front (that is, from overlapped pieces to overlapping pieces) glue the pieces to

COLLAGE SHOPPING LIST

BASICS	✓
COLLECTION OF PAPERS (such as white and colored rice papers, cutouts from magazines, watercolor papers)	
ACRYLIC MEDIUMS, GLOSS AND MATTE (1 pint each)	
SUPPORT heavyweight illustration board	
ACRYLIC GEL MEDIUM , GLOSS (1 quart)	
ACRYLIC PAINTS (see acrylic chapter)	
BRUSHES 2″ flat synthetic brush (for medium/gel) 1″ flat synthetic brush (for medium/gel) an assortment of painting brushes	
KNIVES palette knife 2″ painting knife mat knife or X-Acto	
SCISSORS (sharp)	
BRAYER or other ROLLER	
PENCIL, SCRAP PAPER	
FREEZER PAPER	
MASKING TAPE	
LATEX GLOVES	
WORK TABLE	
OPTIONAL	✓
FABRICS, OTHER OBJECTS	
SOLUVAR VARNISH	
SPRAY CAN OF ACRYLIC VARNISH	
HAIR DRYER	
FILING SYSTEM	

the board with acrylic medium (either matte or gloss). Put firmly in place by covering the piece with a protective sheet of clear plastic or waxed paper (which can be replaced with a clean sheet each time) and pressing with a brayer or your hand or other tool. Don't put paper over the piece when pressing because it will stick to any

BOB KILVERT
Collage Without Paint

WEOBLEY VILLAGE HEREFORDSHIRE
Bob Kilvert, FCSD, FRSA
Collage on acid-free board
32" × 45"
Collection of Mrs. Robbie Dunlap

"In the center of this collage," says Bob Kilvert, "is the Red Lion, one of Weobley's three medieval inns. To the left is The Old Corner House, my home and where my courses are based. I made use of pinks, yellows and blues to distinguish between panels in sunlight and in shadow. The building beyond the inn is a thirteenth-century cruck-timbered cottage and behind is the spire of Weobley's vast Norman church. I used fragments from an advertisement for tweed suiting to represent the tower and the church clock is a button. Details like the inn sign had to be handled with care to avoid making them too literal. The same applied to the figures on the left of the picture, which are formed from scraps of paper."

Kilvert's impressive collages consist almost entirely of torn magazine material and contain no paint or surface drawing. He teaches at Weobley and writes articles about his work that are full of helpful information. Kilvert pays a lot of attention to the permanence of his work and discusses this and other aspects of collage at length in articles in a British publication, *Leisure Painter*. He says you may obtain photocopies of his articles by writing him at The Old Corner House, Weobley, Hereford, England HR4 8SA. I suggest you include return postage with your request. (About three dollars worth of *international postage coupons*, available at your post office, would be about right.)

On a Tear!

In addition to cutting papers, you'll often tear them. Each paper tears differently, depending on how its fibers lie, its thickness and so on. Experiment with watercolor and other papers to see the variety of beautiful edges you can get.

INCEPTION II
W.E. Coombs
30″ × 24″
Collection of Patrick J. Megenity, Haslett, MI

The background for this assemblage is embossed, handmade paper. Coombs used a wide variety of materials, including electronic components (there are resistors and an etched circuit board in this example), sheet metals, plastic rods, copper wire, cross-stitched fabric and pieces of texturized four-ply rag board. In some areas, designs and textures are created on clear plastic with acrylic paints. Some designs are painted with an airbrush. Parts of this assemblage are glued in place, while others are stitched in place with fine copper wire. The finished product is framed or boxed under glass or Plexiglas.

medium that oozes out from under the collage piece. Wipe off excess medium with a damp sponge.

4. When all pieces are in place, you have the option of coating the collage with either gloss or matte medium, or leaving it alone. Using medium will help seal the work against the atmosphere, spills and so on. Also, if you have any splotches of medium on the collage, an overall coat will even out the look of the surface.

5. Dry the work thoroughly. If it's warped, turn it face down on a clean, dry, nonsticky surface and pile plenty of weights uniformly on its back (only if it is a flat collage).

6. If you store the collage flat, place glassine paper between it and other collages or paintings to prevent sticking.

DON'T . . .

1. If you're using oil paint, oil pastel or other oily material in your collage, don't expect subsequent layers of materials such as acrylic mediums, to stick. Save any use of oily materials for the last layer, after you're finished with other materials.

2. Thinking of using hardboard as your support? If your collage involves pouring acrylic paint over your board, as well as piling on lots of gels and papers and so on, be prepared—these things get heavy! I did some collages with a lot of poured paint a few years ago, using Masonite. Foolishly, I even framed them under glass! My chiropractor appreciated it. Use illustration or watercolor board or mat board for the support.

PREPARING YOUR OWN PAPERS

In addition to the wealth of colored papers available, you can make your own. Using watercolor papers, oriental papers, printing papers or any other kind, you simply paint them with acrylic paint or watercolor in whatever colors and intensities you wish, either transparently or opaquely. Be sure you have a place to hang the papers up to dry. You can also prepare your own marbled papers (see Virginia Williams' illustration in this chapter).

You'll find that papers such as translucent oriental papers behave differently when you paint them as free sheets than when you paint them *after* sticking them down to your collage. Try manipulating papers in all kinds of ways—you'll be delighted by the range of results you can get.

VUYELWA
Robert Kilvert
Collage
45″ × 32″

Kilvert draws a sketch of his intended collage on clear acetate and tapes this to the top of his support. As he blocks in his subject by gluing down pieces of magazine pages, he continually drops the acetate down over the picture to check on the positioning of his pieces so far. This works better for him than drawing on the support, because the drawing soon becomes obliterated.

As he tears bits of color from magazines, he never looks for pieces similar to whatever he is trying to represent—for example, he would not represent hair by tearing out a picture of hair.

He works all over the picture until his subject begins to come into focus. "As I work," he says, "I try, not always successfully, to keep mess to a minimum. Usually I have a pile of color supplements to the left of the support and a waste bin to the right. I seldom preserve discarded fragments for future use. As I finish each magazine, I drop the remnants into the waste bin. I have imposed this discipline on myself because, otherwise, I find I am soon wading through a sea of discarded paper, and the best work does not come out of disorder."

Tip: It's a good idea to cut a piece of each new paper you use about eight inches square and write notes on it about that paper's behavior under different conditions. You'll be happy you took notes, because once you've worked with dozens of papers, it's hard to remember how all of them behave or even what their names are.

A FINAL WORD

We've only scratched the surface in this chapter. Collage (and mixed media in general) offers you endless possibilities. There's room here for both methodical and spontaneous artists. (Some say these media are for the truly uncommitted!)

For more about this art form, I can think of no finer book than *Creative Collage Techniques*, by Virginia Lee Williams and Nita Leland. There you'll find plenty of demonstrations and advice on using all kinds of materials and techniques, including monoprinting, photocollage, embossing, frottage, marbling, handmade paper and cast paper.

In addition, keep an eye out for anything written by Bob Kilvert. He teaches (in England) and writes extensively and he's one of those generous people whose writings seem to hold nothing back.

Society Notes

The Society of Layerists in Multi-Media
1408 Georgia NE
Albuquerque, NM 87110

* * *

National Collage Society
254 W. Streetsboro St.
Hudson, OH 44236

Leaf is an extremely thin layer of metal, such as gold or silver. Gold leaf and silver leaf are, of course, expensive. An alternative is "composition" leaf. Composition gold leaf is made of brass, and composition silver leaf is made of shiny aluminum.

Porter began this painting by gluing leaf to a thin sheet of paper in random fashion. Then she tore and cut pieces of this sheet and glued them to the museum board. The reason for gluing the leaf to the thin paper first is to make the fragile leaf easier to handle.

Then she painted loosely with fluid acrylic until shapes began to take form. She worked alternately with more leaf and more acrylic until she had a suggestion of the subject without getting too literal. One of the charms of a leaf painting is that its appearance changes with changing light.

BUG FANTASY
Shirley Porter
Acrylic with composition gold and silver leaf
on museum board
30″ × 40″

AFTERWORD

I called a fellow at Grumbacher named George Stegmeir to ask him a fairly simple question about a solvent. Two hours later, having completely ignored his lunch break, George finally finished answering my question. Along the way, though, he had detoured into a dozen dark alleys and turned on the lights there for me. He told me more than I could possibly fit into this book.

George is one of many people out there who have profound and detailed knowledge about paint formulations and papermaking processes and grounds and supports and chemistry and everything else connected with art. My conversation with him reminded me that no matter how much information I include in this or any other book, there's *always* a lot more!

Everybody can't call George—there are just so many hours in his working day, after all. But you *can* call and write art materials manufacturers and get from them a ton of literature about their products. Sure, some will be sales hype, but mostly you'll get good, solid information. Addresses on page 182 are included to help you in your knowledge search.

The business of art materials is fast-moving. If you're serious about your art, you won't rest with today's information. Tomorrow, some of it will change.

PHIL METZGER

CONTRIBUTORS TO THIS BOOK

Greg Albert
North Light Books
1507 Dana Avenue
Cincinnati, OH 45207

Warren Allin
5901 Kingswood Road
Bethesda, MD 20814

Kurt Anderson
Suite 780
275 East 4th Street
St. Paul, MN 55101

Fred Bartlett
RD #1 Box 77
Wapwallopen, PA 18660

Michael David Brown
2007 Stratton Drive
Rockville, MD 20854

Tom Browning
1820 Prairie Road #B
Eugene, OR 97402

Paul Calle
149 Little Hill Drive
Stamford, CT 06905

Hugh Campbell, III
3801 Millbrook Drive
San Angelo, TX 76904

Bill Coombs
1130 Haynes Creek Drive
Conyers, GA 30207

Louise DeMore
2135 Glenn Street
Los Osos, CA 93402

Edward Gordon
49 Market Street #4
Portsmouth, NH 03801

Robert Guthrie
3 Copra Lane
Pacific Palisades, CA 90272

William Hook
3385 South Clayton Blvd.
Englewood, CO 80110

Robert Howard
55 Westland Terrace
Haverhill, MA 01830

Earl and Leah Killeen
3 South Parkway
Clinton, CT 06413

Robert Kilvert
The Old Corner House
Broad Street
Weobley, Hereford
England HR4 8SA

Margaret Kranking
3504 Taylor Street
Chevy Chase, MD 20815

Jan Kunz
PO Box 868
Newport, OR 97365

Al Lachman
Arbor Vista
18648 Maple
Grayslake, IL 60030

Stanley Maltzman
PO Box 333
Freehold, NY 12431

Ross Merrill
Chief of Conservation
National Gallery of Art
Constitution Ave. at 6th St NW
Washington, DC 20565

Phil Metzger
PO Box 10746
Rockville, MD 20850

Elizabeth Mowry
287 Marcott Road
Kingston, NY 12401

Ned Mueller
13621 182nd Avenue SE
Renton, WA 98059

Claudia Nice
940 NE Littlepage
Corbett, OR 97019

Joseph Orr
Rt 1 Box 1229
Osage Beach, MO 65065

Don Pearson
7819 S. College Place
Tulsa, OK 74136

Shirley Porter
14315 Woodcrest Drive
Rockville, MD 20853

Bernard Poulin
100 Pretoria Street
Ottawa, Canada K1S 1W9

Michael P. Rocco
2026 South Newkirk Street
Philadelphia, PA 19145

Gary Simmons
133 Brown Drive
Hot Springs, AR 71913

Charles Sovek
#3 Logan Place
Rowayton, CT 06853

Sally Strand
33402 Dosinia Drive
Dana Point, CA 92629

Zoltan Szabo
1220 Glenn Valley Drive
Matthews, NC 28105
(800) 336-8091 mail order

Daniel K. Tennant
31 Bixby Street
Bainbridge, NY 13733

Robert Vickrey
Crystal Lake Drive
Box 445
Orleans, ME 02653

Arne Westerman
313-314 Alderway Building
711 SW Alder
Portland, OR 97205

Virginia Williams
329 Carthage Place
Trotwood, OH 45426

Jessica Zemsky
Box 1043
Big Timber, MT 59011

ART MATERIALS SOURCES

For information about art materials, write or call the Customer Service department for the manufacturer or distributor in the left-hand list. Often a well-known brand name is handled by some umbrella organization or distributor you don't recognize, so at the right are brand names along with a number () telling you a distributor at the left who handles that product.

MANUFACTURERS AND DISTRIBUTORS

(1) Bee Paper Company, Inc.
321 Hamburg Turnpike
PO Box 2366
Wayne, NJ 07474-2366
(800) 524-2485

(2) Berol
PO Box 2248
Brentwood, TN 37024-2248

(3) Binney & Smith Inc.
1100 Church Lane
PO Box 431
Easton, PA 18044-0431
(800) 272-9652

(4) Canson-Talens, Inc.
PO Box 220
21 Industrial Drive
So. Hadley, MA 01075

(5) Caran D'Ache
19 West 24th Street
New York, NY 10010

(6) Chroma Acrylics, Inc.
PO Box 510
Hainesport, NJ 08036
(800) 257-8278

(7) Col-Art Americas Inc.
11 Constitution Avenue
PO Box 1396
Piscataway, NJ 08855-1396

(8) Creative Art Products Co.
PO Box 129
Knoxville, IL 61448
(800) 945-4535

(9) Crescent Cardboard
Company
100 W. Willow Road
PO Box X-D
Wheeling, IL 60090
(800) 323-1055

(10) Da Vinci Paint Company
Inc.
11 Good Year Street
Irvine, CA 92718

(11) Daler-Rowney USA
4 Corporate Drive
Cranbury, NJ 08512-9584

(12) Daniel Smith Inc.
4130 1st Avenue South
Seattle, WA 98134
(800) 426-7923

(13) Fabriano Papermill
PO Box 82
60044 Fabriano, Italy

(14) Golden Artist Colors Inc.
Bell Road
New Berlin, NY 13411

(15) H.K. Holbein, Inc.
PO Box 555
Williston, VT 05495
(800) 682-6686

(16) Hunt Manufacturing Co.
One Commerce Square
2005 Market Street
Philadelphia, PA 19103-7085

(17) J. Blockx Fils S.A.
Route De Liege 39
4560 Terwagne, Belgium

(18) John G. Bonner
6501 Fairland Street
Alexandria, VA 22312

(19) Koh-I-Noor, Inc.
100 North Street
PO Box 68
Bloomsbury, NJ 08804-0068
(800) 346-3278

(20) Loew-Cornell Inc.
563 Chestnut Avenue
Teaneck, NJ 07666-2490

(21) M. Grumbacher, Inc.
100 North Street
PO Box 68
Bloomsbury, NJ 08804-0068
(800) 877-3165

(22) Morilla Co., Inc.
PO Box 220
21 Industrial Drive
South Hadley, MA 01075

(23) Multimedia Artboard, Inc.
15727 N.E. 61st Court
Redmond, WA 98052
(800) 701-2781

(24) Nielsen and Bainbridge
40 Eisenhower Drive
Paramus, NJ 07653

(25) Old Holland Paints
3972 KC Driebergen
Netherlands

(26) Pebeo
1035 St. Denis Street
Sherbrooke, Quebec J1K 2S7
Canada

(27) Pelikan, Inc.
200 Beasley Drive
PO Box 3000
Franklin, TN 37064
(800) 251-1910

(28) Pentel of America
2805 Columbia Street
Torrance, CA 90503
(800) 421-1419

(29) Pro Arte
Box 1043
Big Timber, MT 59011
(800) 736-5234

(30) Robert Simmons, Inc.
45 West 18th Street
New York, NY 10011

(31) Salis International
4093 North 28th Way
Hollywood, FL 33020
(800) 843-8293

(32) Sanford Corporation
2711 Washington Blvd
Bellwood, IL 60104
(800) 323-0749

(33) Savoire-Faire
PO Box 2021
Sausalito, CA 94966

(34) Schmincke
400 Beacon Ridge Lane
Walnut Creek, CA 94596

(35) Staedtler-Mars Ltd.
6 Mars Road
Etobicoke, Ontario
M9V 2K1
Canada

(36) Strathmore Papers
39 South Broad Street
Westfield, MA 01085

(37) Talens C.A.C., Inc.
2 Waterman Street
St. Lambert, Quebec
J4P 1R8 Canada

(38) Tara Materials, Inc.
111 Fredrix Alley
Lawrenceville, GA 30246

(39) Twinrocker Inc.
100 East 3rd Street
PO Box 413
Brookston, IN 47923

(40) Whatman International
Ltd.
Springfield Mill, Maidstone
Kent ME14 2LE
England

BRANDS AND THEIR DISTRIBUTORS ()

Brand	
AQUABEE	**(1)**
ARCHES	**(4)**
ARCHIVAL	**(6)**
ATELIER	**(6)**
BAINBRIDGE	**(24)**
BEROL	**(2)**
BIENFANG	**(16)**
BLOCKX	**(17)**
BONNER POCHADE	**(18)**
CANSON	**(4)**
CARAN D'ACHE	**(5)**
COLART	**(7)**
CONTÉ	**(16)**
CRESCENT	**(9)**
DA VINCI	**(10)**
DANIEL SMITH	**(12)**
DERWENT	**(7)**
DESIGN	**(32)**
DR. MARTIN'S	**(31)**
EBERHARD-FABER	**(32)**
FABER-CASTELL	**(32)**
FABRIANO	**(13)**
FREDRIX	**(38)**
GOLDEN	**(14)**
GRUMBACHER	**(21)**
HIGGINS	**(32)**
HOLBEIN	**(15)**
HUNT	**(16)**
KOH-I-NOOR	**(19)**
LANA	**(33)**
LARROQUE	**(33)**
LIQUITEX	**(3)**
LOEW-CORNELL	**(20)**
MARS	**(35)**
MORILLA	**(22)**
MULTIMEDIA	**(23)**
NIELSEN	**(24)**
OLD HOLLAND	**(25)**
PEBEO	**(26)**
PELIKAN	**(27)**
PENTEL	**(28)**
PRO ARTE	**(29)**
RAPIDOGRAPH	**(19)**
REMBRANDT	**(4)**
REXEL	**(7)**
ROWNEY	**(11)**
SANFORD	**(32)**
SCHMINCKE	**(34)**
SENNELIER	**(33)**
SHIVA	**(8)**
SIMMONS	**(30)**
SPEEDBALL	**(16)**
STAEDTLER	**(35)**
STRATHMORE	**(36)**
TWINROCKER	**(39)**
VAN GOGH	**(37)**
WHATMAN	**(40)**
WINSOR & NEWTON	**(7)**

GLOSSARY

acid-free paper Paper that is naturally free of acidic materials or has had its acid content neutralized.

alkyd paint Paint that has as a binder a synthetic resin plus some oil. The resin is made from alcohol and acid.

alla prima Direct painting usually finished in a single painting session.

aquarelle Transparent watercolor.

binder Material that holds pigment particles to each other and to a ground.

blanc fixe An inert pigment of precipitated barium sulfate, used to reduce the strength of paint with a minimum effect on clarity. Also used as body in gouache.

block, watercolor Sheets of watercolor paper stacked and bound together on all four sides. Each sheet is separated from the block after it's been used.

bloom 1. A whitish haze (wax bloom) that forms as wax rises to the surface of a colored pencil picture. 2. A whitish haze in a layer of varnish (sometimes caused by moisture). 3. Blotch in a watercolor painting that occurs when water or fluid paint is introduced into a damp area of paint.

board, painting or drawing Any stiff sheet of material such as hardboard or wood or cardboard serving as a backing for a sheet of paper while drawing or painting.

bristol Paper that is formed by pasting together under pressure two or more sheets, or plies. In early days of European papermaking, mills sent their fine papers to Bristol, England, for pasting. Sometimes also used to describe a strong, single-ply drawing paper.

buffering The addition of alkaline substances such as calcium carbonate to papers during manufacture to neutralize acidity and provide protection against later exposure to acidic environments.

casein A derivative of milk curd used as an adhesive and as a binder in casein paints.

chalk Soft limestone (a form of calcium carbonate) that is easily ground and used in such paints as gouache and pastel.

charcoal Carbon obtained by heating wood in the absence of air.

cold press A mildly textured paper surface—more textured than hot press, less textured than rough.

copal A resin derived from several tropical trees, used in some varnishes and mediums; darkens with age.

crosshatching A set of parallel lines laid at an angle over another set of parallel lines.

damar A resin derived from several trees found in Malaya and Indonesia; used in some varnishes and mediums.

deckle edge Irregular edge of handmade papers, simulated in mouldmade and machine-made papers.

drier Something added to a paint to make it dry faster; siccative.

dryer A machine used to speed drying using heated air.

dry brush Painting with fairly stiff, dry paint, as opposed to fluid paint—e.g., watercolor paint with little or no water added.

dry painting Watercolor painting in which paint is applied to a dry surface (see wet-in-wet).

easel A structure that supports a painting or drawing in progress vertically or at an angle.

emulsion A mixture of mutually insoluble liquids in which one is dispersed in droplets throughout the other. Examples: egg yolk and milk are both emulsions. Each has tiny droplets of an oily substance suspended in a watery substance.

fat Relatively oily.

film, paint A layer of paint.

fixative A fluid usually sprayed onto a charcoal or pastel picture to prevent smudging or flaking of the pigment.

fixative, workable A fixative that allows further work on the picture because it does not cover the picture with a film that resists additional pigment.

French easel A folding easel for travel.

gesso, true A mixture of glue, pigment, and a chalky filler used as a ground for egg tempera and other paints; not the same as acrylic gesso.

gesso, acrylic A form of acrylic paint suitable for use as a ground for many paints.

glaze A transparent layer of paint over other, usually lighter, layers.

glycerin A substance added to watercolor and gouache paints to keep them from becoming brittle.

gm/m² Grams per square meter, a standard way of designating the weight (and therefore the thickness) of paper.

grisaille Painting done in tones of a single color, usually grays (monochromatic); sometimes used as the underpainting for a series of colored glazes.

ground A coating (such as a layer of gesso) put over a painting support before paint is applied.

gum tragacanth A plant gum used as the binder in pastels.

gum arabic A secretion of certain trees, used as a binder in watercolor and gouache paints.

handmade paper Paper actually made a sheet at a time by pouring pulp (a watery mixture of fibers and chemicals) over a wire mesh mould surrounded by a wooden frame called a deckle. These papers have a degree of randomness in their surface textures.

hardboard A dense, rigid board made from compacted wood fibers

hatching A set of of parallel lines.

Homosote A thick, fairly lightweight, gray board with a hard surface but a spongy core; available at building supply stores.

hot press A smooth paper surface, generally less absorbent than cold press or rough.

illustration board Drawing paper glued to cardboard.

impasto Paint applied thickly.

kneadable eraser A soft, rubbery substance used as an eraser; it can be stretched and formed into any shape. Also called "kneaded" eraser.

knife, painting Knife, often trowel-shaped, used to mix and apply paint.

knife, palette Long-bladed knife used to mix paint or clean palettes.

laid paper Paper that has a pattern of ribbed lines (see wove paper).

lean Relatively less oily.

lifting Removing paint from a surface.

linseed oil Oil from the seed of the flax plant, used as a binder in oil paints and as an ingredient in some mediums.

machine-made paper Paper made on a high-speed machine. Unlike handmade or mouldmade papers, these have uniform surface textures.

masking Covering an area to protect it from receiving paint.

Masonite A popular brand of hardboard.

matte A satin, nonglossy finish.

medium 1. A basic kind of art—e.g., painting, drawing, etching, sculpting. 2. The basic material used by the artist—e.g., watercolor paint, oil paint, graphite, clay, steel. 3. The ingredient in paint that binds the pigment—e.g., gum arabic in watercolor paint, linseed oil in oil paint, egg yolk in egg tempera. (Also called binder.) 4. Material (usually fluid, though there are gels and semi-gels) that can be added to a paint to change its viscosity and other characteristics—e.g., water, turpentine, gum arabic.

mineral spirits Solvent derived from petroleum.

mouldmade paper Paper made by machine to simulate the look and texture of handmade paper.

negative painting Defining a form by painting the space around it.

newsprint Inexpensive wood pulp paper.

oil pastel Pastel made with an oil binder rather than a gum binder.

oil stick Oil paint with wax added to allow it to be made into solid form.

palette 1. A tray or other surface used to hold and mix paints. 2. A selection of colors.

pastel A dry paint in stick or pencil form, resembling chalk.

pH A measure of the acidity or alkalinity of a substance on a scale of 1 to 14, 1 being most acidic, 14 most alkaline, 7 neutral. The p is from the German word for power and the H stands for hydrogen. pH is an indication of the hydrogen ion concentration in a substance.

ply One layer of a paper or board having two or more layers. There is no standard for the thickness of a ply; one brand's "2-ply" paper may be thicker than another's "3-ply."

poppyseed oil Oil derived from the poppyseed, used as a binder in some oil paints and in oil painting mediums.

pulp The fluid mass of fibers and other ingredients used to make a sheet of paper.

quire Twenty-five sheets.

rag Fabric (usually cotton) used as the source of fibers in the manufacture of quality papers. The best papers are 100% rag. The rags used are generally the remnants left from the manufacture of clothing, such as T-shirts.

ream Five hundred sheets.

retouch varnish Varnish sprayed or brushed lightly to even the appearance of an oil painting in which some colors look dry, some "wet," or as a protection until a final varnish is applied.

rice paper Papers typically made from such fibers as mulberry, not rice.

rough A significantly textured paper surface, more textured than cold press.

scumble Layer of broken, usually lighter, paint over a usually darker layer, allowing the under-paint to show through.

siccative A drier.

size or sizing (on canvas) Material such as glue used on canvas to protect the canvas fibers from oil grounds.

size or sizing (on paper) Material added to paper either at the pulp stage or later to the finished surface. Sizing alters a paper's absorbency—the more size, the less absorbent the paper will be.

stand oil A thick polymerized linseed oil that has been heated to a high temperature in the absence of oxygen; used in some oil painting mediums.

stomp Stump.

stretching (canvas) Fastening a piece of canvas (usually to a frame of wood strips) to keep the canvas taut.

stretching (paper) Saturating a sheet of paper to make it expand, and then capturing the paper in its expanded state.

stump A tightly wound cylinder of paper, pointed at both ends, used for blending and detail work in dry mediums, such as charcoal and pastel. (See tortillon.)

support The material to which paint is applied (paper, canvas, wood, hardboard, etc.).

tempera Originally, any liquid medium with which pigments could be mixed to make a paint; now, a paint that uses an emulsion as its binder.

tempera, egg A paint using egg as its binder.

template, erasing Flat piece of plastic or metal with openings of various sizes and shapes. Used to restrict erasure to the limited area of one of the openings. Also called erasing shield.

tortillon or tortillion A tightly wound cylinder of paper, pointed at one end, used for blending and detail work in charcoal and pastel. (See stump.)

transfer paper A sheet of paper with graphite on one side, used to trace a drawing from one sheet onto another.

turpentine A solvent distilled from the sap of pine trees.

turps Short for turpentine.

varnish A resinous protective covering for a painting; also, an ingredient in some painting mediums.

Venice turpentine Raw, unrefined sap from the Austrian larch tree.

watercolor board Watercolor paper glued to cardboard.

watercolor Transparent, water-based, water-soluble paint with a gum binder.

wet-in-wet Method of painting in which paint is applied to an already-wet surface.

wetting agent A substance added to water to break down its surface tension.

wove paper Paper with a smooth, unlined finish (see laid paper).

BIBLIOGRAPHY

✓ Denotes authors who have contributed to this book.

Acrylic Painting

Holden, Don [Wendon Blake]
The Complete Acrylic Painting Book
Cincinnati: North Light Books, 1989

✓ Killeen, Earl Grenville and Leah
Raechel Killeen
The North Light Book of Acrylic Painting Techniques
Cincinnati: North Light Books, 1995

Collage

✓ Kilvert, Robert
Articles on Collage and Collage Conservation in publication called
The Leisure Painter, England. Article photocopies available from Kilvert.

✓ Williams, Virginia and Nita Leland
Creative Collage Techniques
Cincinnati: North Light Books, 1994

Colored Pencil

Greene, Gary
Creating Textures in Colored Pencil
Cincinnati: North Light Books, 1996

✓ Poulin, Bernard
The Complete Colored Pencil Book
Cincinnati: North Light Books, 1992

Drawing

✓ Albert, Greg and Rachel Wolf
Basic Drawing Techniques
Cincinnati: North Light Books, 1991

✓ Brown, Michael David
Washington DC and *Viewpoints*
Rockville, MD: Winterberry Publishing, 1995

✓ Calle, Paul
The Pencil
Cincinnati: North Light Books, 1985

Dodson, Bert
Keys to Drawing
Cincinnati: North Light Books, 1990

Goldstein, Nathan
The Art of Responsive Drawing
New Jersey: Prentice-Hall, 1991

Guptill, Arthur L.
Rendering in Pen and Ink
New York: Watson-Guptill, 1976

✓ Maltzman, Stanley
Drawing Nature
Cincinnati: North Light Books, 1995

✓ Metzger, Phil
Perspective Without Pain
Cincinnati: North Light Books, 1992

Metzger, Phil
How to Master Pencil Drawing
Rockville, MD: LC Publications, 1991

✓ Nice, Claudia
Sketching Your Favorite Subjects in Pen & Ink
Cincinnati: North Light Books, 1993

Petrie, Ferdinand
Drawing Landscapes in Pencil
New York: Watson-Guptill, 1979

✓ Simmons, Gary
The Technical Pen: Techniques for Artists
New York: Watson-Guptill, 1992

Egg Tempera Painting

✓ Vickrey, Robert and Diane Cochrane
New Techniques in Egg Tempera
New York: Watson-Guptill, 1973

General Art

Calle, Paul
An Artist's Journey
Cincinnati: North Light Books, 1994

Mayer, Ralph
The Artist's Handbook of Materials and Techniques
New York: Viking Press fifth edition, 1991

Metzger, Phil
Enliven Your Paintings With Light
Cincinnati: North Light Books, 1993

Tate, Elizabeth
The North Light Illustrated Book of Painting Techniques
Cincinnati: North Light Books, 1993

Vickrey, Robert
Artist at Work
New York: Watson-Guptill, 1979

Vickrey, Robert
The Affable Curmudgeon
Orleans, MA: Parnassus Imprints

Gouache Painting

✓ Howard, Rob
Gouache for Illustration
New York: Watson-Guptill, 1993

✓ Tennant, Daniel K.
Photorealistic Painting
Laguna Hills, CA: Walter Foster Publishing, 1996

✓ Zemsky, Jessica
Capturing the Magic of Children in Your Paintings
Cincinnati: North Light Books, 1996

Oil Painting

✓ Anderson, Kurt
Realistic Oil Painting Techniques
Cincinnati: North Light Books, 1995

✓ Browning, Tom
Timeless Techniques for Better Oil Paintings
Cincinnati: North Light Books, 1994

✓ DeMore, Louise
(First Steps in) Painting Oils
Cincinnati: North Light Books, 1996

Leslie, Kenneth
Oil Pastel
New York: Watson-Guptill, 1990

Sarback, Susan
Capturing Radiant Color in Oils
Cincinnati: North Light Books, 1994

Schmid, Richard
Richard Schmid Paints Landscapes: Creative Techniques in Oil
New York: Watson-Guptill, 1975

✓ Sovek, Charles
Oil Painting: Develop Your Natural Ability
Cincinnati: North Light Books, 1991

Pastel Painting

Katchen, Carole
Creative Painting With Pastel
Cincinnati: North Light Books, 1990

✓ Mowry, Elizabeth
Paint the Changing Seasons in Pastel
Cincinnati: North Light Books, 1994

Watercolor Painting

Koschatzky, Walter
Watercolor History and Technique
Vienna: Anton Schroll & Co., 1969
English translation: Thames and Hudson, 1970

✓ Kunz, Jan
Painting Watercolor Florals That Glow
Cincinnati: North Light Books, 1993

Pike, John
Watercolor
New York: Watson-Guptill, 1966

Reynolds, Graham
A Concise History of Watercolors
London: Thames and Hudson, Ltd., 1971

✓ Rocco, Michael
Painting Realistic Watercolor Textures
Cincinnati: North Light Books, 1996

✓ Szabo, Zoltan
Zoltan Szabo's 70 Favorite Watercolor Techniques
Cincinnati: North Light Books, 1995

✓ Westerman, Arne
Paint Watercolors Filled With Life and Energy
Cincinnati: North Light Books, 1994

INDEX

Page numbers in italics refer to artist's works.